THE DANCER AND THE DANCE

MERCE CUNNINGHAM

in conversation with Jacqueline Lesschaeve

Revised and updated

Marion Boyars New York – London

First paperback edition published in the United States and Great Britain
in 1991 by Marion Boyars Publishers Inc,
26 East 33rd Street, New York, NY 10016
and by Marion Boyars Publishers Ltd,
24 Lacy Road, London SW15 1NL

Originally published in the United States and Great Britain in 1985

Distributed in the United States and Canada by
Rizzoli International Publications, New York

Distributed in Australia by
Wild and Woolley, Glebe, N.S.W.

Library of Congress Cataloging in Publication Data

Cunningham, Merce.
 The dancer and the dance.

 English version of: Merce Cunningham, le danseur et la danse.
 Includes index.
 1. Cunningham, Merce. 2. Dancers–United States–Biography.
 3. Modern dance.
 I. Lesschaeve, Jacqueline. II. Title.
GV1785.C85A34 1984 793.3′2′0924[B] 83–25721

ISBN 0–7145–2809–9 Cloth
ISBN 0–7145–2931–1 Paperback

British Library Cataloguing in Publication Data

Cunningham, Merce
 The dancer and the dance.
 1. Cunningham, Merce. 2. Choreography–Biography
 3. Modern dance–Biography
 I. Title. II. Lesschaeve, Jacqueline
 793.3′2′0924 GV1785.C/85A34

Printed in Great Britain by
Billing & Sons Ltd, Worcester

Contents

Acknowledgments

The Dancer and the Dance began in 1977 with a first interview in English with Merce Cunningham that I translated and published in a special issue of the French Review *Tel Quel* (Nos 71-73). In 1980, subsequent conversations took place until I reworked the whole collection and translated it into a book published by Pierre Belfond, Paris, under the title: *Merce Cunningham, le Danseur et la danse.*

This English version aims to restore the language of the original conversations, especially Merce Cunningham's eloquent voice, while remaining faithful to the form and content of the French edition. For this, Marion Boyars joins me in thanking Henry Nathan, who prepared and edited the book from the original tapes, English transcript and French translation. Merce Cunningham made further revisions and additions in 1983 for which we are very thankful.

The publishers and I also thank David Vaughan of the Merce Cunningham Dance Foundation for his kindness in updating for this book the chronological list of Merce Cunningham's choreographies up to December 1984, as well as the lists of films and videos and of the dancers of the Company from 1953 to 1985. He has also supplied the brief summary of Merce Cunningham's career and helped us to collect the photographs contained in this volume, although I alone am responsible for the sequence in which they appear.

Jacqueline Lesschaeve

LIST OF PHOTOGRAPHS

LIST OF CHOREOGRAPHIC DRAWINGS

Preface

If a dancer dances, if he choreographs, he does so because to him this mute art is more eloquent than any other. I know the dancer's distaste for language, which he believes somehow in contradiction with his life and art. I felt, however, and still feel, that under certain conditions, and once this reticence was overcome, the questions of poetics raised by dancing could be brought up. I also felt certain that one of the chances that they could be raised lay with Merce Cunningham, whose dances I had often seen in New York and in France, ever since a year spent in the States in 1956, and the fortunes of friendship led me, in 1964, to see the first performances of his company in Paris at the Théâtre de l'Est.

The new link made with the arts of music and painting in Merce Cunningham's work, opens up for dance a space that is both new and proper to it. So much so that the vision of most traditional or contemporary choreographers seems often hackneyed or old-fashioned compared to what can be seen in Cunningham's work. Compared to his style, most contemporary dance, often marked by a dated expressionism, can often verge on caricature. Because of this, a new inventive choreography, a different language, has to arise and develop. It is this birth and development that we can follow in detail in listening to Merce Cunningham. No doubt the feeling can be compared to that of entering a different world of sound, an experience more commonly shared when you go from one musical form, too familiar and overly charged, to new problems and pleasures. Cunningham does offer a new horizon, another dance, of which this book wishes to reveal some of the laws, the dances themselves having already introduced us to so much new

beauty. The fertility of this new field is recognized and admired by a whole generation of writers, artists, theatrical directors. Merce Cunningham's dances have been performed in most theaters and festivals as well as in the most unexpected and novel surroundings.

When, in May 1977, we found ourselves, Merce Cunningham and I, sitting on a bench in the studio at Westbeth among the dancers warming up, the *koan* – familiar to Merce Cunningham as a living enigma to be solved outside the apparent logic of discourse – was soon mentioned. As we began to talk, I saw with equal clarity the difficulties of the attempt and its necessity. A few weeks later, I could estimate how many such *dense* hours of conversation would yield the material for the book that I meant to do, though I could not yet imagine it clearly. These conversations happened in three different places, each with a very special atmosphere. A few days at the Maison de la culture in Rennes where the Company was appearing, a few others at Scheveningen near the Hague, one week at Westbeth, the New York studio, provided the raw material necessary for the book. These were days of intense receptivity to physical, visual as well as verbal stimulation, while classes, rehearsals, programs, video screenings, reading through files and archives, listening to recollections of all kinds, reinforced and gave a specific rhythm to the experience of the dialogue. Merce Cunningham, with a contained enunciation broken at times by large bursts of liberating laughter, was literally bringing up, and for the first time in this manner, the living questions of his art of dancer and choreographer.

After that, this book was simply left to be *done,* as Merce Cunningham likes to say of his dancing. It was an astonishing experience. And when I had the pleasure to see the same experience shared by Henry Nathan who undertook the delicate process of bringing the book back into English, it was made complete. But as sensitive as we mean to be to this art, in this field, dance always has precedence over any words about dance, and only the dancer and the choreographer – in this case Merce Cunningham – can truly embody it.

J.L.

Torse

There are no fixed points in space.

Merce Cunningham

1. *Torse.*

JACQUELINE LESSCHAEVE: *Merce Cunningham, the chore-ography for classical or modern dancers follows often predict-able sequences: mainly soloists doing variations in relation to (or against) a background of a group of dancers. You deliberately broke with that procedure of repeating familiar sequences, and you involved yourself in exploring the range of possible move-ments. Starting with one of your recent dances, could we take note in some detail of what differentiates it from the older, more traditional forms?*

MERCE CUNNINGHAM: Imagine going to the other extreme of what you described. Say you have eight people each of whom is doing different sequences, all of whom are being soloists. That is immediately far more complex. Think of how they divide the *corps* in classical ballet: you have eight girls on each side of the stage, eight girls moving symmetrically which you can perceive at a glance. If you have these two groups of eight girls doing totally different phrases, that's not very complicated but it's already more unexpected. Now go further still, take each eight. Have four do one thing, four something else. You immediately see that you can go to the extreme: you can take all sixteen and have each dancer doing clearly different movements. That would be done not just to be complex but to open up unexplored possibilities.

Further: in classical ballet as I learned it, and even in my early experience of the modern dance, the space was observed in terms of a proscenium stage, it was frontal. What if, as in my pieces, you decide to make any point on the stage equally interesting? I used to be told that you see the center of the space as the most important: that was the center of interest. But in many modern paintings this was not the case and the sense of space was

different. So I decided to open up the space to consider it equal, and any place, occupied or not, just as important as any other. In such a context you don't have to refer to a precise point in space. And when I happened to read that sentence of Albert Einstein's: "There are no fixed points in space", I thought, indeed, if there are no fixed points, then every point *is* equally interesting and equally changing.

I began to work in that direction, for it opens up an enormous range of possibilites. As you're not referring one sequence to another you can constantly shift everything, the movement can be continuous, and numerous transformations can be imagined. You still can have people dancing the same phrase together, but they can also dance different phrases at the same time, different phrases divided in different ways, in two, three, five, eight or whatever. The space could be constantly fluid, instead of being a fixed space in which movements relate. We've grown up with ideas about a fixed space in the theater to which spectator and dancer refer. But if you abandon that idea you discover another way of looking. You can see a person not just from the front but from any side with equal interest.

Taking nothing else but space, you see how many possibilities have been revealed. Suppose you now take the dimension of time. Our eight dancers can be doing different movements, they may even do them to the same rhythm which is all right, there's nothing wrong with any of it! (laughter) – but there is also the possibility that they can be doing different movements in different rhythms, then that is where the real complexity comes in, adding this kind of material one on top of and with another. One may not like it, but it seems to me anyway that once one begins to think this way, the possibilities become enormous. One of the points that distinguishes my work from traditional choreographies, classical and modern, is certainly this enlargement of possibilities.

J.L. Your dancers often enter into unison groups and break up from them. These movements give a sense of exploding or changing in time and space, but it's disconcerting to those used to more linear changes.

M.C. But just think of a group of six people walking along on

the sidewalk together. At any moment they can all walk off in different directions, at different rhythms.

J.L. It's especially visible when you see children, grouping and separating, walking off, going off, in very different dynamic modes. The same holds for flights of birds, at once fluid and abruptly changing.

M.C. One of my recent works, *Torse,* is very clearly made in that way. The groups of dancers are constantly changing. I finished it in 1975. the whole piece was done using chance operations so as to have the possibility of any formation of the dancers appearing.

Say, for example, that you had two groups, not with the same number of dancers, one downstage and one upstage, somewhat diagonal, and say they were simply to exchange places, though they're doing two different phrases. Now obviously they could pass through each other, but say the movement wouldn't allow for it. Let's suppose that this group's tempo is slower, and that I want both groups to end at the same time (that could happen, yes ...). I could for instance have the first group start, stop for a while, start the second one that would pass through the first one. Because of the different rhythms, they could end together, as the first one would start more rapidly to go to a stop and then go on, while the other group would go more slowly but regularly.

The other fact in that dance that I like very much, actually, is that if you saw the whole dance - it is fifty-five minutes long when the three parts are danced one after another - you would see that each one of the ten dancers appears at some point as a soloist. You have to watch, really use your eyes, but if you see it a few times, you see that each one comes out separately at one point, some way, back or front, as a soloist. And though the general feeling throughout is that the dance remains a dance of ensembles, it is very individualized as well, each dancer at one point or another has a chance to appear outside the group. It's subtle enough; it doesn't happen in an obvious way or place, but I'm sure it's felt. Or it may come about that there are no groups on stage, just two solo dancers. That was decided as well through chance means, which included this constant appearance of soloists. And as I worked it out from step to step, I didn't decide

any of it ahead of time. As chance made a solo possible, long or short, I would see which dancer could do it, and in what way.

J.L. I especially admired one of the sequences where, leaving them all very distinct, you set a whole group of dancers in a small part of the stage, leaving the rest empty, which by comparison seems much bigger; after which you shift them all on the other side in a continuous flow, which gives the feeling of much more space than if the dancers had been spread about all over.

M.C. If you don't divide a space classically, the space remains more ambiguous and seems larger.

J.L. I think Torse, *because of the many questions it brings up, would be a good basis for studying the composition process.*

M.C. I'm going to give it in a workshop. I will not be able to show it the way my dancers do it, but I will show students the basic process. What's interesting in it is that all the elements were dealt with simultaneously, and even though to some people *Torse* looks like classical work, it isn't really. The movements do have a certain emphasis on line but the line is not at all a classical ballet line.

J.L. The coherence of a certain type of movement through Torse *gives the impression that the way it seems to float in space is achieved by means that are very precise and used throughout, and that gives the flowing sensation that is so beautiful.*

M.C. I figured out the phrasing and the continuity ahead of time, before the dancers came to rehearsal. Not, of course, the way they would dance the phrases, but the phrases themselves. It took a long time. I worked on it by myself with the help of video. There are sixty-four phrases, because that's the number of hexagrams in the *I Ching*. The phrases are formed like the numbers themselves. For example, one has one part in it, two has two, three has three, up to sixty-four. But I didn't make it as though one were one rhythmic beat, and so forth, metrically. Let us take the second phrase, it will be clearer. The counts are related to *weight changes*. That is, if you stand on your foot, that's one; if you bend your knee, that's a weight change, so

that's two. Now that could be done slowly or quickly. At sixty-four, you have sixty-four weight changes. Or say, in phrase ten, for example, you have to produce ten weight changes, which means you're on one foot or both or whatever – but you might stand on one foot for a long time and circle the arms, which is not a weight change but changes completely the structure of time for this phrase. I figured them all out ahead of the rehearsal period with the dancers or I never would have been able to finish the piece in the rehearsal time available. And I allowed for repetition within a phrase, for instance: thirty-six is nine times four, or six times six.

That was for the sixty-four movement phrases. But then you take the space and you have a similar process. I numbered the space with sixty-four squares, eight by eight. Then I used the *I Ching* as it comes out: the hexagrams come out double most of the time, one over the other, for example thirteen over fifteen, that means phrase thirteen along with phrase fifteen. Then I would toss to see how many people did each phrase among the men, the women or both. Gradually all the combinations would come out and I would see them more and more clearly and try them out. Most of the paperwork had to be done ahead. But the crucial moment is when you try it out physically.

Sometimes you would have all the dancers doing the same phrase. That was decided by chance, the number forty-nine, for instance, comes up a couple of times alone, and in that case they danced in unison. Let's look at all this more closely: for instance, this is hexagram thirteen over hexagram twelve, and say that the following one is by chance the five or seven. I had prepared what would be phrase five, and working on it with the dancers I would see how it could move through the space, starting from where they stood before. I did the same with the space they occupied, numbered as you remember from one to sixty-four: someone was standing in space thirteen and someone in space twelve. I would choose how many dancers would come in those two spaces, and to go to forty-nine in terms of space – forty-nine is a specific place – they all go in that direction, but they can do it by such or such a detour according to the phrase they have to dance. This last point is important, as the dancers may as well go straight there as go while forming circles or whatever figure is

suggested by the dance phrase to get them there. The dance phrase itself was generated, as you remember, by its own number.

So I made a space chart and a movement chart, both in sixty-four distinct units, and I had to deal with them both, this chart and the movement chart. Then there would come up the possibility of exits or entrances or the possibility of a duet and that's done by tossing coins, according to which some dancers leave the stage or not. I would toss a coin to see what to do. That's how those trios and duets appear in the piece. What it amounted to was a *continual change.*

J.L. There are only about ten dancers, but one gets the impression of a flock of them. This constant shifting makes them seem to be everywhere.

M.C. I know. A lady saw *Torse* once and said, "But you must have sixty dancers". For a lot of people, especially people accustomed to classical ballet, it's very difficult to watch. They're disturbed because they realize it's clear but they can't see it, can't deal with it at first sight.

J.L. It's at once precise and strict, and in constantly shifting motion. I understand better now why someone I know well, who is a mathematician, liked Torse *so much. He literally saw* numbers at work. *To give this continual sensation of flux, you must have been quite selective in the choice of the movements themselves.*

M.C. I did leave certain movements out, you're quite right. I was thinking about the torso, as the title indicates, and I retained mainly the range of body movements corresponding to five positions of the back and the backbone, positions with which I mostly work: upright, curve, arch, twist and tilt. Those five basic positions are very clear and the leg and arm positions in relation to those are clear, too. When you assemble all this to form the phrases, the possibilities are numerous though they stay within a certain vocabulary. It's wide but strict. I remember, though, when the dancers danced *Torse* for the first time, they found it very difficult to do. Now they're used to it, some of them even do it extremely well, the ones who've danced it often like Chris

Komar, Robert Kovich, Ellen Cornfield and Meg Harper.

J.L. To what extent do the dancers know the complexity of the structure they're working on?

M.C. I think they're aware of it, because even if you're only dancing a part, after a while, you begin, if you're at all conscious, to develop a sense about what the others are doing, and you realize they're doing something else. You have to begin to know where the other dancer is, without looking. It has to do with time, the relationship with the timing. If you paid attention to the timing, then, even if you weren't facing them, you knew they were there. And that made a relationship. It depends also on how you think something can be created, too. If you always think that relationships are only one way, then that's the way you do it. But if you think relationships can be many ways, then that comes into your possible perception. It's like a cat. It doesn't have to turn around and look at something, it knows it's there. In human beings, it comes by experience, and certainly my pieces develop this faculty.

J.L. A word about the music for Torse.

M.C. The music is by Maryanne Amacher. I don't know how to describe it, you almost don't hear it. Sometimes there are no sounds at all. Every once in a while I hear a railroad train. It's quite like subliminal sounds. It's very quiet. Sort of still.

J.L. What indications did you give for the music?

M.C. None. I asked John [Cage] who he thought might make some music for *Torse,* and he suggested Maryanne.

J.L. Did he know of the piece you expected to do?

M.C. I'm trying to remember ... I think he must have known somewhat, because I was working on it so much before I did the piece, making all those charts.

J.L. I'd like us to jump ahead to your work with video, by talking about the splendid film (double screen) of Torse *that you made with Charles Atlas, and for which you were one of the cameramen!*

M.C. Yes it's a color film of the whole piece, fifty-five minutes long as well. We chose the double screen because of the nature of the choreography. It wouldn't have been possible with one screen. We did the shooting in a large theater in Seattle where the dance company was in residence, that allowed for very good camera work. And in that case, too, we prepared all the takes in advance. The shooting itself only took three days. The idea is that on the two screens you see everything that happens on the stage. When half the company appears on one of the screens, the other half appears on the other - that's the simplest case. We didn't do much that way because the dance itself opens and closes so much. The other extreme case is where all the dancing can be happening on one screen for a few seconds, while the other screen is empty.

At first, I felt strange as a film cameraman ... And I was afraid of having wasted film and time, but it turned out the camera wasn't working! ... One of the three cameras was stationary and took the whole stage, and the other two, moveable, were placed slightly lower. The stationary camera was handled by a technician, the mobile ones by Charles Atlas and myself. We followed the groups of dancers and took what closeups were possible. After that Charles Atlas edited the film. In its final version it is projected on two screens using two synchronized projectors.

Dance is like water

J.L. I know you rather dislike talking about dance. You prefer dancing and I understand that. If I bring up the subject, it's so as to face the contradiction between the mute, visual arts and the arts of language, a contradiction very often invoked by artists who, like you, work with their bodies.

M.C. Yes, it's difficult to talk about dance. It's not so much intangible as evanescent. I compare ideas on dance, and dance itself, to water. Surely, describing a book is certainly easier than describing water. Well, maybe ... Everyone knows what water is or what dance is, but this very fluidity makes them intangible. I'm not talking about the quality of the dance, but about its nature.

J.L. Still, isn't music also fluid?

M.C. Yes, that's true, but music at least has a literature, a notation. If you want to read music you can take a score and get some idea of it. Nothing like that in dance, until very recently. Everything is in people's memories. Also, and this is obvious, dancers work with their bodies, and each body is unique. That is why you can't describe a dance without talking about the dancer. You can't describe a dance that hasn't been seen, and the way of seeing it has everything to do with the dancers, and that's the trap. Personally, I find that marvelous. How could one experience dance except through the dancer himself?

J.L. I see what you are emphasizing but, curiously, I am not altogether convinced. I like springtime and water very much ... and I appreciate what you say when you speak of the ephemeral, fluid character of dance, but isn't that somehow too easily

making a virtue of necessity? One has not yet been able to do otherwise, so one pretends it's great.

M.C. It may be that this will have to change, as public interest keeps growing. At present, there are some serious attempts at writing about dance. I think especially of the writings of Edwin Denby. Denby's are certainly among the most perceptive and poetic. They have been gathered in several volumes. It's true that talking about dance easily changes into or ends up as commentary and gossip about personalities. Whereas if you listen to musicians talk, they make a very plain distinction between the piece of music and the musician's interpretation.

J.L. In dance, as well, couldn't one speak of the dance 'piece'? It's hardly done, but it's possible, isn't it?

M.C. Yes, that will surely come about. It will be different when there is more liturature. For centuries, dance was transmitted from person to person without a score, which is by and large how it is still done, though it's changing slowly.

J.L. This mode of transmission has surely had consequences on the training of young dancers and choreographers.

M.C. Certainly. And then you have to take into account that the person who dances, like everyone, has troubles, everyday problems, is more or less tall, can jump more or less high. All that affects how you see the dance much more than people imagine.

I remember going to see a dance program a long time ago with Edwin Denby. We talked about all that, and particularly how one goes to see *a* dancer dance. Eventually you go to see the same dance, maybe it will be the same dancer, but it may also be very different. He or she may dance differently that evening, or you may see it differently. Edwin thought that the most pertinent comments on dance were generally made not by professional people, but by enlightened observers and amateurs.

J.L. Speaking of this, have you seen the book by Loie Fuller?

M.C. No, but I know she wrote a book.

J.L. It's funny. She was an extraordinary dancer and woman. But there is very little trace of that in her book. On the other

hand, you read accounts of her meeting the princes and sovereigns of her time. You can try to imagine what might have been her audaciousness and talent, but the book reads more like a fairy tale mixed with lots of trivia.

M.C. Yes, many dancers are like that.

J.L. The very big book of notes of Martha Graham is impressive by its volume, but have you seen anything interesting in it?

M.C. I haven't seen it.

J.L. You've published yourself a book called Changes: Notes on Choreography. *The book is composed in a rather special way . . .?*

M.C. It was just notes on dances, which were never complete notes since they were sometimes sketches, sometimes indications of steps, sometimes fairly full instructions about the dance; or they were simply line drawings that I'd made to give me an indication of what the movement was to be. There were photographs of course in it, and the writings were not so much articles as they were notes for lecture demonstrations. Everything was overlaid, one on top of another as you've seen if you've looked at the book. Two points about that: the idea was to make a presentation that was comparable in a way to some of the dances I make. In the book where the dances are simple, the pages about them are simple, and not overlaid necessarily. Where the dances themselves are complex then things are overlaid and it is in that sense that it was comparable to the dance.

There was also a production problem with the book. I was away on tour when it was printed. Some pages that were printed were printed incorrectly, and not clearly. It was difficult to read them at all. Everything, though, was originally meant to be clear. Dick Higgins, who ran the Something Else Press then, which now doesn't exist, was reprinting a number of books which had come out earlier, such as Gertrude Stein's *Making of Americans*. It was a wonderful press. He asked me to do a book and said, 'You can do anything you want.' At first I said, 'I can't do one, I don't have the time'. He said, 'I'll get someone to work

with you.' So he found Frances Starr, who edited the book and really did a great deal on it, almost all of it as a matter of fact. I'd go to her to arrange the material but then I was running away, having to go on tour, then coming back, and finally Dick said we had to get it out or we'd never get it out. So we decided to publish it. And then, as I said, I was constantly away so some pages turned out differently from what was intended.

J.L. Last, I would like to say that Jim Klosty has published, in a quite regular form, a beautiful picture book called Merce Cunningham *(The Saturday Review Press/Dutton Publishers).*

From Seattle to New York

J.L. Merce Cunningham, how did you become a dancer?

M.C. I didn't *become* a dancer, I've always danced. I always had an appetite for dancing. I should say, though, that it didn't just suddenly occur to me either, at the age of five, that I could become a dancer. There is nothing in my family history that suggests that I would be a dancer. My father was a lawyer, and so are my two brothers. One of them is now a judge. Both of them have always lived in the same town in the State of Washington.

J.L. You felt different from the beginning?

M.C. That's difficult to say, and understand. The only thing that I can think of is that my father had a certain theatrical talent in the courtroom. I don't see anything else or at least anything obvious.

J.L. If he was a lawyer, I imagine he took pleasure in the arts of language.

M.C. Yes. He also had a great sense of humor and loved good stories. He was an astonishingly open and generous person, broad minded in a quite amazing way for someone who lived all his life in a small town. For him it didn't matter what profession you followed as long as you really worked at it. He loved very different people. He just didn't care for phony people, 'windbags' as he called them. So there I was at the age of eight, already dancing, going to the little dancing school in Centralia. I had wanted to go there without knowing what it was all about, and my parents let me do it.

More than dancing it was the idea of being on stage, in a theater that attracted me. Later, still without having any idea of

what I would become, dancing was always an integral part of theater for me.

When I was eight, I remember dancing a sailor's hornpipe. It was a common dance in vaudeville and music hall in America. You learned it in small schools.

My dance classes didn't last long because the school soon closed down, and then there was nothing. So, for several years I went on studying without studying dance. But when I was thirteen I asked my mother if I could learn tap dancing with Mrs. Maud Barrett who had opened a dancing school in Centralia. Mrs. Barrett went to the same church as my mother which we all attended since we were brought up as Catholics. I didn't know her but I knew she was a friend of my mother. I'm sure my parents were very surprised at what I was asking but they let me have my way. In fact, I had seen, probably two years before, around the age of eleven, an evening that Mrs. Barrett had organized. She gave a recital every year in a theater in town that was used as a cinema but had been originally a vaudeville house. There was a stage, small, but still a good stage. She'd have her students there and they'd do all kinds of dances. She knew tap dances and waltzes and soft shoe and lots of other dances. And the audience was filled with the parents of the children who were performing. I remember the little kids doing dances wearing all kinds of costumes that she kept year after year.

Then, at one point, she came on stage dressed in a yellow gown with white pantaloons and little black patent leather shoes, swinging Indian clubs. I'd never seen anyone do that, and she was also talking to the audience because they were all her friends; that was quite a sight. Then she put the clubs down on the side of the stage. She didn't really stop talking. And she put something over her skirt. I couldn't figure out what it was at first, but I later realized it was a big rubber band. Then she got up on her hands and walked around the stage and didn't stop talking. It was such a sight to see this woman, who was no longer young, with this kind of energy. It stunned me. I thought, I have to study dancing. And my parents let me study with her. My father had a good feeling about letting people do what they want to do. His idea was that as long as you worked at it, it was all right. And he rather liked Mrs. Barrett. She'd been in a circus, in vaudeville as

well. She must have been close to fifty then, a marvelous woman, full of energy and spirit. As a little kid I was fascinated by her. She would teach us a tap dance and then we would shuffle around and try to do it. Then she would get up in that nervous energetic way she had, and say: 'No, that's not it.' She would do it, and her feet would just fly and it was wonderful. You could hear it, I can hear it still. It was perfect, and what we were doing wasn't. I can hear the kind of sound she made, the rhythm was remarkable. After a few years she began to ask me to dance with her daughter Marjorie who was two or three years older than I was. She would make tap routines for the two of us. We would go and do them in little halls. I was in high school by then, and we did that for several years. Then one summer when I was still in high school she proposed that we all go to California on a tour. She would go with her daughter and me, and she also wanted to bring along Mrs. Fail, who played the piano for these shows. She also took her small son Leon along. Of course we didn't have any money or anything, that was perpetual. I thought the whole idea was marvelous, of course, though I never knew what was really going on. We set out. Mrs. Barrett had this funny old car, and the five of us (Leon was very small) got into it. I remember my mother wanting to see us off, so Mother took the car down to have it filled up with gasoline before we started off. I'm sure my parents thought this was just hopeless, the whole idea. But off we went, I don't think we had any engagements, if you could call them that, before we left. It was real adventure. But Mrs. Barrett was determined and by this time Marjorie and I had a sort of act, first a duet together, then she did what Mrs. Barrett called a single, then I did a single and we did a routine together, then Marjorie did some other kind of tap dance and I did a Russian dance, sometimes sitting on my heels with my legs going out from under me. We did an exhibition ballroom dance as a finale. Then we would bow and that was it. While Marjorie was dancing alone I had to change into a full dress suit, and I only had two minutes. It was very funny. Anyway, Mrs. Barrett got us some engagements in three or four clubs, and sometimes we played in movie houses where they had shows - we'd play in between the movies. We got to Los Angeles. I don't remember playing in San Francisco, though we may have. It's a long time ago. We stayed

for at least a month and we finally found our way back.

J.L. That was your first experience of having a public.

M.C. Playing that way was quite strange because ordinarily we'd played in the fair grounds and little clubs around Centralia.

Then I went to school for a year at the George Washington University in Washington DC, which I didn't like at all. I did some dancing, went to some classes. It was like musical comedy dancing, not strict classical ballet. It was clear enough but it wasn't as interesting to me as Mrs. Barrett. Just after that I really wanted to study theater. I couldn't get it out of my mind. So I went back home and told my parents that I would like to go to New York. Of course they wouldn't hear of that. It was out of the question.

J.L. At that age you could almost do whatever you wanted?

M.C. That's true, but they suggested I go to a school in Seattle which they knew about, because they knew of the lady who ran it, whose name was Cornish. The school was named after her, The Cornish School for Performing and Visual Arts. I did go there for two years. It was a wonderful school. Miss Nellie Cornish was a remarkable woman, with a real sense about young people being trained in the arts. We went to school from eight in the morning till six at night. As Aunt Nellie said, you make your own schedule here. At eight o'clock we had a dance technique class. It was Martha Graham's work, taught by Bonnie Bird, who'd been in her company. She was a very good teacher. Then at 9.30 there was a eurythmics class two or three times a week. There was a theater class which was why I went, I was going to be an actor, but I liked dancing, so I took dance classes also. There were acting classes, diction and singing classes, a workshop about making dances, composition, theater history at some point, and another dance class.

J.L. You were lucky.

M.C. Yes, I later realized how lucky I was. At first I thought, if this is what school is in Seattle, a school in New York must be marvelous.

J.L. *You were eighteen or nineteen then.*

M.C. I never had serious dance training before that. For months I could hardly crawl up the stairs, but I did it. Day after day at eight o'clock in the morning. We had two technical classes a day, almost every day, plus all the rehearsals.

The first summer, I went to Mills College in Oakland, California. Bonnie Bird at the Cornish School got me a scholarship. I hitchhiked down there, but I didn't have to pay for the classes, which was fortunate as I didn't have any money. I went back to the Cornish School for the second year and that was the year John [Cage] was there. He had come to play for the dance classes. And he also started a percussion orchestra and asked me to be in it, which I thought was marvelous. The school was the same; that is, Miss Cornish was still in charge of it. The second summer I went again to Mills College, where the entire Bennington School of the Dance was in residence. Martha Graham, Doris Humphrey and Charles Weidman, and Hanya Holm were there. I'd heard about them for years but I had never seen them. Martha Graham asked me to come to New York and be in her company. I just said yes. Because I knew I didn't want to go back to the Cornish School, and although I didn't quite know how, I knew I was going to go to New York. It was simply an excuse: in a way, I had no idea what I was going to do - absolutely none. I had never seen her dance, not even at the summer school. They just came and taught, they didn't give any performances. I was asked to join two other companies but they didn't seem as interesting. Besides I was prepared for her by Bonnie Bird. So I went. I mean I came back to Centralia and just said to my parents, I'm going to New York. My mother's mouth fell open. My father looked at me, then looked back at her and said, 'Let him go, he's going to go anyway.'

I left for New York. I went on a train and sat up all the time for as many days as it took. At that time you could go all around the United States for the same price, so I went to San Francisco and Los Angeles where I knew some people, and I stopped in both cities. Then I went across to New York. I went to the Graham studio and Martha said, 'Oh, I didn't think you'd come.' I didn't say anything, but I thought, 'You don't know me very well, lady.'

She was astonishing, very beautiful, and a marvelous dancer. I thought she was amazing to watch. In a few years she became a large public figure. In her company she had up to then only women, then she got one man, Erick Hawkins, who came to dance with her. He was the first man. I'm sure it was just by accident that I became part of her company, simply because I appeared. But she didn't really know very much about dancing for men. I began to study in her school and to see other things. And every day there was a class. I had no money - in terms of that, I could barely survive and simply eked out a living. I didn't have to pay for classes, so it was all right as long as I could find a way to survive every day. I got a job for that first year teaching in a school for a few hours and we did go on a tour during the year. For that time it was a fairly long tour, about six weeks. We also had two or three performances in New York.

After a time, I went to study at the American Ballet School. Actually Martha suggested I go there. Lincoln Kirstein who directed the school was a friend of hers and I think she thought it would be good for me to go to another place where there was a technique which would push my body in a different way than her particular work did. I'm guessing, because actually ...

I remember Lincoln Kirstein saying, 'What do you want to study ballet for? You're a modern dancer.' I said, 'I really like all kinds of dancing,' which was true. I had no strong feeling about it one way or another. Somehow they fixed it so I could study there, I had to pay a little bit of money, I managed it and they were very nice. I studied on and off for a year or so, probably more than that but not steadily, because I would be working with Graham as well.

J.L. How did you turn from theater to dancing?

M.C. Well, the first year I was in New York, I was with a small theater group, and we did some plays. I was involved with two of them, one of them was a play by e.e. cummings called *him*. We presented it twice, not in a theater but in somebody's living room. I even had trouble getting to all the rehearsals. I realized that the next year it wasn't going to work, I either had to do the dancing or something else, and I decided to do the dancing, but I think the choice had already been made at the Cornish School because I

had even there by the second year been doing more dancing than drama. I was also interested in the possibility of being in musical comedies in New York. First of all, that was a way you could dance as a job instead of eking out a living, but I gradually lost interest in it.

There were a number of short tours with Graham. In 1944 John Cage and I gave our first program. I began working on my own dances probably the second year I was there, just to work at making pieces. I was still with the Graham company but it was just the same as when I had decided to go to New York: I knew the time would come when I should leave the Graham company, though that didn't happen for another year, but I had made up my mind about that. I did six solos altogether – and we presented them in the Humphrey Weidman Studio. The solos were two or three minutes. One was five or six minutes long. I changed costume between each one. I change very fast. It was a legacy from my vaudeville days with Mrs. Barrett. The theater on 16th Street that Doris Humphrey and Charles Weidman had was small but the dance space was fairly large. It was not impossible and there were a few seats, 150 or so. We decided to give our one performance there. It was such a problem to just manage to pay for that and to do it. The next year, although I was still with Graham, I did a solo program in another theater, at the Hunter College Playhouse, which is bigger than the one we had the year before. I had been trained up to that point in composition classes with Louis Horst and the Cornish School, with all those ideas about 19th century forms being variation, sonata, chaconne, ABA and so on. I didn't find these very interesting and from the beginning of my solo dances I began to work with John Cage, who already had ideas about structure which were both clear and also contemporary.

I started with the idea that first of all any kind of movement could be dancing. I didn't express it that way at the time, but I thought that any kind of movement could be used as dance movement, that there was no limit in that sense. Then I went on to the idea that each dance should be different. That is, what you find for each dance as movement should be different from what you had used in previous dances. What I am trying to say by that is that in looking for movement, I would look for something I

didn't know about rather than something I did know about. Now when you find something you don't know about or don't know how to do, you have to find a way to do it, like a child stumbling and trying to walk, or a little colt getting up. You find that you have this awkward thing which is often interesting, and I would think, 'Oh, I must practice that. There's something there I don't know about, some kind of life.' Then maybe something would come which I would think lively. And I would see how it worked within the structure but, as I say, the structure is not something that pinned us down. It was something underneath, that you had to play with.

J.L. It's rather difficult to get rid of what you're supposed to know.

M.C. Oh, absolutely, it's hard. First of all, it is difficult to do it anyway, because of habits and growing up. Most of all dancers are terrified about losing what they've practiced. Whereas I really think I didn't express it this way, but I had a feeling there always must be something else, there must always be something more. Different kinds of movement. At the same time like every other dancer I went every day to class. Or rather I did it myself because at that period I was already teaching class. I worked alone as I still do in the morning.

J.L. It's very difficult to work alone.

M.C. It's terrible, the most difficult thing being to keep up the endurance and rhythm, without someone else to compete against. I'm sure that over the years that's why I have a kind of structure in the class, because I had to have that for myself or I never would have kept it going; without it one dissolves. I wouldn't say everybody has to but I had to. Your whole energy builds and you keep it up if you work at making a structure. One has a tendency when one works alone to do either what one knows or do a lot of, say, one exercise one day and then not do it the next. But my idea always was 'Oh, I have to do everything, every day, even though it's only a little bit.' Even now, on tour, I get up very early and go to the theater before the other dancers and I work an hour, an hour and a half if there's time, before I give them a class, because I know that most of them can't - some

of them could do it themselves – but most of them can't. They would not understand how to do it right. I had to learn. And it might deteriorate too.

J.L. At the time we're talking of, you were training yourself already and not taking classes anymore at the American Ballet School or at Graham ...

M.C. No, I did my work and worked on my dances and I would go to the Graham rehearsals while I was still in the Company. But shortly I was out of it, and then I was simply on my own.

J.L. How did you feel using the two styles of training: Graham and classical ballet?

M.C. In Graham's Company I looked probably like a ballet dancer because my legs were straight and I had a certain lightness. Yet I had not had ballet training when I first went there. When they would say, 'Oh, you must have studied ballet,' I didn't understand why they thought I had because my experience was so limited at that time. But as I watched and looked I began to understand. I could see how they might think that. But I wasn't turned out enormously. I had to practice all the time. I was not elaborate in any sense. Nor did I really understand ballet. There were so many technical details in it which were unfamiliar to me that it was simply a question of learning how to do them. The major teachers at the school at the time taught the Russian style. Two of them had been with Pavlova. It was this Russian style that became popular from 1910 on. I learned it and that was confusing to me because I had some technique, and I didn't go in as an elementary student. I tried to grab onto those exercises never knowing what they were about. But I worked at it and began to get some sense of what I was doing. I worked by myself and tried to think what were the basic principles behind those exercises, or those of Graham. What were they about? What's the back doing when the leg is horizontal and so on? And I spent hours trying to puzzle that out.

J.L. Where did you work then? Where did you do this?

M.C. In a very small loft on 17th Street, in a place which was falling to pieces, of course. I had a little living space up front and

I worked at the back. I had a small, what do you call it, potbelly stove, round, with a big pipe which runs up the back and that gave most of the heat. I used to collect wood from the street and put it in to keep warm. Actually there was some heat during the day, but nights it was freezing. It was an old building, it was bitter, really bitter, but if I sat close and had enough wood I could manage.

I'm sure that it's really at that time that something gradually began to happen, even though I couldn't know what it was. They were detailed exercises, and I wanted to keep this idea of the use of the back somehow with the legs. I had a great facility with my legs, with the speed, precision and all of that. I had no trouble with rhythm at all, and I never understood when some people were having trouble. Mrs. Barrett once said, 'Oh, your rhythm is great.'

Apart from that, in the Graham style, they kept talking about the heaviness in the work. I understood what Martha was about. I could see it. The gravity. I thought the way she moved was very beautiful. Even when I was first there, I thought she was amazing, but I didn't think the rest of it was interesting at all. Those exercises that they do sitting on the floor, I could do them but when I left Graham I never did them anymore. I just tried to see what the movement was, not to expect it to be like she did it, not in the least. The same with ballet exercises: if I put my leg out there and it's supposed to go out at a 180° angle and your back's supposed to be straight, how do *I* do that? And you're supposed to have your arms wide. How do *I* do that? Not just an ego trip, but to find out, since I didn't have anyone else to work with but myself. At the same time, not just to get a position, but how do you go from one step to another? Which is one of the key questions of dancing. I would think that is what makes up dancing. At the same time, the position, once you get where you're going, has to be clear.

It was difficult for me at that time - probably still is - to talk with dancers. Not that I don't like them. They would mainly talk about the way somebody did something: they didn't like this or did like that, it always had to do with personalities. It's like gossip. That's entertaining and I like it too, but I also wanted to talk about ideas and there wasn't anybody I could talk with,

except John. I couldn't talk with dancers. Graham's dancers all thought she was marvelous and if I said anything against her work, that was the end. The ballet people didn't know who I was and they wouldn't talk to me anyway at that point.

What I was trying to find out was how people move, within my own experience, which I kept trying to enlarge. If I saw something that I didn't understand then I would try it. I still do. There are lots of things I can see I don't understand, things for the feet, fast things, jumping things, which though I did them easily I never could quite understand when I was doing them. Now I can understand them. I mean, I can give them to my dancers and make them do them - at least it looks like it. What I'm trying to say in all this is that it remains always interesting if you get outside yourself. If you are stuck with yourself you stay with what you know and you can never attempt anything outside that.

At that time, Lincoln Kirstein who had founded the Ballet Society (which later became the New York City Ballet) asked me to make a ballet for one of the four programs he did every year. Balanchine was involved in them, naturally, but Lincoln wanted to also have young choreographers. With seven or eight ballet dancers, including Tanaquil Le Clerq, and I was in it, I did a ballet called *The Seasons*. John wrote the music for it. It wasn't long, probably fifteen or twenty minutes, but it seemed long to me. When I accepted, I thought, I'll try and find out how to work with ballet dancers. And I worked very hard on it. Isamu Noguchi did the costumes and the decor. I've always found that when I work with people who are not trained directly with me I have simply to make compromises. In other words, as I later did with the dancers from the Paris Opera, I try to make clear what I want and then see how to get that without making them feel fake. Or uncomfortable. If I did, I found it might work. And in this case it did. It was the first ballet that I had ever done, so there were movements that nowadays if I were working with them I could make clearer to the dancers. Then I didn't know how, but now I do.

This ballet was also done two or three times later on at City Center, when the Ballet Society had become the New York City Ballet.

J.L. Could we date the first time The Seasons *was shown?*

M.C. 1947.

J.L. Just after the war, then. In New York at the time did you feel any effects from the war period?

M.C. During the war, two large companies were in residence and performed in New York: the American Ballet Theater and the Ballets Russes de Monte Carlo. Quite apart from the war, there weren't many possibilities for dancers to perform, as there are now; the only companies that performed for an extended period of time at all were the ballet companies, and their seasons lasted no more than two weeks. If they happened to play at the same time they split the public. A modern dancer would give a single program once a year.

When Lincoln Kirstein started the Ballet Society in the autumn of 1946, his idea was to sponsor new works, particularly ballet works. The first programs were given in theaters with inadequate stages, but in the spring of 1947 he managed to get the Ziegfield Theater, where *The Seasons* was first presented. The Ziegfield Theater no longer exists but it had a very good stage. It was big and was quite a beautiful theater. Then the Ballet Society went to the City Center.

J.L. The reason I asked about the war period is that at that time many European writers, poets, and painters came to New York and it probably created a different milieu, though they knew each other more or less, each one was mainly doing his own work.

M.C. That's right. As a matter of fact it was during that war period that I saw (I didn't have much to do with them in the sense of friendship or anything of the kind) the paintings of Max Ernst and Marcel Duchamp and Piet Mondrian. But sometimes I would go to parties at Peggy Guggenheim's where they would be (John and Xenia Cage were staying with her and Max Ernst), and there were other artists who had come from abroad. That was a totally different world from the one that I knew through the Graham circle, and I expect that probably prompted me in some way to go and look at their work. Peggy Guggenheim had a

gallery on 57th Street and I remember very often seeing shows there. She showed not only the surrealists but also younger artists, and I began going to art exhibits. It's funny because the American School of Ballet was on 59th Street and Madison Avenue, and at that time the important galleries were on 57th Street, so one could go to class and then go and have a look. I began to do that. Because there were so few performances we were not always rehearsing or concerned with something being prepared the way we are now, so we had time to look around the city.

I always had the feeling when I was with Graham that it was very confined. I don't mean that her work was confined, but it was a kind of closed circle, so to speak. It changed later, I'm sure, but at this time, it was closed, as were the other modern dance groups, like Doris Humphrey's. It was simply assumed that you had nothing to do with anything else. When I went to study ballet, many of those modern dancers thought that this was very odd and strange, and almost mad, which was of no concern to me because I was simply interested in studying ballet.

I began to know the painting world and, through John Cage, the music world. By the time we gave that first program together in 1944, the audience who came to see us was very small of course, but was composed of many of these painters. Very few dancers came, perhaps some of the Graham people came, I don't remember exactly. I do remember a number of painters coming and young composers, people interested in new possibilities. Right from the start there was a difference between what I did and what I had been doing with Martha, even though I was still in her company. There was a fair difference. The Graham dancers were loyal to Martha naturally, and had very strong feelings about her. I was doing something you weren't supposed to do, and not at all as Louis Horst, whom we all had some sort of experience with, said we ought to.

For the dancers, Louis Horst was quite a remarkable man. I didn't like his ideas but he had an extraordinary eye about dancing. He really *looked* at it. When he died I wrote Graham a note and said I thought he was remarkable in his absolutely fierce devotion to dancing for all those years. I'm not sure that he liked what I did, but he wouldn't *not look* at it. He would look

at it and years later after he was dead, I remember a friend of mine, Drusa Wilker (her married name is Sherman) who had played the piano for dance classes for many years, – she became a great friend because she is such as a warm-hearted person – she told me she wanted to see *Winterbranch* because she had read all the criticisms saying that it was impossible and it sounded to her absolutely marvelous. So she saw it, and did find it marvelous, and said, 'You know what? Louis would have liked it'. That may be. Maybe. Anyway, as I began to do my own work, I grew more and more separate from that modern dance situation, which was probably bound to happen.

J.L. Did the link with painting develop at that time?

M.C. Yes, I remember, for instance, hearing painters talk, not about dancing of course. I didn't know them well so I didn't say anything at these parties or gatherings, but whether there were a lot of them or a few, they would talk about painting and this was interesting even though I knew nothing about it. I'd seen very few paintings of any kind other than some reproductions in books, and so this was all totally new to me. But I began to realize who these people were in terms of art history, and I would listen and they would talk about their work, or somebody else's work and the kind of talk was so different from anything I knew in the Graham world where talking was about technical things or what Martha might be doing or not doing.

J.L. At the time Martha Graham was engaged in some kind of war, wasn't she, that had almost been won?

M.C. She was a very strong woman who demanded or felt she needed that kind of objective to keep going, because of course there had been a great deal of animosity toward her work.

I began to see another world, and the taste for it grew also through the American Ballet School. I began at the same time in New York to go to ballet. I hadn't seen very much. There weren't that many programs and I didn't have much money but you could go for very little and sometimes get in free at the intermission for the second ballet. I did that as often as I could the first year I was in New York. I went to see as many dance programs as possible. At the time I knew very little about ballet

history. Looking at all these programs and trying to make sense of all this to myself, I began to read about it.

Because of the war, the Ballets Russes de Monte Carlo was stationed in New York and toured the States. They had a season in New York in the fall and in the spring. Some of those dancers studied at the American School of Ballet. So you could see them work there. I remember seeing Alexandra Danilova in class once, a wonderful dancer. I don't mean her technique, but the quality, the way she was on stage, a warmth she radiated. Seeing her in class, not knowing who she was – I'm sure I'd seen her but I didn't make a connection. The whole thing was so bewildering to me – I thought she was absolutely beautiful to look at. I asked who she was and when I found out, I felt foolish: 'But that's Danilova!'

J.L. Was John Cage in New York then?

M.C. John was not there for the first year or so when I had come to be in the Graham Company. But when he came he suggested we do a program together. He said we must do something. I began to see that was what you had to do, but it was so difficult – and still is of course. You had to do everything: rent the place, get the tickets printed, print the program, do the publicity, sell the tickets, answer the phone. We made a list of names and sent out cards, got the money to mail them. In terms of now the money was nothing, but then it was gigantic. Two hundred dollars was like ten thousand now, because I was probably living on fifty dollars a month. But we just did it, and I, not being very bright about any of all this, just plodded on. I think if I'd thought half a second I would never have done it. It was so difficult and also it was – what do you call it? – in a way, forward – as though I were pushing myself in a way that someone else wouldn't have.

I remember the same thing when I first came to the Graham studio. I began with classes and Martha was planning two or three programs at Christmas time. I had come in the fall, and she put me in one of the pieces. I can't remember the name of it now, but we just went ahead and rehearsed it and when we were performing in it, suddenly here we were in this elaborate New York theater – a Broadway house it was – a very good theater,

and just before I was to make my first entrance in this piece, I suddenly realized that here I was coming on and that this was New York. I had never thought of it before, and I thought, Good Heavens, what am I doing here!

Anyway, there is so much in life, if you ever stop and think, you simply wouldn't do it. I remember a girl who was in my company for a number of years; she was a wonderful person. We were having class one day and she asked me how to do a certain movement, and finally I said, 'Marianne, the only way to do it is to do it', and I think that's the only answer I've ever been able to figure out. You just go ahead and do it.

Not long ago, we were in Amherst giving a program, that's where she lives now, and she told me that story, and said, 'You know, I never forgot that. When you said that to me I was dumbfounded but that was the only thing to do, just go ahead and do it'.

I think in my case it was *naïveté*. That may not quite be the right word because someone bright about that kind of thing could also have the drive to do something. But I didn't know a great deal. I just pushed on, tried to work at things and then present them, so to speak. If there's something that you have to do, if that needs to be done, you'll find a way to do it. At least that's been my experience.

J.L. When John Cage arrived in New York, did he know other musicians?

M.C. He got to know them through Davidson Taylor at CBS and Minna Lederman, who was the editor of *Modern Music*. He had been involved with music in Chicago, but also he knew a lot of artists and had met some of the people who were in New York. He came to New York then because so to speak it was time for him to come, because of his own work and situation - just perhaps as it's necessary for a French artist to come to Paris. You may not stay but you have to come and find out whether it's where you belong or don't belong. It's the same with dancers. If they are really serious about dancing, they will at some point come to New York. They may not stay, but they have to come and find out what it is.

Black Mountain.
Birth of the Company

J.L. We are now in 1946, and you've left the Martha Graham Company. How did you live at the time?

M.C. Teaching here and there. I lived on almost nothing, in the old ramshackle loft I told you about. I couldn't teach where I lived because it was too small, but I would rent a studio some place and give classes two or three times a week, hoping I'd get some students. Every once in a while I'd go and teach for a few days, or a day, in a situation outside of New York where they would pay a little more money, so I could pay the rent. At the same time, I was making dances – solos – giving programs. John and I even went on tours . . . I would write fifty letters and get two engagements. We managed two years, maybe three. We drove across the country. The first year, we went to Black Mountain, in North Carolina. We had an engagement there for which they couldn't pay. We got along so well that they invited us to come back and teach in the summer. I didn't have any dancers with me then. I did work with two students who were there that first summer. The next year we toured again . . .

J.L. Can we come back to that summer at Black Mountain where you met many of those who were to become great painters, musicians, writers? Around Josef Albers who had come from the Bauhaus there was an atmosphere at once very strict and very free, and that seemed to be good for developing all sorts of talent.

M.C. It was a very lively school, with many different people from different fields. The first summer Buckminster Fuller was there, and Richard Lippold, Willem and Elaine de Kooning, Isaac Rosenfeld among others. John had arranged a festival of Satie's music for that summer (thirty-five half hour concerts with a few longer ones). At the end we did *The Ruse of Medusa,*

translated by M.C. Richards. Fuller was in it and I was in it; the sets were by Bill de Kooning, and it was directed by Arthur Penn. It was a marvelous summer, too, because there were lots of ideas around. What was interesting about Black Mountain was that it was small. There were probably at the most two hundred people in the summer, in the winter there were many less. We all ate in the common dining room; you would sit down at the table, and there would be up to eight other people, a physics teacher, or students or guests, or whoever, so there was an exchange of ideas and you heard about many different subjects.

J.L. I seem to remember it was in that dining room, that had a good floor, that you worked and gave performances.

M.C. That dining room was the only space they had for performances. It was a big open space, quite large, which they used for all of their parties or programs, as well as for eating.

J.L. There are institutions that set out to be such places, but it's rare that they ever become so lively and productive.

M.C. No, you can't force it. This is what Nellie Cornish at her school aimed at: anybody studying one art should come into contact with all of the others through the best possible people she could get as teachers.

J.L. Is there such a place now in New York, for instance?

M.C. Probably not with different artists. There are centers for activity in Soho but it ends up with not being different disciplines, but one discipline with different ideas.

The next year, whatever summer that was, John and I went on another tour. We did a crosscountry tour that time. We borrowed a car from Sonja Sekula. That was the year of the terrible snow storms! We set out in January. We skidded off the road twice. Once the trunk opened and all my costumes fell out. Another time we turned around three times, and went down an embankment. Unbelievable!

We would drive all night and part of the day and then give a program. It was fantastic. Once in Ohio, I danced in a museum, we had to drive on that night to get to a place on the East coast, because I had planned the tour and the connections between one

engagement and another were tight. Some people insisted we go to a party after the program, so we went, and they proceeded to insult us about how bad the dancing and the music were. After which we had to drive on to the next place. Just about ten or more years later, John met a man who said, 'I was at that program you gave in Columbus, Ohio. Do you remember it?' and John said, 'Of course I do'. And the man said, 'I've never forgotten it. It changed my life!' And then not long ago on one of our tours, I was having dinner with a lady and she said, 'Do you remember giving a program in Columbus, Ohio?' and I said, 'In the museum. I certainly do. It was frightful'. She said, 'Well, to us in the audience, it was amazing. I had seen dancing before, but never anything like this. We simply didn't know how to deal with it'. I said, 'Well, that's something.' She said, 'I've never forgotten it'. And I said, 'Neither have I!' After that, during the summer of 1949, we came to Paris. John was writing articles for papers in New York on music festivals. I remember we went to Sicily, and there were some in France. John went to Aix. I stayed in Paris in the summer and found a studio to work in, very small, in the Salle Pleyel over by the Russian church. The person whose studio it was said, 'Would you teach?'. There were a few people interested in American modern dancing, some of whom had been in the United States during the war, as well as young Americans living in France. I agreed to teach in return for the use of the studio for my own work. I would work every day and I would give classes two or three times a week, and it lasted two or three months. At some point John and I gave a program: at the beginning of the summer, I had met two dancers on the street near Notre Dame, Tanaquil Le Clerq and Betty Nichols, who were both in Ballet Society and had come to France for the summer. We had gone off and had something to eat or drink. Jean Hélion, the painter, whom I had known in New York, suggested that I give some kind of program at his studio, and he would invite friends. So meeting Tanny and Betty we asked them if they would like to be in a dance. I made a duet for Tanny and myself and a trio for the three of us, using John's *Amores* and his *A Valentine out of Season*. We performed this in Hélion's studio. A stove that was in the middle of the space had to be taken down. People stood up except for two ladies who were

given seats. One of them, Bethsabee de Rothschild, was pregnant, the other was Alice B. Toklas. Later, we performed publicly at the Vieux Colombier.

Then back in New York in September I started again trying to find some place to teach.

I began to make dances with other dancers. At that time the dancers whom I had used were trained in other ways. Either they were classical dancers or dancers who had been trained in the Graham style, and although some of them studied with me, their principal training had been in other techniques, and in the beginning it didn't work for me. I kept thinking there's no point in complaining about this all the time. If you don't like that for whatever reasons, good or bad, you have to do something else, so I began to work out some kind of technique. I had been doing that all along by myself, but I hadn't found a way of giving it to other people. Gradually my ideas became clearer, so I simply changed my teaching and started working with dancers whom I had trained.

I worked in a little studio with two or three dancers. That's when Marianne Preger, now Marianne Simon, the girl who had asked me how to do it, who had been one of the students in Paris, came to study with me in New York after we came back. She said, 'Are you going to teach?'. I said, 'Yes, if I can get any students', so she said, 'I'm one'. The first time I taught she was indeed the only student, but gradually a few others came. I couldn't do very much publicity and people wouldn't want to come necessarily anyway, because they didn't know who I was. They knew I'd come from Graham. Sometimes they'd come thinking I would be teaching Graham's technique and finding that I didn't, would go away, but that was all right. It was during those several years that I gradually evolved ideas about technique, giving classes and so on. My point always was to make people strong and resilient in the head rather than giving the same class every day, to give them some kind of elasticity about technique.

After about two years, John and I went back to Black Mountain for the summer. I said I would like to bring some dancers with me, but as I didn't have the money to support that, I agreed I wouldn't take any salary if they would take care of the dancers' needs while they were there. I brought six people, I

think, and they had to come down on buses and all that, but it was the first time that I'd had a company of dancers for an extended period with me. It was only three weeks but it was long enough (Carolyn Brown says it was three weeks, she'd remember much better than I would). We gave two programs and I made three or four dances. Some pieces we had already done. We came back to New York that fall and that's when I thought: somehow I had to find a way to continue to have dancers to work with.

So we found a studio on Sheridan Square, not that good, for what seemed to me an astronomical rent. I kept it for two years. I worked in the morning, gave classes and rehearsed in the afternoon. I taught two classes every day, 4:30 and 6. It was a most exhausting time but that way the dancers had a class. We had to pay the rent, and I still lived in the loft on 17th Street. I made a lot of dances and developed a repertoire for six of us. I'd make one dance and maybe we'd do it and maybe we wouldn't, and then I'd just start to make another one. Eventually at the end of the two years, all of us went on a tour across the country.

Bob Rauschenberg had been at Black Mountain and John and I had met him there. There was a kind of compatibility about ideas and after we returned to New York we saw Bob a great deal and I realized we could probably work together. While I was making *Minutiae* I asked Bob if he'd do something visual for it. I didn't ask him for anything specific. I said that it might be something we could move through. He made an object which was very beautiful, hanging down from pipes, but I said, 'It's marvelous but we can't use it because we rarely play in theaters with flies.' He didn't get angry at all about it, he just said he'd make something else. I came back a few days later and he had made something else that was later exhibited. Wonderful object! Colors, comic strips all over it. You could pass through it or under it or round it. He made it out of stuff he'd picked up off the street. I loved it because it was impossible to know what it was. When we presented the dance a lady in one of those dance journals was so irritated: 'What is this thing? A gypsy fortune telling booth?!!' That was in 1954. When we went on our tour we took that amongst other pieces and we had to cart it around, send it by

train. There were two packing cases, which at that time was enormous for us.

J.L. Now it's quite clear that the main thread of your work is teaching and making dances.

M.C. The main thread actually is whatever dance I'm working on, because the teaching is what is necessary to provide for the dancers. Otherwise I'd never have done the teaching, because it doesn't interest me. The teaching provides continuity for the dancers – but I must admit for me it was also simply a way to make ends meet. On all these tours we used to go on, a great part of it was that you did a program and gave a master class to students of whatever university you happened to be in.

J.L. One class doesn't do much.

M.C. Oh no, nothing. It was funny but also interesting in that it's like a game: you are suddenly confronted with anywhere from ten to two hundred people and you somehow have to make it work. More often than not, I managed to make something happen for them. It may be something very simple. Very often they'd range from people who'd never had any dancing to people well-trained, mostly classical training or Graham work. I would simply do it, and if it didn't work I would demonstrate it again and insist they do it. I more or less followed the form I used for a class, fitting it into each situation. I would demonstrate the exercises clearly enough for them to see what they were and then I would talk. I could say, 'This is what you do', or 'You don't do that', to make it happen. Not that I talked very much ...

The Class

The class is the moment when you have to struggle to make the movement pass completely into and through the body.

J.L. The daily dance class is a vital necessity for any dancer. To train dancers to the requirements of your choreography, you had to develop your own continuity of exercises, because the Martha Graham and the classical techniques were both unsatisfactory for you.

This morning, watching you give your class, I took some notes, made some observations that I'd like to put to you. As far as I know, no attempt has been made to present the logic of the development of a dance class in a way that is not too technical. When I ask you to talk about your class, I realize that we are going to refer to a process that is little known and that will have to be explained carefully, but I think it's worth doing ...

M.C. Well, I have a feeling that in building up a class, it's trial and error most of the time. You try something out and it does or it doesn't work, and finally you keep what works. I told you I was interested in the beginning in the idea of using both the back and the legs. I thought that in the modern dance, they used the torso, the back a great deal, the legs not so much. In the ballet, on the other hand, they used the legs a great deal, the arms too, in the great Russian School, and the back not so much, though the back obviously sustains the legs and arms. That's very general, but I wondered if there were some ways to put them together. It implies that you deliberately abandon certain highlights of one or other of these techniques, and go beyond them. So my class usually starts with things for the back.

J.L. Your first exercises, instead of being the classical plies, are made up of slight bendings forward from the vertical position, the feet and hips firmly fixed. The spinal column is stretched to lengthen it by curving it from one end to the other, and the

stretching includes the lower back which is so hard to mobilize.

M.C. Yes, the spine; well, it's the whole back actually that is at work. It affects the lower back because you don't let the hips go. Mostly when you bend over you let the hips go in order to counterbalance. I thought to try to make a connection between the back and the legs, rather than simply letting the legs go. You use the spine and pull the back using the muscles in the back which people rarely use. That's why everybody has back trouble. You start by establishing the link between back and legs instead of working on them separately.

J.L. All these rhythmic twists and tilts clarify for me what you are looking for when you talk about flexibility: you're not looking for a general suppleness, a body able to fold and unfold on itself, but rather a flexibility in every direction starting from the spinal column seen as a single trunk that includes the two legs.

M.C. Yes, I start from a standing position because that's mostly the way we move. We don't really move sitting down much . . .

J.L. You're alluding to some of the Martha Graham exercises that are done on the floor. But you don't use the bar at all the way ballet does. You start in the middle right away, standing up, with no support other than the legs planted on the floor.

M.C. Standing up, yes, and the first exercises are usually for the back. You see, the torso will only work certain ways. It doesn't do much, but you can extend those ways as much as possible. Starting with that idea of the legs and back working together, we alternate: legs firmly held, we work on the back, then we come to the legs and in order to isolate them, I keep the back still and do leg exercises. After that we put the legs and the back together.

J.L. It's only then that you get to the pliés.

M.C. My idea was to warm the back, and then the legs. The legwork begins with the *pliés.* As to *pliés,* it's all that you can do with your knees, bend them and straighten them; you can't do anything else. And you have to learn how to do that clearly. Your

knees will only bend a certain way properly. If you do it the wrong way you get into trouble.

J.L. I notice that you use the same leg positions as in classical technique, adding only exercises with the feet in parallel position. The arm positions are not fundamentally different either. I'm not talking here about style, of course.

M.C. For each *plié,* the arms are held in a particular position so that the dancer gets accustomed to holding the arms in various positions. Because when you start, as a beginning dancer, you have to use the arms.

J.L. That's one of the most tiring things, when for a whole hour you have to keep your arms wide open, or at least return to that position constantly.

M.C. Oh, yes, in a way it's worse than the legs, because the arms are so easy to move.

J.L. Afterwards it seems so natural but then it's funny to remember the effort it took at the start.

M.C. It's because the arms are easy to move, so one doesn't know how to hold them, whereas the effort to move the legs makes you concentrate on how to move them. And you have to learn to anchor the hips somehow. If you're not balanced in any position, somehow, whatever position you're in has no tranquility. It just gets frantic and it has to end a certain way. It's like something that falls beyond its pitch. It has to fall, but up to a point you can control it and make it go in other directions; but beyond a certain point it's hopeless. There's nothing you can do. That's what all that turning out was about. It's about learning how to keep the hip down and lift the leg in open positions. Once the hip gets up it usually knocks the balance off. Not all the time. It's also about how you want somebody to move, because you *can* move with your hip up; it's certainly possible, people do it all the time ...

J.L. In the legwork I saw a lot of quite classical dégagés, développés, *extensions, leg circles ...*

M.C. Yes, full up and extended up, but you see, what else would

you do if you think of the way the knee works? You can do it two ways: *dégagé* or *développé*, there isn't anything else.

J.L. The variety of your movements is enormous, but it looks like most of what you've chosen and used has been taken from classical training.

M.C. A great deal of it has, but not all of it. There are certain things in the torso that the classical ballet doesn't do at all. That's why I start from the back in the beginning, so that all the way through, it stays part of it. And even the positions that look really quite balletic, when ballet dancers do them, they aren't. That is why they find them difficult.

J.L. Would you explain the difference?

M.C. In classical ballet there are certain positions that you do - *épaulements* - which have to do with twisting the shoulders, with or against the leg action. But all of my work comes from the trunk, from the waist, nearest the hip, and you tilt it or you twist it in every direction. It doesn't come from the shoulders, but from much farther down. Further than that, I relate it to or against the leg. Say my leg is out there, I turn to that leg, or away from it - against it. I tilt to it or against it. I have eight directions that I use, to open the space up all the way round. My feeling was that the *'épaulements'* come from the fact that on a proscenium stage you are moving to and from the public and the *épaulements* were done in order to give a sculptural effect. When the movements were fast as with Balanchine, they couldn't do the *épaulements* so clearly any more. The torso was even less mobile. I thought that it wasn't basically true that the body could not move while the legs were moving rapidly. So I worked at it and thought about it over a period of years, tried things out and finally came to the conclusion that if the action were deeper in the trunk instead of just in the shoulders, then you might be able to move both the back and the legs quickly. That's what *Torse* comes out of.

J.L. When you come to the legwork as such, which is amazing for the extremely rapid combinations, you nevertheless link it to movements of the arms and the head that require quite exceptional coordination.

When you compare that to the best moments of the classical batterie, *you realize how, while requiring the same rapidity, you add to it a range of head and arm movements. This calls for a completely new level of coordination.*

M.C. In the beginning, I didn't know whether it would work or not, but I kept trying. And *Torse* is the first dance where I really took those elements and tried to use them all. I used the idea of the leg's direction at varying speeds, at varying tempos, in various kinds of phrases; the body changing constantly with or against the legs. Also, doing that in the air, jumping and changing the direction of the torso, which is the hardest thing to do. That's what the material of *Torse* is.

J.L. So here we get a clue to the way you build your pieces. Are they all, like Torse, *built around such kinds of questions?*

M.C. Yes. All of them. For one dance the question may be a simple one and for another it may be a complex one, or there may be several questions. All the dances come from something like that.

J.L. To take up the thread of the class again, all of the leg circles are done from the start without the bar, without any support. That too requires work on the back. In classical training, the dancers are supposed to hold the back when at the bar, but if they do, it's because their instinct is good. I'm struck by the degree to which they can do a whole class without holding their back very much. They are told to hold it, from time to time, but they aren't confronted with the need to do so before the last third of the class, when they leave the bar and work in the middle. And at that point they have a great deal more to think about. If their instinct is good, or if they look at the best dancers carefully, they find out how to do it, but it's a lot of trial and error. Fortunately the lazy ones often do find out, because it's so difficult to move the legs without gathering the strength in the back. With the grands battements *as well, you do rapid movements of the torso?*

M.C. Yes, that way, you have to balance differently. It seems to be one of the directions technique could go further or change, it's

not a question of esthetics, but a question of what the body can do.

J.L. At the same time there's no tendency to extreme movements in your class, for example the bending over and arching that they do in ballet classes.

M.C. I don't use them in class, but I might, it's an idea. Sometimes in a couple of pieces the girls arch very much, but it's not something we train for particularly, unless this kind of movement turns out to be interesting in a particular dance. And it works both ways. You've put something into the training and if you need it for a dance you're working on, you can incorporate it. A lot of the exercises come from the dances. I've made them into exercises. Some of them are still out of early dances. They're changed from what they were because now they are exercises. The phrasing has to be clear so the dancers can deal with it physically. The rhythms ordinarily in the classes are relatively simpler than in the dances, because the dancers are concentrating on something else, on the physical part, and not on numbers and rhythms. By that I mean that the class is the moment where you have to struggle to make the movement pass completely into and through the body.

J.L. But in the third, final part of your class it's rhythmically very difficult, the centre, the enchainements, *the dancers had better know how to concentrate on numbers . . .*

M.C. Well that's where it should be, by that time it should get there. In the Graham classes, they mostly thought to repeat the same thing, and my idea was that it wasn't really necessary. You could go from one thing to another and also, within limits, you could change it. I tried something like that today: there was one phrase, a jump in the air phrase. They were doing a lot of skips, *sautés,* which I called step skips, then suddenly we did it in five and not in four or eight, it wasn't even, and that was a nice rhythm, made an interesting end. It came by chance.

J.L. In your class, a remarkable feature is the eagerness of your dancers, their dynamism; they are constantly dancing, there is no left-over time, they are constantly trying and doing. In many

classes, even the best classes, the dancers wait to be told to dance, have a tendency not to re-occupy the space. In your class it's a continuous flow of work.

M.C. There may be a reason for that. I've worked so many years in cold studios! Everybody is moving all the time to keep warm! No, it's true enough, but it's not that easy to obtain.

J.L. Especially in the last part of the class, where everywhere else the energy diminishes, in your class, even when the sequences become difficult and things don't go so well, the dancers start again very rapidly.

M.C. The dancers have to be very strong. And I also want it done clearly without anything about expression. So you will see the movement on that person, not something he or she adds which makes it harder to see. I want to see what the shape of that movement is on different people. You have to see it on the dancers. In the ballet there is some ideal you have to imitate or strive for. It was the same in modern dance when I started. There was an idea of somebody whom everyone was supposed to look like or be like. Some idea about style that didn't seem to me to be very interesting. So from the beginning I tried to look at the people I had, and see what they did and could do. Of course, you have a dancer who has a long arm, with a long wrist, and another with no wrist, so to speak. You can't expect this one to dance like the other one. You can give them the same movement and then see how each does it in relationship to himself, to his being, not as a dancer but as a person.

Then assuming you arrive at anything, it is like a juggling act, because on the one hand there is what you want the movement to look like, and at the same time there is a person who is not yourself, who is doing the movement. I don't expect that person to do it the way I'd do it. But I try to give the movement clearly, so that it will be done clearly, each dancer in his own way. And that's the big trick: how to get that out of the dancers. Because it isn't only training, although that has a great deal to do with it. It has to do with temperament and the way they see movement, the way they are as persons and how they act in any situation; all that affects the dancing. It's all part of it.

J.L. Still, imagine a dancer fully shaped: sometimes you can really change the way the head is carried by some back exercises.

M.C. Of course you can stretch them out; that's quite true. If they get to become dancers they always begin to look different.

J.L. When you choose your dancers, what kind of criteria do you use?

M.C. It varies a lot. It's a kind of guesswork, because you have to accept something on good faith. It happens. I see someone in the class in New York, a person who might not be well trained yet, so to speak, but he or she has something that strikes my eye. I know that if my eye keeps returning, there's something there. So I try to see what it is, even if, as I said, they are not yet technically skilled. Then I watch to see how they work in class, how they act in terms of rhythm and movement and so forth. If it goes further than that, I try to talk with them to see what kind of person they are. A lot of it is gamble, you gamble on somebody and they gamble on you. You accept it on some kind of good faith, hoping something good might come out and often enough it has. Not always. There have been times when it really hasn't worked for some because they had another idea, perhaps, about what it was going to be for them, not just the dancing but the whole situation. Or my idea about them was not clear enough. But I think more often than not, it worked; something has happened anyway.

And they change, you know. They're young kids very often, and as time goes by, their bodies simply change anyway. A young dancer is like the way a colt is, the joints and all that. You can see that, and it's often marvelous because even though the young dancer may think that he or she is hopeless, you begin to see something marvelous taking place and gradually if it works, one day, suddenly it becomes a single thing, even if it's only one position. And you can often tell when they know it because a look comes over their faces. They don't realize that's what it is. When that happens I always go and say, 'Well, that's fine now. Just continue.' They must cling to it, because too often they feel that nothing is happening, that they're stumbling along. So if you

think there's something interesting, you try to encourage them, not to defeat them, because it's simple enough to knock the balance out of them. They're usually so frightened, insecure about whether they're doing ill or well. If you give them something so difficult they can't do it, it will make them sad, and that doesn't interest me very much. Lots of people think that's the way to push people. That's not the way I work; I know I can do it because I've done it, but I don't like it. So if I see something good, I try to encourage them and get them to bring all their attention to that moment. At the same time I don't really like teaching. It's so rigid. By that I mean the class is stiff, dancers simply go through their exercises some way. I think this is a problem lots of dancers come up against, and it probably makes some of them stop dancing when they realize they're going to have to do these exercises every day. Because it's so much a part, the nerve in fact, of a dancer's life. And I remember feeling this, years ago. 'Oh, my god, I have to do that again every day.' Then I thought, 'What if you thought of it another way, as if, so to speak, it were a meditation? And each time you came to it, even though it might be the same exercise, it was new, it was different.' And that seemed to me a way to support myself, going through this daily discipline. Some way to make it come alive. Otherwise you spend this hour and a half doing something you don't like. A lot of dancers really think of class as a drudgery, a monotonous work, because of the constant repetition.

The end of class is often more lively because there you have some sense about moving more. But all the same, the dancer has to do those beginning exercises, so it's a conflict. However, he does them. He doesn't have to do what I do, but he has to do something about warming up, about taking care of himself. So you have to figure out some kind of procedure. For myself I figured it out, and I've tried to impart that to my class. I don't think it works for everybody by any means.

My experience with Graham was to see how Martha could do things and how marvelous she was to watch, but she could not explain it. She could give you some sort of emotional explanation, and I would notice that the dancers had some feeling about it very often, but couldn't do it. Then I went to the American Ballet School and there was a particularly wonderful

teacher named Obukhov, an old Russian. He did very complicated exercises, terribly complex, and they were slightly old fashioned in style because that was what *he* was, but that didn't matter because everything was so *clear*. Then he'd make extremely difficult combinations and say, 'Everybody got it?' in sort of half Russian, half English, and we'd all nod and he'd say, 'and now, *dance!*' I thought that was wonderful. In fact, with Graham as well as in ballet classes, what I wanted to see was how the movement operates, not how you think it feels to you; how you get from this position to the next one, and move everything from there. You have to get the idea that movement comes from something, not from something expressive but from some momentum or energy, and it has to be clear in order for the next movement to happen. Unless you can begin to see that way, you don't get a progression in the movement, a going from one movement to the other which seems logical. By logic I don't mean reasoning but a logic of movement. Some people have an instinct for this, but you can point it out, and with most of the dancers in my company I can point it out. They can see what it is and do it, some better than others naturally. They begin to see the force of the particular movement itself. We grow up with habits, for instance we walk in a certain way, we adjust ourselves physically to life, we grow up to certain kinds of gestures. People mostly will step off the curb with the right foot. And go up again with the same foot, and suddenly in the dance, you have to step up with your left foot. In *Summerspace,* for example, a girl had to do *chaîné* turns to the right and to the left. She said, 'But we never do *chaînés* to the left'. I said, 'Well, *here* you do them to the left'. She was terrified. I said, 'No, just go ahead and *do* it. Do it till you find out what it is'.

J.L. So the dancer has to compensate for the asymmetry developed in the course of living. One of my teachers who is very dear to me, Lillian Arlen, used a lovely expression, she said you have to 'disassociate', by which she meant that first you have to 'undo', and clearly distinguish the parts and circuits, and associate them again afterwards. Not dissociate but separate and re-associate. The only problem is that the tradition from which she came brought with it altogether definite ideas about

what it was natural to associate, and if you did otherwise you were unnatural. Then you would be doing outrageous things, and then, 'none of that'.

M.C. Yes,: 'We won't have that!'...You know, I really think the method in the Orient is the best, where they start to teach you some sort of dance, however simple. There are certain kinds of dancing in the Orient, not all of it but some of it, where you begin by learning a dance, and I think that's a marvelous way. Actually, when I began dancing that's what happened. We learned dances with Mrs. Barrett, simple ones, but it's perfectly clear that's what they were.

J.L. Some dancers are trapped the other way. They're comfortably involved in their exercises, though they get to the middle of the class in very poor condition.

M.C. Yes, there's a phrase that dancers use: they call them 'class dancers'. In other words, they work all right in the class but somehow they're not so good on stage. The point about this is that it is not the stage, I think, but about *dancing!*

What often interests me in a dancer: I have some idea as to how they will do a certain gesture. Then they do it, and it ends up by being more than I expected, it's longer and goes further than what I anticipated. That's a pleasure and I'm always amazed. it's just an amplification and I've always liked that very much. Something that is fuller, and the whole movement gets bigger. I've had several dancers in the company that gave me that kind of sensation. I've always enjoyed it.

If you have a good body and use it, it's all right, but it's also interesting if you don't have it and manage to make something out of it, as many dancers have. They've managed, sometimes with a body that seemed at first not very prepossessing. They've worked and somehow, something begins to happen. And that's fascinating to watch happen. I try not to have any idea about how a dancer should look. In other words, to allow for a wide latitude of shapes, so to speak. On the other hand they do have to be able to dance. There are some requirements. There might be a person in class who I think would be wonderful in a particular dance. But if he or she could not do the other pieces in the

repertoire – because of the nature of my company, I can't have a large number of people – I have to draw a practical line.

J.L. It is true that your dancers on the whole, from early on up to the ones that are with you now, are very different from one another but at the same time have something in common.

M.C. That's partly because they study and work with me. I mold them, so to speak, I think that's bound to happen. As I said I try not to have some idea about how they should be. Tall and thin, or short and thin. I try to allow for a diversity. Mostly if they can dance, then I get interested. Giving our programs, there was so little response – not now but earlier – in terms of anybody liking it, or any press, or publicity, I had to find another way to keep going. And even though with the dancers in all those early years, Heaven knows there was no money, they were so faithful that we were able to work. Carolyn Brown, Viola Farber, Remy Charlip, and the people who were with me the first several years. We were able to continue working, and I remember thinking. 'Well I can't pay them anything, or so little. What can I give them?' I decided what I could do was to arrange to teach some place so that they could have a class every day. So they knew that was steady, and then we would be able to rehearse. I fought to keep a studio, a place in New York, where they knew there was class and they could come every day. Sometimes we had it only three times a week, but steadily. We kept it going.

J.L. While we are on the subject of the work and the training of dancers, or of a dancer building himself, what about the training of the mind? It may seem ironic, but I have often become irritated with the lack of that. Dancers take class after class. They endlessly repeat exercises in the hope, or rather the certitude, that it will be enough. If your body requires that a number of things be done every day, one might think the same for the mind. You want mentally supple and resilient dancers. How do you cultivate that?

M.C. It's true that dancers do their class work, their daily physical routine, and that's all. They have to learn the parts they do and they deal with that. When they're doing classical repertoire, if they have a leading role, they have to try to find

some way to interpret it. If they are very good, if they happen to be brilliant, something can happen.

Also, with a great number of those who run companies, I suspect that mostly they want the dancers to learn the steps and do them as well as possible and that's it. And in a way they're right, because it is a big problem that takes, of course, a great deal of their life. It's a big problem indeed to get different people to do things according to some concept you have about doing it well, whatever that means. If they are learning an old ballet, they know perfectly well that it starts here and is going to go there, and that during that time they have to do this and they must be exactly here, and the music here and then there, and so forth. That will be where the 'mind' enters, and that's so to speak sufficient.

In my work, although all this enters it also, there's the possibility that they could do it slightly differently; not in all of the work but in some of it.

In rehearsals, very often, the dancers are really quite good about bringing up their questions about dancing a particular piece. That's why rehearsing on stage is so important. I encourage them a lot, if there's something, to bring it up, not to be frightened about it, they all know that now. And given the constant shifting in my work, they don't automatically think they're wrong if something doesn't work ... We try and find some way to make it work.

This is even more so when we do an 'Event', where in each place it's different; though the material is the same, the order is different. They have to rethink the way they will operate. Also probably a lot of the dancers who have worked with me may have come to study with me originally because of the ideas, not just my ideas but the rapport with contemporary music and art. That may have interested them, and they may have come to see what it's all about. The biggest problem always is that it takes so long to get the physical thing clear. There's not very much time left for the rest of it, which is unfortunate.

J.L. It seems to me that time is missing to understand the feedback from the experience of training and dancing. There should be a moment and place to speak about what has been

done during the class, to break that very wall you sensed yourself around Martha Graham and her dancers, for instance. The work itself would probably get better from it. But how could that happen when, no sooner out of class, you are back to the dressing room, most of the time physically exhausted? After which, you return home, and maybe there you might find courage enough to think about it alone? But maybe not ... Though while dancing is not the right time and place either, because things cannot be slowed up according to everyone's wish. Anyhow it seems to me that something is missing.

M.C. I tried to do that when I gave workshops in New York. Sometimes there are composition workshops, sometimes teachers' or repertory workshops, I'll have one soon. It will be a repertory workshop, showing them how *Torse* was made, taking the same ideas, and the same steps and doing it another way, with one dancer at a time. As it's done, I explain what the process was as much as I can. Such a workshop I can only do once or twice a year. Mostly I don't have time.

However, I never thought and still don't, that dancing is intellectual. I think dancing is something that is instinctual. No matter how complex something I make or do may be, if it doesn't come out as dancing it's of no use. I don't care about the diagrams – those are things that one does, that I need to do often with my pieces because of the complexity. But that's only the paper work - you have to get up and do it. When I give composition workshops, illustrating the ways to use chance, the students get so involved with the papers, the possibilities become so fascinating, I've always had to stop them, get them to give up the paper, get out there and work on it, otherwise it never materializes: it doesn't come alive. And what then is the point?

J.L. Still, this division between the intellect and the body is not so valid. Because if you only work physically, nothing much happens either.

M.C. I remember having had people in classes who were deeply interested in the ideas, they would come to study dancing, and I could see immediately, in the class, that it wouldn't work, because it was all up here. Then they would think, 'Oh, yes,

technique!'. And we'd have a few classes. They would start and it wouldn't work. I would explain three times for elementary classes. For others I'll explain once, if they don't get it, forget it. But I do explain for elementary classes. And I would explain again, and they'd say, 'Let's do it,' and still it didn't work. They would look at me as though I had done something wrong, but if they were really bright they suddenly realized that it was in them that something was missing. If they perservered, sometimes they got some place, but mostly they gave up dancing, because they realized that wasn't what the world was for them. In most people, there's such a split between instinct and intellect. A technique class should, in a way, within a certain scale, put them together so that both are working in unison.

J.L. In class, it's mostly physical problems, the knowledge and mobilizing of the body that matters. It's an amazing process but it's a very secluded and lonely one for each dancer. It ought to be shared in some way instead of being, as it mostly is, a kind of combat fought out alone and in the dark.

M.C. Yes. I don't know if it has to be that lonely, but it has to be first a necessity in yourself. You ask questions and try to find answers, you are constantly thinking that probably it isn't the only answer or the right one, but at least you have some kind of answer.

J.L. The moment the classical language was formed, they really started with children. Have you ever thought of having children in class, and working with them?

M.C. Not that I wouldn't like it, but in my situation it isn't practical. I remember once I was teaching in Boulder, Colorado, in summer, trying to make some money to pay off something else. I was looking out the window one morning and there were several children out there. They were skipping and running about playing, little kids, and I suddenly realized they were dancing, you could call it dancing, and yet it wasn't dancing; I thought that was marvelous. There was no music. They were skipping or stopping the way children do, and falling down. I asked myself what it was. Then I realized it was the rhythm. Not the immediate rhythm, for each one was doing something

different; but the rhythm of each was so clear because they were doing it completely, the way children do. And children have an extraordinary way of inventing without being self-conscious. It's wonderful to watch. We would like to start with younger people, young children, but that would involve a much more elaborate school. I couldn't, personally, but if somebody else did it it would be alright. The other problem with teaching has to do with not distorting the child's body.

J.L. You think good dance teachers are rare. What makes a good teacher?

M.C. A bad teacher gets in the way, a good teacher doesn't disturb the student.

In principle it's a matter of developing the student's physical talents, and of teaching him to execute a number of steps of some technical difficulty. The teacher should keep that in mind. On the other hand, he should take constant daily care that the student not injure himself, not deform his body by exaggerating the effort required to master these techniques. And hope that each student will find out for himself, by daily practice, how he can dance. It' a very long process, which requires that you learn how the body functions, and attentively, every day. You also have to see that the student works by himself and doesn't just follow. You get a kind of intuition of what each student aims for, and at the same time of where he is, day by day.

It's not easy, but if one concentrates, invests one's energy and time, it's possible to measure the student's progress. When giving my exercises, I take care not to impose a style of any kind. I just hope it appears as natural as possible. Anyway, it's very important that every day the student has the feeling that he has *danced,* however little. Even something very simple, like some running steps, is enough. Rightly or wrongly, I have the feeling that in every class, and after the warming up exercises which should take a good deal of time, at some moment the student should touch the utmost limits of what he is capable of then, and every day, he should achieve that and enlarge it.

It's also very difficult to find good teachers, because what I ask isn't what is usually done, it's a particular way of teaching, or it would be done everywhere, and it implies rather precise physical

qualities. That narrows the field further.

Ideally if I could, I'd just work with my company, I wouldn't give classes, I don't like them. But not everyone is like me, there are people who enjoy teaching and do it well. So the situation isn't too bad ...

Solos

I think of dance as a constant transformation of life itself.

In one way or another, what we'd thought we couldn't do was altogether possible, if only we didn't get the mind in the way.

J.L. One of your first solos had the beautiful and ambiguous title, Root of an Unfocus. *How would you understand it: Root of a decentering, root of a turbulence?*

M.C. The title is mine. 'Unfocus' here refers to a disturbance in the mind, an imbalance, it's a photographic term which signifies a blur, an unclarity. It's one of the first solos I made. I was still concerned with expression. It was about fear. The dance was in three parts. The first part gave the impression of someone realizing there's something unknown. The second part shows the dancer struggling with this but it's futile because there's nothing there. In the third part he is defeated by it. The ending was a series of falls and crawling off the stage. In a sense I was still making a conventional modern dance, with great differences of tempo between the three parts. However, the whole piece was based on a time structure that John Cage was using at the time, and that he called the square root system: you had a phrase, for instance, of ten counts. Then the structure for that section was ten by ten. Then the next section was eight by eight. We knew that at certain structural points we would meet. It didn't always happen (because we were dividing the phrases differently) although we were both very accurate. There was a back and forth between us. The music was composed by John for prepared piano.

J.L. So that was a moment where you still danced to music.

M.C. Not exactly. Nor was what John wrote written to my dance. We both worked independently within the structure which we had agreed on.

J.L. A recording of the music exists. Is there a document of the dance?

M.C. No, only one or two photographs.

Nine years later, I made another solo, called *Untitled Solo,* which was done to music that was already written, a piano piece by Christian Wolff. I worked on this at Black Mountain College in 1953, that summer when we were all there. The music was a complex piano piece and, although I was not following it note by note, I was attempting to follow its structure, so to speak. Although I could somewhat read the score, it was very complicated, I really had to have David Tudor's help. David Tudor, who was a remarkable pianist, was there that summer working on piano pieces for his program and I didn't like to ask him to come and rehearse every day, but I did ask if he would come once in a while because I was having a difficult time. He came one day, we would work together, then I'd just sit down and David would play through it, then we would work at it together again. Finally David smiled and said, 'Well, this is clearly impossible, but we're going right ahead and do it anyway.' (laughter)

I had made the dance by preparing a gamut of movements. I would figure out a movement or a phrase and would write it down so as to be clear about what it was - this was before video - then I'd figure out something else: a movement with the feet, slightly like a *pas de bourrée,* small motions for the hands, head turns, repeated things. Then I'd throw two coins to find the order, by chance means. And where it was a phrase, that was what I did. But when it was a single movement, I would throw coins again to see if another movement was done at the same time. Once five different things came up, all separate, and I spent days practicing without the music, to figure it out, just to *remember:* the continuity, what came next, was such a problem. It reordered the whole coordinating system. I would think, first of all, it's impossible, then I would say, 'Well, I'm going to try it'. So I would do one movement with the feet, then the hands and see how I could fix that, then the head, each time practicing it all together. The dance was five or six minutes long, which for a solo is *long.* Finally by the end of the summer I was just barely able to present the dance. It absolutely rearranged my idea of what coordination was, or mine, certainly. Listening to the music was strange, trying to know where I should be at certain points in relation to the sounds, and when I was trying to do this complex

dance *with* it, oh, it was impossible. But, as David said, we went right ahead and did it anyway.

That was when I was beginning to use chance means. I also began to see that there were all kinds of things that we thought we couldn't do, and it was obviously not true, we *could* do them if only we didn't get the mind in the way. That's what I have found continually throughout my experience, that the mind will say, 'Oh, I cannot do that', but if you try it, a lot of the time you *can* do it, and even if you can't, it shows you something you didn't know before.

I find this, time and again. When I give workshops, with students, the two questions they ask concerning the chance procedures, are: 'If something comes up that you don't like, what do you do about it?'. My answer to that always has been that I would accept and deal with what came up. And they ask 'If something comes up that you can't do, then what do you do?'. I explain that I would always try it, because the mind will say you can't do it, but more often than not you can, or you see another way, and that's what's amazing. In some cases it *is* impossible, but something else happens, some other possibility appears, and your mind opens. It's like necessity being the mother of invention. You come to a necessity, you *make* it a necessity, so you *find* a way. You have to be very strong and determined.

One day, we were making a film for German television, years ago, and I said at one point, 'Oh, I think dancers have to be a little stupid to go through with what they do every day.' The interviewer was shocked. But I said 'You know, they really *do!* To go through certain kinds of things, you have to be wholly innocent or foolish,' because if you thought about it for half a minute you wouldn't do it. (laughter)

J.L. Why 'Untitled Solo'?

M.C. Working with coins was very new to me at the time, I didn't know what it was, and I called it 'untitled' because there wasn't any title. Actually, the dance is quite dramatic. The drama comes from the intensity. It was physically difficult for me to do that dance, because of the changes, the play of movements against each other, the abruptness of the rhythm, the shifting. It was technically very hard to do. And that was

where its drama came from, not that I put anything into it – when I first did it I could just barely get through the dance – but because of the way it went from one gesture to another. There were rapid foot things and then all of a sudden hands, and head thrown around. It just about broke my neck once, I remember, flinging myself around (laughter). Normally, drama is produced by contrast, something against something else followed by a resolution out of it one way or other. This doesn't in that sense have any resolution. It just ends. It's a form of spinning that I had to do several times, my head's up in the air, my arms somewhere and then it's incredible: stop! I've made solos since then, of course, often inserted in dances prepared for the Company, in *Canfield* and *Scramble,* for example and also numerous solos for the *Events.*

J.L. From the beginning in the solos, until now, you have kept up the double role of dancer and choreographer?

M.C. It's very common in modern dance simply because if someone wants to dance and has an idea about dancing that isn't traditional, he has to make the dances himself, otherwise no one will. It's a practical necessity. It was the only way a modern dancer could do it. The tradition in the ballet has been that there's a choreographer who makes a dance for the dancers. Last year I did a solo called *Tango.* I can't tell you what prompted me to do that piece. I was working on *Exchange* at the time, and sometimes when I'm making a dance for the Company, I think of some other very different idea for some reason. It may be that the dancers were not available, probably because of the costumes, I've forgotten why, but I started making a piece for myself. I thought I'd make a solo; it lasts six minutes.

J.L. Why 'Tango'?

M.C. It's curious, the minute you give a title people want to know why you did that ... The word has many meanings. For example it's Argentine ...

J.L. It's the code for a flight, a hue ...

M.C. A type of dance, or just a word ...

J.L. Yes, with five letters, two vowels, three consonants, no sound repeated ... What costume did you wear?

M.C. Mark Lancaster did the costumes and the decors. He put the television set on the stage. I think it's visually on all the time, but you hear the sound during only one part of the music when it is turned on and everything else is turned off.

J.L. So you have the image behind you constantly?

M.C. I think so but I'm actually not sure, because I'm not in a position to see it most of the time.

J.L. With a special program on it?

M.C. No, whatever happens to be on, probably whatever is best received in that theater. In Lyon, I think we had Lauren Bacall, in an interview she gave on the French TV. Suddenly I realized she was on.
 The solo has a very simple structure underlined by the music: four minutes; half a minute; a minute and a half. it's like a vaudeville act. The costume is not elaborate, I carry a blue towel and there's a raincoat on the stage. I'm dressed in yellow: yellow sweater, yellow sweat pants.
 In this dance the movement came first in each section, and then I worked on the time and the space. Only the rhythms are complex. It's a dance made to be done in a small space. The structure is simple, but quite strict, or supposed to be.

J.L. A word, perhaps, about the solo called Solo?

M.C. I call it 'the animal solo'. I'm dressed in a unitard which was painted by Sonja Sekula. Her designs suggest different animals. The dance images go from one kind of animal to another, bird, snake, lion, in eight minutes ...

J.L. I want to come back to your earliest solos, among which two titles struck me. Both are from Finnegans Wake: In the Name of the Holocaust, *and* Tossed as it is Untroubled.

M.C. The first is a word play by Joyce in *Finnegans Wake* on 'In the name of the Holy Ghost'. The second is derived from Joyce's 'Unhemmed as it is uneven', which is his play on 'On

earth as it is in Heaven'. The first was religious in tone, very probably linked to my Catholic upbringing. The second was more joyful with many jumps and hops.

J.L. I seem to notice three sorts of titles: those like the ones we just mentioned that have a literary resonance, others that are more traditional, and a lot of short titles: How to Pass Kick Fall and Run, Dime a Dance, Springweather and People, Lavish Escapade, Nocturnes, RainForest, Second Hand, Suite by Chance, Cross Currents, Changeling, Antic Meet, Summerspace, Rune, Winterbranch, Signals, Changing Steps, Torse, Fractions, Sounddance, Scramble, Exchange, Locale, Roadrunners, Channels/Inserts, Trails, Gallopade, 10's With Shoes, Fielding Sixes, Quartet, Coast Zone, Deli Commedia, Inlets, Roaratorio, Duets, Pictures, Doubles, Phrases . . .

M.C. Yes, in the beginning my titles were much longer than now, perhaps because the solos I did then were short . . . I think that recently I've chosen shorter titles, with open, multiple meanings.

J.L. I'd like to mention the fact that you continue to dance yourself, to the astonishment of those who can't imagine a dancer except in terms of the stereotypes of youthful promise and maturity, whereas you are concerned first of all to continue your explorations through dancing. As you rightly say 'You don't stop living, so you don't stop dancing'.

M.C. I dance because it gives me deep pleasure. Not only because of the questions that are raised through dancing, but because of dancing itself. Still, it's not indispensable that I do so - others will go on dancing, my Company in particular. But I don't see why clichés or conventional ideas should interfere with the explorations that I can still make. Those people who are shocked think of dancing in a very limited way. I think of dance as a constant transformation of life itself.

The Dances I

The dances always originate in a particular physical question.

J.L. When we spoke of Torse *you said that each of your dances was constructed around a precise physical question. Once this material is chosen, you draw out a web or syntax that I'd like to look at in its diversity in a number of your dances. In particular, without the support of classical or modern styles and phrases, you've found a way at once subtle and ample, of combining units of movement that might otherwise be thought difficult to discern or identify. When one speaks of phrasing in dance, is it still possible to do so other than in the nineteenth century sense?*

M.C. Certain details can contribute to phrasing movement. You can amplify a phrase by very small movements that don't need to be evident for them to be effective. For example, in a dance called *Second Hand* made to Erik Satie's *Socrate,* I gave each dancer a certain number of different hand gestures which could be done in any order. Throughout the length of the third movement each dancer could make a choice about which one of those hand gestures he wanted to use. They were small things like finger signs, hands closed or opened; the dancer could hold them or change them as he wanted to in relation to some other movement he was doing. It was as with the leaves of a tree. If you really look at a tree, no two leaves are the same, even though each leaf has the same general shape and structure. All these gestures were almost unnoticeable in the dance because they are small and they may be held only briefly. Each dancer had twenty changes of hand shapes; they did not have to use them all. I did ask them to keep the same order each time, I think, although perhaps I didn't even do that. If one saw the dance often enough, one would probably begin to perceive that this was going on, that there was some change. But if one did not see it often, one would not be sure, as probably one would first look at

the other more obvious movements.

Second Hand was made in 1970 but you could say that I began it long before that. Many years ago I made a solo to the first movement of the *Socrate*. It is a solo in which I stood in one place and did the dancing without moving away from it for about five or six minutes. John Cage had made a two-piano version of the first part of the *Socrate,* drawn from the original piece for orchestra and voices. John always wanted me to do the whole of the *Socrate*. Years went by and I was making other dances. Finally, about 1969, John said he was working on the two-piano version of the other two parts so that if I wanted to do the piece, the whole work would be available. I didn't say anything about it, but I began to listen to the recording of the *Socrate* I had, to listen to it again. It is an extraordinary piece of music. One day, when we were touring in the United States, we had a meeting about the music for the Company. There was a problem with the electronic music. David Tudor and Gordon Mumma, Mumma was with us then, had great trouble setting things up for three electronic pieces each evening because they had so little time, and they asked if it would be possible for me to make a program in which one piece was not electronic so they wouldn't be so rushed. I said, 'of course', and began to work on the *Socrate* quietly by myself, and then on another tour, two or three months later this question came up again, and John said: 'You should do the *Socrate'* and I replied: 'I'm doing it.'

I continued working on it, and eventually worked with the dancers. Then came the moment when it was to be performed for the first time. John had to get the rights from the French publisher to use the arrangement he had made for two pianos, but the publisher refused permission. So what John did was to write a new piece using the same phraseology, the same rhythm, changing the melody of the *Socrate* by means of chance operations to what we now use when we do the dance so that there was no copyright problem. Same phraseology, same rhythm, but the melody is entirely new; and he made it for one piano so that he could play it. It's a very practical piece. John said he was going to call his piece *Cheap Imitation* so that the title, not just the music, would imitate Satie. I said if you are going to call your piece *Cheap Imitation* I'll call mine *Second*

Hand since I had worked at it years before and here I was back again.

The first movement was the solo which fortunately I remembered exactly as it was; the second part I made as a duet with Carolyn [Brown], and the third part is with the company, all of us. It's a long piece which takes a large stage. it lasts at least 35 minutes, the first movement is six, the second over eight, the third is twenty-two with the entire company in it. As to the space, during the solo, the first movement, I stood in the same spot. In the second movement, Carolyn and I moved through the space as though we were outdoors, probably prompted by the title, 'Bords de l'Illissus'. In the final movement, 'Mort de Socrate', in an attempt to keep the space from being static, I decided to choreograph it in such a way that the dancers would have made a complete circle by the end of the piece. I began the movement standing alone at the back of the stage, and the dancers gradually entered and throughout the dance we make this spiraling circle before the final exit of the dancers leaving me on the stage alone.

The circle is in no sense explicit. Dancers break off and move in different directions as the dance continues, but the diffused circular pattern is present.

The rhythm and phrasing were taken from the music.

J.L. In what order did you work on - 1) space, 2) rhythm, and 3) movement?

M.C. In this work the music was the first consideration, its structure and even its content. I worked out timings for myself, studying the phrasing and the rhythm of the music, and then worked on spatial ideas which led to the movement ideas.

J.L. Yes, that's one of the things which is most delicate and complex to try to figure out. For a given piece what are the bases of composition and why?

M.C. It depends very much on the piece. At any one time, one thing can be for a moment more important than something else, but only more important in the sense that you have to deal with it at that precise moment. The next moment it can be different.

The costumes for *Second Hand* were designed and dyed by

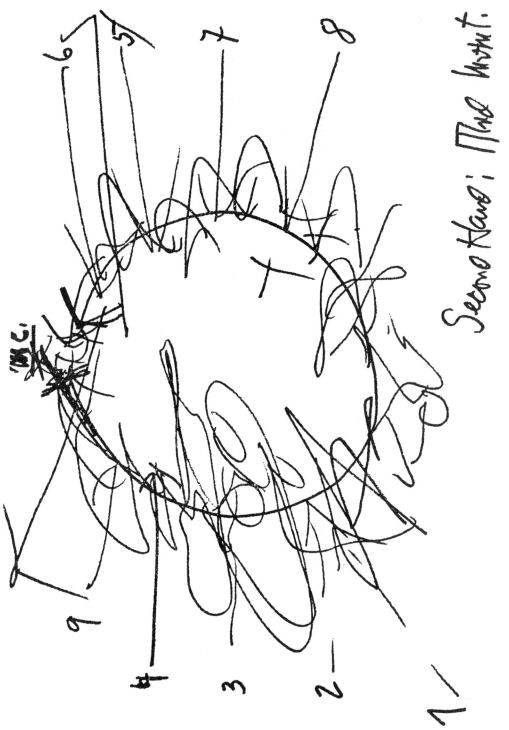

2. *Second Hand:* third movement

Suite By Chance: Movement

+ - Still; -- Moving
+ - silence; -- Still-Moving
+ - phrase; -- neutral

Still-Moving:

position in → 1) Held position (weight on legs): +- Horizontal 1-5
Silence -- Vertical 1-8,

2) Jumps

3) Extensions

4) Back

5) Head

6) Arms

7) Falls

8) Weight elsewhere (than on legs)

if silence appears:
cast- +- remain
in position of
end of preceding
action
-- - cast for
new position
out of Held
position

Moving

+ - phrase & fast- ++
 medium- +-
 Slow - - -
-- - neutral

Still-Moving
Cast for
superimposition

3-3. *Suite by Chance:* movement

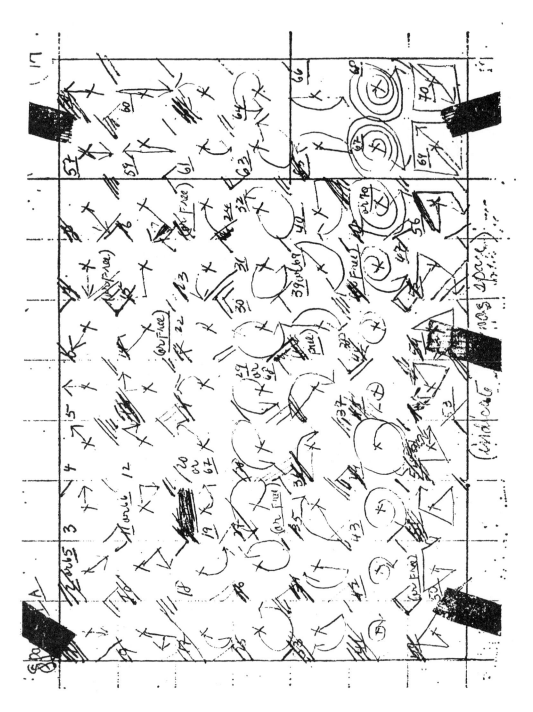

4. Suite by Chance: space

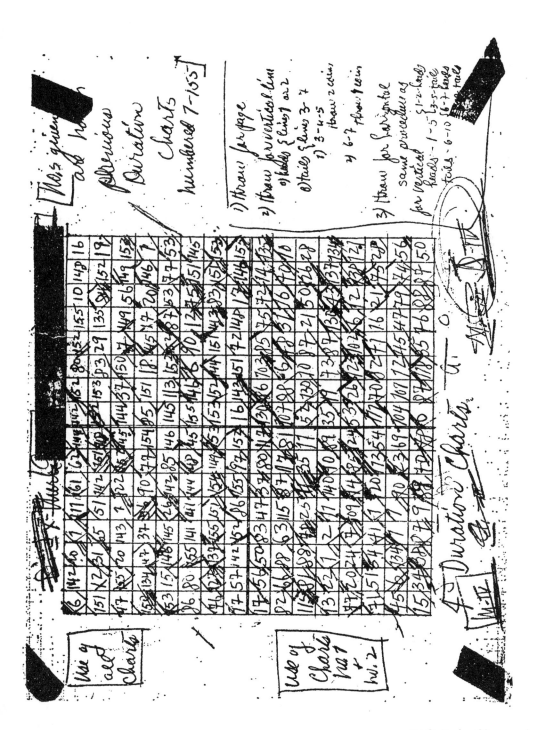

5. *Suite by Chance*: duration

Jasper Johns. They consist of leotards and tights, each of a single color except for the edge of one side on the arm or the leg where another color enters. This second color is the major color of another of the costumes. This becomes apparent when the dancers line up to bow. Jasper asked that the bow be arranged in order to show the color succession.

Suite by Chance was a very elaborate dance. It was the first one I did with everything done by chance. There were four parts in it, still, so to speak - if I can use the word - in classical form: The first movement was *andante;* the second movement was very slow; the third movement a little faster; the last movement was very fast. Apart from that, I subjected every single thing to chance. I made a series of charts of everything: space, time, positions, and the dance was built for four dancers going from one of these lists to the other. Then it ended.

It had originally been intended to have a score for piano by Christian Wolff, but when I was working on this, he became interested in what was at that time - 1952-1953 - electronic music, and he asked me if I would be interested in having an electronic score, and I said 'Certainly, fine,' and so he made it on magnetic tape using oscillator sounds. This changed the way I worked with time. Originally we had expected to be able to connect in some way with the piano sounds or with counts, but we no longer could do that. Consequently I had to connect through minutes and seconds. I used a stop watch for the first time. It was OK. It was just another way of working.

Suite for Five: This one, just by the title, indicates the number of dancers - there were five - actually there were to be six, (laughter) but one of the dancers was injured or unavailable, and couldn't work during the time I was preparing this, so I made it for five. The space was done by taking pieces of paper and marking the imperfections in each piece - if you look at any piece of paper, this one for instance, you see little dots - I would number these dots, and by chance means decide where somebody started in the space and to what space he went next, the next one and so on.

Each dancer had different dots. I superimposed them to see if there were any points that came together, and where they did, I would have sequences with people together.

Originally, it was a series of five solos for me – *Solo Suite in Time and Space*. Then I began to make more dances, a duet for Carolyn Brown and myself, a trio and a quintet for all five. Later I added a solo for Carolyn – so that's why when you see the dates it's something like 1953-1958, because different choreographies were added over that period of time. But the procedure for making the dances remained the same. I would make a gamut of movement for a given dance and then figure out the space with the pieces of paper and their imperfections. The time was done in seconds. I gave some kind of allowance for how long a given movement or sequence of movements might take. Say the person is here doing a certain kind of movement, and he's going to end over there – the chance means would say how long that would take. If it were a very short time, in order to get from here to there to do that movement, they would have to do it quickly – but if it were a long time – say, take a minute to go from here to there – the movement could go indirectly even though they ended over there. Now in the course of that, they might cross somebody else's path, and I would allow for some kind of connection, a lift or a pose – the trio and the quintet are made that way.

Septet was done at Black Mountain in 1953 to Erik Satie's *Three Pieces in the Form of a Pear*. It had six dancers: three men and three women; it is a conventional dance done *to* the music. It's a short ballet. I don't know how else to describe it. Although now I'm sure that for anybody looking at it, the relationship of the dance to the music would seem perfectly sensible, if not conventional, at the time I remember musicians not objecting, but saying that the music and the dance relationship was odd because there would be an accent in the music, and there would be no accent in the dancing. Now, that's perfectly acceptable. We did that piece many times, and I hope to bring it back if I can, for a number of reasons: one is that it's a useful piece in terms of people touring; it can be done on many different stages; it has no set or any problem like that; the music is simply four hands at the piano, and it's a relatively simple piece to keep together over time. It's also a desire on my part, to see what that piece would look like now. We have a film of it that was done while we were in Helsinki in 1964, and I have some notes – so that I have been able

91 THE DANCES I

to bring it back. Some of it is on the 'Dance in America' program - two sequences of it.

Nocturnes was a white ballet, made to the five *Nocturnes* of Satie. There were 6 dancers who would divide into couples momentarily, and then fragment into 6 individuals who appeared in the space and disappeared from it, or remained only partially seen. The program note read: 'from dusk to the witching hour'. I have only a few scattered notations and some photos. One note reads: 'categories - passing steps, adagios, physical feats, stances (stillness)'. The 4th dance was a duet for Viola Farber and myself. What an extraordinary supple quality she had!

The white decor that Rauschenberg did was very beautiful. The dancers were also all in white. The women had marvelous white headdresses. The only color other than white was special makeup on the men's faces. One half of my face was red and the other half was white. Another dancer's face was half yellow and half blue. I had told Bob that at one point in the dance I was going to have something taking place in the back, at what should seem to be a great distance from whatever else was going on. He asked me more questions about it, but I had not done anything yet, I just had this idea: maybe the dancers could be behind something you'd see through.

The first performance that we did was in Brooklyn, at the Academy of Music, on a tiny stage, and Bob had made this beautiful set arrangement, a scrim which took up one part of the stage over on the side, which you could see through, at the end of which was a rectangular white opaque form – I didn't know what the material was – white opaque so that it wasn't transparent all the way, but there was one transparent part so people could come in and be there and then disappear again before they re-appeared. We rehearsed morning and afternoon in the theater, and just before the dancers were to leave to go to eat something, the firemen arrived. They took one look at this beautiful set and said, 'You can't use it - it's not fireproof'. We had never encountered this problem before. It was already late in the afternoon. Bob was marvelous and Jasper [Johns] was there helping him. They both said, 'Don't worry, we'll take care of it'. I said, 'I'm not going to worry . . .' And I didn't. I went away. I had to eat something. I was starved. I came back around 6:00 p.m.,

the program was at 8:30, and there were Bob and Jaspe.
had taken off all the stuff that the firemen were worried ;
and built something beautiful out of green branches with le
they got someplace - I think they must have gone to a pa
(laughter) We were only doing one performance, of course, so we
managed to get through that ...

*J.L. It seems you have a predilection for Satie's music which
accompanies several of your first dances.*

M.C. Yes, that's so. I liked the music *very much.* Previously to
this, I had done solos to Satie pieces of music. Then we began to
get involved in electronic music. But one of the things we were all
concerned with - David Tudor, John, and myself - was that the
musical part remain live. In other words, we did not want to have
recorded music.

J.L. But why specifically Satie among all composers?

M.C. Partly, it's just out of love for his music - but also because
the quality of Satie's music remains mysterious and not quite
definable, and his formal - his structural inventions, are
interesting, at least they were to me in ways that I didn't often
find elsewhere. I can listen to Satie music now - for instance the
Three Pieces in the Form of a Pear, which I have heard over and
over for years, and it is still just as refreshing as the first time -
whereas that doesn't happen to me with the music of other
composers that I have listened to - I find very quickly that I
begin to know the formal procedures, and it doesn't hold my
interest as Satie's still does. The focus on Satie was brought by
Cage. Although I knew Satie, of course, from way back - Louis
Horst had used the *Gymnopedies* in his composition class, I
didn't know very much of his music and John - when he gets
interested explores everything, as he always does - he found out
that there was a great deal, and at Black Mountain he had
assembled the whole thing in a Satie festival so that we could
listen to most of it. Then it was only a question of which
particular piece I might be concerned with.

One of the practical problems, I must say, in our situation is
that as we changed, as we continued to change, and began to
have different kinds of music, we were dependent upon musicians

who could play both electronic and piano music.

J.L. Were you interested in other modern composers? I'm thinking of the Second Viennese School: Schoenberg, Berg, Webern.

M.C. I made the *Labyrinthian Dances*, which used a four hand piece by Joseph Mathias Hauer, the Viennese composer who invented the twelve-tone system at the same time as Schoenberg but independently. But my work in the beginning was done with American composers – Morton Feldman, Earle Brown, Christian Wolff, who, like John Cage, worked on new musical ideas.

Dime a Dance was a series of fourteen dances which I had made – solos, duets, and so on – for all six of us. David Tudor selected music to go with it – only knowing of the *tempo* of each dance. I didn't tell him anything about quality, but he would start the music with the dance, and stop whenever we stopped, regardless of where he was in the music. That had, among other things, a solo for me which was done to a Beethoven *Bagatelle*, for example. There were pieces by Debussy, Alkan, Gottschalk. David chose the music from the nineteenth century – each dance was constructed within a particular formal arrangement, and David found a piece of music which would fit it in terms of meter. But other than that, there was no relationship, so that whatever idea anybody had about that particular piece of music did not work in this context, and it gave it a wholly different effect.

Antic Meet and *Summerspace* were done the same summer – 1958 – at the Connecticut College Summer Dance School. I worked on them at the same time though they are very different.

Antic Meet is a series of absurd situations, one after the other, each one independent of the next. I do remember at some point I shifted them around – instead of running it in the order I had, I would try a different order to see if something else might function. Since it involved costume changes, although they weren't that elaborate, it was necessary to arrange the choreography in such a way that some of the dancers could be off stage long enough to change before coming on again. I had to make the continuity work for that part of it. Bob Rauschenberg did the decor and the costumes. I remember talking with him, but I worked on it up in Connecticut, and he was in New York. At one

point I told him that I wanted to have a chair on my back. He thought about it and said 'Okay.' (laughter) After a while he said, 'Well, if you have a chair, can I have a door?' and I said 'Sure, why not? Fine.' I also told him that in one part I wanted to wear a sweater which had four arms. That was all right. He said something about the girls wearing special dresses, and I said, 'It's fine, okay.' So he was making all these things, and I was up there, during the summer, trying to get the dance together. I came down to New York to see what he had done - he said I should. He had gone off to thrift shops and gotten all kinds of marvelous things. He dragged out a fur coat at one point and said, 'Could you use this?' and I said 'Of course,' not having the slightest idea what I was going to do with it, but I obviously was going to use it - it looked alive. Then he brought out a bouquet of artificial flowers, and said 'Could you use this?' and showed me how it disappeared - it was from a magic shop - and I said, 'Absolutely, absolutely' - again not having the slightest idea. Then he put on one of these dresses that he had made from a parachute. (laughter) It looked like Givenchy - it was elegant and beautiful - it was made of nylon silk. I could see it would work wonderfully. There were four dresses - there were four girls and two men in the piece. In one sequence they're walking around slowly, they wave their arms and they now and then meet each other. Bob thought about that and eventually put them in dark glasses - they had to dance with those black glasses. He'd understand, as he always has, that some things won't work simply because it's a physical impossibility - and he's always been marvelous about changing because of that. I said - 'Oh, there's one thing I want to know - is there some way we can bring somebody on stage, so that they're hidden and all of a sudden, they appear?' He said, 'let's use a cardboard, a huge cardboard box - like a refrigerator carton - that could be folded up.' You moved it in; all you saw was a plain box. Then it moves along, and there's somebody sitting on the ground ... Remy Charlip and I did a kind of acrobatic and tumbling act, falling and jumping over each other. Bob designed marvelous tank tops on which he drew things that looked like tattooing. There was one part for all six of us in which we did a lot of jumping and falling on the ground, and he made beautiful hooped shapes that

95 THE DANCES I

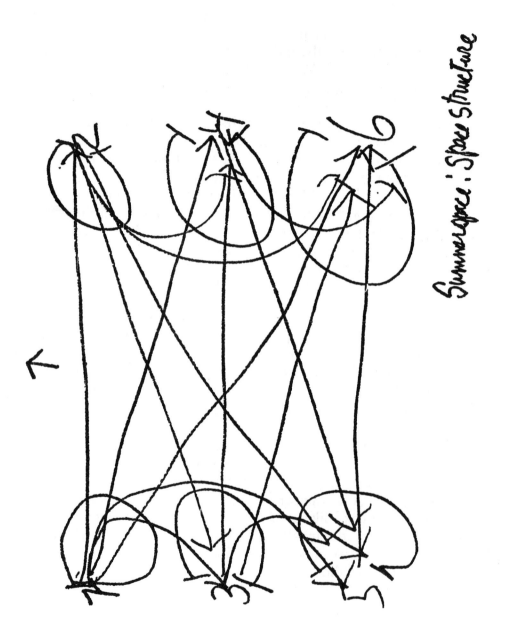

Summerspace: Space structure

6. *Summerspace:* space structure

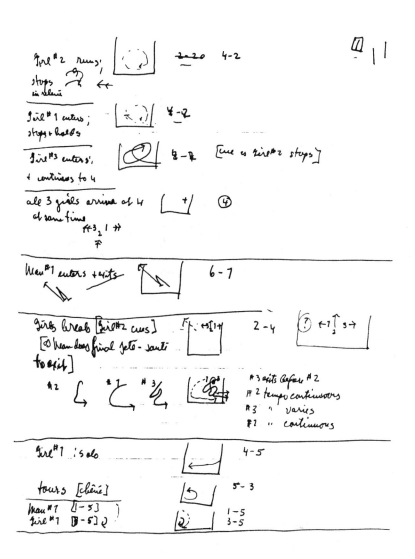

Girl #2 runs;
stops
in relevé
2-2-0 4-2

Girl #1 enters;
stops + holds
4-2

Girl #3 enters;
+ continues to 4
4-4 [same as Girl #2 steps]

all 3 girls arrive at 4
at same time
←3₂1→
4

Man #1 enters + exits
6-7

Girls break [Girl #2 cues]
[① Man does final jeté - sauté
to exit]
2-4

#2 #1 #3

#3 exits before #2
#2 tempo continuous
#3 " varies
#2 " continuous

Girl #1 : solo
4-5

tours [chêné]
5-3

Man #1 [1-5])
Girl #1 [3-5] ♪
1-5
3-5

were simply again tank tops of stretchable material which hung down. He sewed a hoop made of plastic material around the bottom edge - so it sticks out, bounces. Those for the women were slightly longer than those for the men, as I remember.

And the door ... I had said, 'Fine, if you want a door, that's fine, but how about getting one? 'Oh, any theater has a door,' was the answer. And I thought, 'I'm not sure about that, but I won't say anything.' So Bob came to Connecticut to work on all this a week or ten days before the performance - of course there wasn't a door. But that didn't stop Bob. He found one - built one with wheels - and this door, Carolyn would roll it on - she was behind it - you couldn't see her - and then I'd open it up, and there she was ... (laughter)

The music was John Cage's *Concert for Piano and Orchestra*. Very often on tour it would be done with the solo for piano alone, and David Tudor would play it.

Summerspace starts from a totally different point of view than *Antic Meet*. It was about space, as the title indicates. I was trying to think about ways to work in space - so I devised this piece - I was still working on a proscenium stage at that time. I decided to number the entrances and exits one, three, five, and two, four, six, and to link them by all the possible trajectories. You can go one to one, one to two, one to three, one to four, one to five, one to six ... that's six, then if you go to two, you can go two to one - that's just the reverse - so you go two to three, two to four, two to five, two to six - so that's five. From three - one, two and three are taken care of, so you go three to three, three to four, three to five, three to six - that's four. Four is taken care of except for four - and five and six then five to five, and to six, then six to six - and it comes out to twenty-one altogether: 6+5+4+3+2+1 = 21 space possibilities ... Then for each of those 21, I devised different kinds of phrasing, different kinds of movement possibilities - moving through space. Some were repetitions, some were very elaborate phrases, some were whatever ... Then, by chance means, I devised not only the order, but whether they were fast, medium or slow - and the phrase was done in three possible levees - I called it at that time: high, middle and low ... High meant either *relevé* or in the air, middle meant at normal height ... low meant going toward or on the floor ... Given all of that, I

had the sequence of phrases, and I devised a different order for each of the six dancers - again, there were possibilities of crossing, or coming together, sometimes it turned out that two or three dancers got the same movements, more often it turned out they got different movements.

When I spoke to Bob Rauschenberg - for the decor - I said, 'One thing I can tell you about this dance is it has no center...' So he made a pointillist backdrop and costumes.

Morton Feldman, who did the music, was in New York, Bob must have been in South Carolina, and I was in Connecticut. Somebody asked Morty here in New York what he was doing... He said he was writing a piece for me, that Bob was doing the decor and so on. This person said to Morty, 'How is it that Merce can be up there, Bob down there, and you're here doing this?' Morty said, 'Suppose your daughter's getting married, and suppose I tell you her wedding dress won't be ready until the morning of the wedding, but that it's by Dior' (laughter) - That is a description of Morty - not of the piece - but of Morty! (more laughter)

Bob was there for the performance. With Jasper helping, we were sprayed outdoors in our tights and leotards. I had rented a house that had a garden, and they rolled out the drop in the yard. We did it on a matinee, at the last performance of that festival.

J.L. And the lighting?

M.C. Bob did it originally, I thought he lit it marvelously - like a painter's light - not at all like 'lighting'. It was 'overall' lighting, but it changed constantly, not in reference to the dancing - it was like sunlight changing - like sitting here while the lights are changing.

J.L. You gave that dance to several other companies?

M.C. Yes: to Birgit Cullberg's Swedish Ballet. The Boston Ballet did it once; I gave it to the New York City Ballet, and in France, to the Théâtre du Silence.

J.L. It looks like it is the piece you gave first - and most - to other companies, is that right?

M.C. One reason for that is that it's a piece I thought ballet

dancers could do ... without too much disorientation. That isn't true, but I thought so.

J.L. Why did you think so?

M.C. Because it's full of turning, of things connected in some way to their vocabulary – full of leg extensions for instance. And it doesn't have an enormous amount of torso movement. It has more speed though. Margaret Jenkins, who lives in California, has notated the dance and knows it well. She can teach it. I don't do that very well, reteaching an old piece. Somebody else has to do it; after that I can look it over. She taught it to the Boston dancers, and to the Theatre du Silence. She did a marvelous job. When I saw the Theatre du Silence in New York, rehearsing, I thought it was going to work. Some things they didn't do well, but they had enough of the sense of the piece. They were trying to make it work amongst themselves. It was a give and take. If you demand that they do it a particular way, it will never work anyway. It's not an easy piece to do because it should look perfectly natural.

J.L. Is it more difficult than Changing Steps?

M.C. No, though probably it is in some ways. There are technical things in *Summerspace* related to speed – in the turning. You see, it should go dazzlingly fast, and then suddenly get slow – suddenly, not ritard, but suddenly get slow – and that's not easy to do. The original dancers – Carolyn, Viola, of course, could do that beautifully – had the sense of it, even though some of them were not that strong technically. Giving it to other people not trained that way – to get that sense across to them is very hard to do in two weeks, or whatever time you have. It's hard for them to hold it – that is the difficult part – because the other pieces they do don't work that way, so when they come back to this, the tempos are all washed out ...

Rune was done the year after *Summerspace*, also in Connecticut. It had six dancers, again, four women and two men; twenty-five minutes long, with five sections, each section roughly five minutes – although they shift back and forth – again it was gamuts of movement. It was originally called *Autumn Rune,* but I never used the whole title. It's a very sparse kind of dance, with

a number of rhythms - jagged, - short, fast movements - and then again something very quiet and extremely slow. What I had planned was to make a series of separate blocks of choreography so that the order of the dance could be changed, not necessarily from performance to performance, but that was one of the ideas involved. Again we found that when we were touring, it was not possible to do that kind of changing because it takes many rehearsals and since the dancers, including myself, were often tired, we simply couldn't do it. This is the only dance I wrote down quite thoroughly; this was again before video.

J.L. How many pages for Rune?

M.C. It goes into two note books, about 40 pages, handwritten with space directions and stick figures.

J.L. Could you do it again with these notebooks?

M.C. Yes, but not that easily. When I thought to try to bring it back about a year ago, I would start to work through the notes, the dancers would listen to me and try it out but it didn't work. I knew it was not the dancers, they were fine, the notes weren't adequate, at least I hadn't read them adequately. So I decided to try again. I went back, started all over again and the second time it did work. I looked at everything and tried to puzzle it out inch by inch. It took me a long time because all the indications mean something and I knew they did when I put them in, so I clearly had to work at it until I found out what it was they referred to.

The original notebooks were done when I was going to Europe on Icelandic Airways, a flight which took many hours, so I thought I'll write it out, otherwise I knew I'd never remember the details.

What it amounts to is that given a five-minute period, you can have both silence and action, action meaning dancing. When there's no action it means if you're on the stage you're still, if you're off stage, it's empty. Out of these five minutes if you have one minute of silence, you have four minutes of possible activity, then given all these units of movement, the next thing is to see what would work in that particular four minutes. By these means, or by chance means, you choose a certain unit, then

along with that unit, what else could be done. If that unit takes a small part of the space, then maybe you have to have something that doesn't occupy that same space as there would be no room for it. So within the dance they move from big, huge things, to where people are still. There's one point where one of the women stands in the upstage right corner and moves in a slow circular way with the torso, but staying in place.

All the way through the piece, you have both the idea of the five minutes and the idea that these separate blocks can be placed in any order. I tried to make separate blocks that were not related to one another and yet were clear; in order to facilitate the indeterminate juxtaposition of these blocks, I made them in such a way that nothing in the way of transitions was ever added. It's what I wanted, simply those units of movement which were kept. Bringing it back, I remembered all that, but it was not written down because I would get bored writing. And also, if I was here and doing it, it would be something else; but sitting in an airplane ... I think we have it back now and we'll do it this summer. The music is by Christian Wolff, for two pianos or small orchestra.

Field Dances implies both country fields and spatial fields. At first, it had four dancers in it, although eventually it got so that everyone could do it. My idea was to make something that anyone could do, not just professional dancers. It's an indeterminate dance in that each dancer has a series of relatively simple movements, it's not intended to be a long piece, they can do the movements in any order and any number of times, they can repeat, they can go on and off stage; there were certain sequences that two dancers did together and three dancers and four, each had these movements that he would do with any person, sometimes with a special person, sometimes with three or four, but all relatively simple movements, like swaying back and forth. Naturally, as my dancers did it, it began to take on a different kind of flavor because they're dancers, but it has been done by students. The field idea was the idea of being out of doors, and instead of a linear thing, having a field of movements. The music is John Cage's *Variations IV*. I had imagined sound that could come from far away. When we've done it in the theater he used radios, I think it's radios, and put them out in the

halls, so that it's something you hear in the distance. It was made in 1963.

Winterbranch. I wanted to make a dance about falling, so I worked on falls. I remember trying out a lot of things with Steve Paxton, and I realized that for dancers it is hard to do a lot of falling, you have to be covered, then I thought of shoes, or sneakers. I also wanted something where they don't necessarily make entrances but where you walk in. By entrances, I mean you don't necessarily come on stage doing a dance, but you walk into a place, you start something, you finish it, and then you walk off, although that's not consistent with the piece. So I made a great number of different kinds of falls, trying them out myself, with Steve, eventually with the Company, and then when Bob Rauschenberg came, I said that we needed to be covered, wearing shoes, that the light could be night, and that was going to be his part: making the black . . .!

Variations V was a complicated piece that we don't do anymore. It requires all sorts of technical paraphernalia. It was a 'mixed media' event: there were antennae placed in a grid all over the stage, photo-electric devices on either side, and film and TV circuits. John's music was constantly being produced but it was only heard when the dancers opened the circuits because of their proximity to the antennae or their interrupting the beams of photo-electric light. This piece was commissioned by Lukas Foss and the French American Festival and first performed at Lincoln Center. A film was made of it in Germany in 1966.

How to Pass, Kick, Fall, and Run is a title I took from a book on football. 'Pass' is pass the ball, 'kick' makes sense; I don't think 'fall' was in it. I liked that title very much. I added 'fall', and I liked it because there was going to be falling in the dance. There isn't really passing but the word works so well that I don't care about that. It's about 20 minutes long. John Cage tells stories, one in a minute's time unless it's a very long one, then it goes to two minutes, but most of them are only one. If the story has very few words in it he tells it slowly, as it must take a minute. Then he may have two or three minutes of silence. If the story has a lot of words then he must say them fast. He rearranges the order of the stories each time. I had planned originally for the sections of the

dance to be performed in a different order each time, but the rehearsing gets so complicated, I always had to give it up. I mainly wanted to make a dance which really moved around, though no ball is passed ...

Choreographic Moments

I always felt that movement itself is expressive, regardless of intentions of expressivity, beyond intention.

J.L. You have said that what you liked especially in Torse *is the fact that every dancer at one point or another appears as a soloist. I sense in your pieces two antagonistic and therefore fertile extremes: one exemplified by the dancer alone. All of your dancers, each one* alone. *The opposite is the complex material made up of all the dancers' trajectories. Solitude affirmed on the one hand, and at the same time a complexity that can be seen in the solos as well as in the ensembles and that might be called a* choreographic saturation *as has never before been brought about. In between these extremes are the intersections where dancer crosses dancer and where evocative power and poetic eloquence play on the spectator, without leaning in any way on an intentional expressivity.*

M.C. An example: we did the piece called *Winterbranch* some years ago in many different countries. In Sweden they said it was about race riots; in Germany they thought of concentration camps, in London they spoke of bombed cities; in Tokyo they said it was the atom bomb. A lady with us took care of the child who was on the trip. She was the wife of a sea captain and said it looked like a shipwreck to her. Of course, it's about all of those and not about any of them, because I didn't have any of those experiences, but everybody was drawing on his own experience, whereas I had simply made a piece which was involved with *falls,* the idea of bodies falling. I had told Bob Rauschenberg that it was more like night than day, and that it could be artificial light rather than moonlight, light that you can turn on and off, which means you can get abrupt changes of light. I also told him you can do the lights at random, which he did. The music by LaMonte Young was his *Two Sounds* and it somehow entered your head. It was loud and persistent. All this

reference to riots and atom bombs wasn't my experience, and I wasn't doing something artificial, so I wondered, where do those lights come from in my experience? I thought about this a long time, and one of the things it could have been is that we toured so often in a Volkswagen bus, driving at night, at two in the morning and seeing lights from on-coming cars illuminating something, a person, a tree, or whatever, constantly changing. That's not something I thought of when I made the dance, but it's in my experience. None of the other people's experiences were wrong, but it's what I mean when I say I'm not telling them how to think. It's true of all my pieces that I've felt them strongly. They all came out the way they are, but as movement, since that's what I'm basically interested in.

J.L. In the same vein, I'd like to understand the origin of what seems to me present in all your dances and in a way touches me greatly, I mean those choreographic 'moments' where without their having been sought, or any intentionally cultivated emotion, the instants of beauty are all the more eloquent. For example, in a different sense than Winterbranch, *I think of* Signals *and of the moment where one of the girls puts out her two arms on the shoulders of the boy who is in front of her, his back to her, she has a leg slightly lifted, she is on* demi-relevé. *He puts his arm backward, happens to touch her thigh, not looking, and she lifts her head slightly. Such moments seem to me an equivalence of the lyrical moment in duets, but in a way that is modern, 'found' not 'sought for.'*

M.C. Yes, I agree. You see a man and a woman dancing together, or being together, it doesn't have to be thought of this way, but you make a gesture which can suddenly make it intimate, and you don't have to *decide* that this is an intimate gesture, but you do something, and it becomes so. I quite agree with you. I don't think that what I do is non-expressive, it's just that I don't try to inflict it on anybody, so each person may think in whatever way his feelings and experience take him. I always feel that movement itself is expressive, regardless of intentions of expressivity, beyond intention.

J.L. I remember another of these very beautiful moments in

Un Jour ou Deux, the ballet that you made for the Paris Opera. There had been downstage left a solo, without anything else going on, that I would qualify as one of quiet desperation, at least that's how I saw it. I think it was Claude Ariel who danced it – Wilfriede Piollet entered diagonally from up stage, stopped an instant and as Ariel continued, slowly walked, turning around him, touching one of his shoulders and leaving the same way. The moment seemed to me very moving. It was perfect solitude, much more so than when he was alone, someone approaching him without his realizing it, a slight touch without his feeling it, as he finished dancing. I'm attempting to figure out how those moments came about, not from a decision to make such and such a sentiment felt, but rather as an intersection of distinct trajectories, and so all the more touching.

M.C. Gesture *is* evocative: those moments which are not intended to express something, but are nevertheless expressive. There's a point in a very recent dance I've called *Locale,* for example, just in the beginning of the second part, where one of the men leaps towards a girl who's on the floor; another man lifts this girl into the air, and another girl who's been with the first man comes over and stretches her arms and body over him. It suddenly seems to be, again, not something expressive but something almost intimate in a way. But I just wanted a man leaping towards a girl who's then pulled up by another man so it's a continuous movement. Then I thought the other one is over there, I must get her back to him, so I had her come and do the gesture over him, and I thought, what if she is down over him? So I tried it myself, just did something of the kind and said to Catherine Kerr, 'Go and try it with Joe [Lennon]'. She went and, bending over him, she turned her head so that the side of her face touched his chest and I thought, that works very well, but it isn't as though I set out to make an intimate connection. It just came out that way.

J.L. What's marvelous is the way you have twenty things like that happening at the same time.

M.C. The one you spoke about in *Signals* probably came about because I wanted him to face her, stay in a slow tempo, because

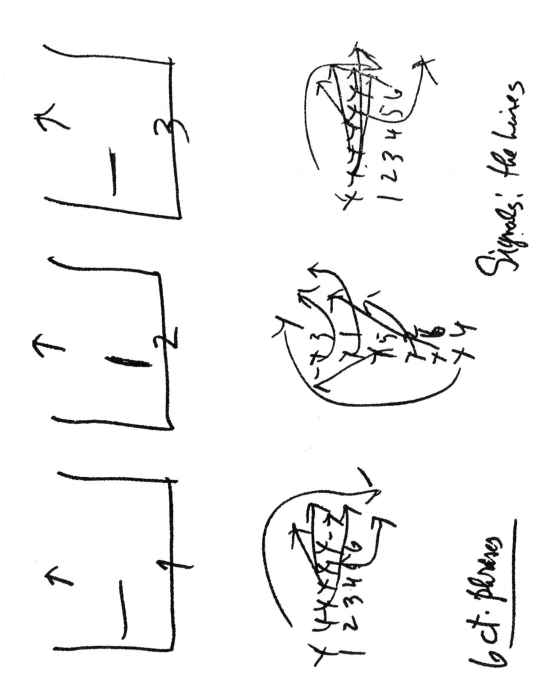

8. *Signals:* the lines

SS

- 3 girls' entrance
7 man's "
- 3 girls' phrases
girls' solo
7 man's entrance
2 "'s "
3 girls "
4 " exit

SS

CB/ Annemarie Sorgin / Ellen O'Reilly
VF/ Ilene Strickler / Judy Shoaff
BL/ Leslie Woods / Katherine Anderson
SN/ Elaine Bauer / Desirée Alinova
MC/ Tony Catanzaro / Woytek Lowski
AR/ David Brown / Mark Johnson

Boston
X/14/74

[SS - 2 hrs]

Larry Robertson
Clyde Nantais

II

Nov. 1974

13 14 15 16 17 18 19
20 21 22 23 24 25 26
27 28 29 30 31 1 2
3 4 5 6 7 8 9

WB

Ellen O'Reilly / Judy Shoaff
Stephanie Moy / Ilene Strickler
Kathy Devlin / Janine Duffin

Tony Catanzaro / Clyde Nantais
Alphonso Figueroa / Danny Murphy
Larry Robertson / Ken Cunningham

WB X/15/74

CK/MH auto 4 slow turns [WB-2 hrs]
VS/ 2 men into fast turns
people pile into slow
SH/C & 2 men. fall + carried

1 girl solo (CB)
1 man entrance - exit
2 girls' entrance - exit
1 girl's solo (VF)

X/16/74

[SS - 2 hrs]

VS/ 3 m [at figure] X/17/74
MH/CK [at figure] [WB - 2 hrs.]
SH/C 2 men [carried across rear sky]
MH/ DK [close]

9. *Summerspace, Winterbranch*: Boston 1974

the next thing, they would start to move together. *Signals* is really like a little traveling group of players that come out, place their chairs, sit down and do their parts. We've danced it in many places. Each has a kind of role, each does his little thing, then they pick up their chairs and leave. In fact some sit and some go away. I had an idea about a set that was really picked up chairs. It could happen in a French park, or in a theater, so working at it, I tried to think of something that you could do in a very simple circumstance. *Signals* is also an example of a piece that could change. The moment with the man with the stick: originally I had wanted it to be a quartet as it is now. When I was first making it, Mel Wong who was holding the stick, was to pass it from time to time to me. Valda Setterfield was the girl in it, she was so nervous about the stick – 'If you get hit you get hurt' – so I stayed out of it to make it simpler. Then eventually when I gave Mel Wong's part to Chris Komar, I remembered what I had originally planned, so that now there are two men who pass the stick back and forth.

J.L. These games have an almost maleficent aspect, it's playtime but this way of dividing the partners, separating, interfering in unexpected ways, is not so innocent. At the end of Signals, *you seem to have rhythmically structured a whole movement based on a loud breathing made by one of the men.*

M.C. In fact, the rhythmical movement came first. The men start the specific movement and the girls come to it. Well, we couldn't figure out how to cue it, so the girls would know when to come. So I said I'll make the signal and I remember thinking and trying a number of things. And I thought, 'Oh!' saying it with a nasal sound. Well, I took it as the signal for that part, and it works well except you have to make the sound on the intake of breath.

J.L. At another moment, you play with all the various ways that six dancers can disengage themselves from a line they've formed, in various directions, ways and angles, several times and in various rhythms.

M.C. In fact, four times, once a flat line and a diagonal line, then a flat line and another diagonal one, then they go over here

and make squares, and in a slower rhythm, in six instead of the faster sixteen and twelve of the beginning. I wanted at first to give each of the six people something different to do; but since I wanted to make them change places when they formed the line again in another direction, I asked them all to learn all the sequences. It was quite complex to arrange ... Still, there are those rhythmic units when they do those small rapid things with their feet. Then they enlarge the movement and go back and forth, then the tempo's fast and it's a different count, you have to keep juggling back and forth.

J.L. How do they get to that change of rhythm constantly?

M.C. Practice. By doing it. Nothing else for it.

J.L. But that's why the classical dancers find it so difficult, changing rhythms like that. How could they do it easily?

M.C. I think a good dancer could do it once he accepted it, and learned how to deal with it. It's not that complicated.

The Dances II

Even with all this preparation, however complex it is, if it doesn't become dance, *then it's meaningless.*

J.L. RainForest: *The choreography is beautiful, strange, there is something muffled about the movement, and Barbara Lloyd, who was the first one who did it, was especially beautiful in it.*

M.C. Yes, it's a character dance and since such a dance is made specifically on a given body, its flavor changes sharply when some other dancer takes over the part. You know about the pillows: I saw Andy Warhol's pillows in an exhibition and I thought they were marvelous and asked him about the possibility of having them as a set and he agreed. They are silver in color and filled with helium: each of those at the back of the stage is tied to a fishing line with a weight on the floor to keep it from disappearing into the flies, and the ones that are loose are only half filled with helium, sometimes they go up anyway, but they can move freely and not necessarily disappear. We like them to give as much as possible the sense of moving; they need not stay still. In fact, it's like a landscape. In a rain forest, there is always something over your head, the sense of something up there from which the rain is dripping. There are rain forests in the northwest. I thought that the pillows would give a sense of space since they're not fixed. For the costumes, Andy had no idea except nudity. That was not possible for the vigorous movements I had choreographed. So I said to Jasper, 'As if skin were torn', and Jasper cut small jagged holes in our flesh-colored leotards while we were wearing them. Carolyn said that she wanted Jasper to do hers so that she would have an original Jasper Johns ...

J.L. *The very slow duo at the start with you standing and the girl at your feet and another man arriving, is especially beautiful.*

M.C. The piece suggests a little community of six people, but you only see two or three of them at a time.

J.L. It's quite slow throughout, isn't it?

M.C. There are quick things, but they are soon dropped, and something slow happens out of it; there is a fast duet, but it doesn't last very long. Mostly it has a sense of moving slowly as the pillows do.

I was working on *Walkaround Time* during that same period and I was shifting gears as much as possible from one piece to the other ... *Walkaround Time,* which had more people in it, was probably one of the reasons why *RainForest* has fewer.

Walkaround Time is my homage to Marcel Duchamp. When the idea came up about using *The Large Glass* for a set, I began to think about Marcel. I wasn't going to do something imitative, but it was going to be my reactions to him; I didn't think I could do anything else. There are many personal references to Marcel in that piece. There's one part of the dance where I'm at the back and I change my clothes running in place, because he was so concerned about motion and nudity. Then I knew the objects that would be *on* stage would be transparent although I had no idea how big they were going to be, because I never saw them until the day before the performance; but I knew that we could certainly be seen behind them, so I kept that in mind.

Marcel Duchamp had consented to the idea of having a set made from *The Large Glass* as long as Jasper Johns would be the one who would do all the work. He did go to see what it looked like while Jasper was making it, and the only thing he asked was that it be assembled at one point in the dance, and I said certainly, so I did it at the end. The idea of the middle part, the entr'acte, comes from *Relâche,* where there is an entr'acte, with a movie in it. I wanted to make a long piece so I wanted to have an entr'acte, so to speak, to break it up in the middle. The entr'acte lasts seven minutes.

J.L. I would have said it was only two or three minutes. There was also some woozy music on while the dancers relaxed on stage.

M.C. Well, they would change the music every time. Once there

was even a recording of somebody, in Japanese, singing 'Parlez-moi d'amour'.

The whole piece is 49 minutes, two parts and the entr'acte. The set consists of the seven objects of the *Glass*. They limited very much what one could do in the space; it meant that all of your traffic had to be lateral from one wing to the other. Two of them were hung from the flies. Three were placed in fixed positions, being moved from these only once near the end of the dance. The remaining two objects were relatively small and easily moved. There were originally eight dancers, and that was never changed. The music is by David Behrman. There is a movie of it, made by Charles Atlas.

Walkaround Time was made also with Carolyn Brown very clearly in mind, the images she produced. The solo she danced in such a luminous way was central to the first half of the work. There was one movement she did, which I had not choreographed, but knowing Carolyn, I realized it was there for a reason, not decoration. I watched and understood. She needed it to support herself getting from one complicated balance to the succeeding one. It came out of necessity. It was beautiful and expressive.

Canfield, made in 1969, is a dance that in its entirety can last one hour and fifteen minutes. It is comprised of 13 dances and of 14 others that I call 'in-betweens'. The title is from the game of solitaire. While playing it one summer day on vacation in Cadaquès I decided the procedure could be used for choreography. The various components of a deck of cards were allotted to aspects of dance. To each of the fifty-two cards I related a word that implied movement, for example, the Queen of Spades indicated leap; the Ten of Diamonds lurch; the Seven of Hearts bounce, continuing for all fifty-two. Then I used the idea of thirteen cards in a suit to indicate the number of dances comprised in the whole work. To red and black were allotted fast and slow. When two or three face cards came up in succession, they referred to the possibility of duets and trios.

I played the game to find the continuity of movements for each dance, thirteen games in all. Each time a card was placed it opened up different possibilities. A card game seems to me to be a formal procedure, the rules and continuity of playing being

1) 2 ♡ tilt - fast ♦ 4 ◊ walk - fast 7 ♡ bounce fast 5 ◊ | V⁵ Deal ~fast
2) ◊ ♡ brace* - " A ◊ twist - " 4 ◊ arch slow ◊ | ~cat - fast
3) J ◊ pull - slow ~8 ◊ jump slow 8 ♡ kneel ~42 ~" | curve - "
4) K ◊ lope - " 6 ◊ perch - " 6 ◊ bow - " 8 ◊ | ~ensemble - "
5) J ♡ stretch - fast ~J ◊ slide fast J ◊ wriggle A ♡ | swoop slow
6) A ◊ drag - slow ◊ ◊ leap slow 2 ◊ brush* 5 ◊ | tiptoe - fast
7) 9 ◊ lean - " 5 ◊ extend fast 0 ◊ swing 5 ◊ | drop slow
8) 4 ♡ rise - fast 10 ◊ stumble slow 9 ♡ bal.* 9 ◊ | push - "
9) ◊ ◊ sway - slow 3 ◊ glide " 7 ◊ leap 2 ◊ | bound - "
10) K ◊ sprawl fast 8 ◊ kick fast 6 ◊ crawl 7 ◊ | dash - "
11) A ◊ kneel* slow 9 ◊ bal.* " 6 ◊ collapse K ♡ | shuffle - "
12) K ◊ sit - " 10 ◊ birth " 10 ♡ reach fast ◊ | run - fast
13) 7 ◊ fall - fast 3 ◊ skip " 3 ◊ float 3 ♡ | turn slow
 | lop - fast

1 person less than whole company visible

leave 1 category out each move off Ent.

1)	3	2	~total~	X (1)	/
2)	X	1	7	1 (1)	yes
3)	6	X	2	1 (1)	/
4)	2	4	X	3 (1)	//
5)	3	X	1	5 (1)	/
6)	6	2	1	X (1)	yes /
7)	6	2	X	1 (1)	/
8)	3	4	2	X (1)	yes

10-13. *Canfield*: list of movements

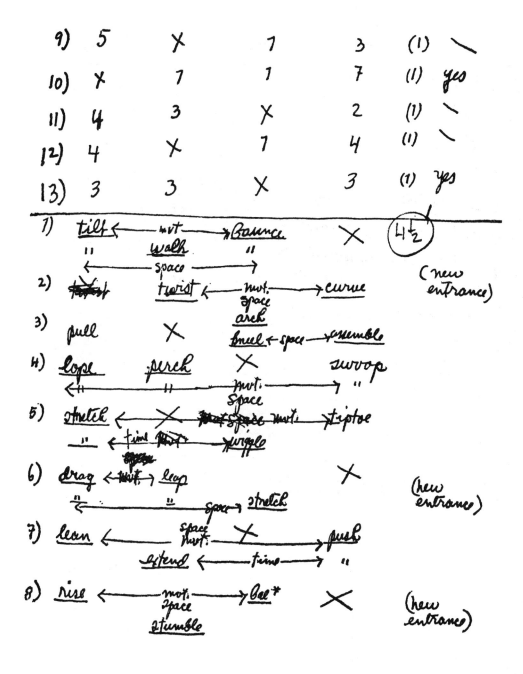

9) 5 X 7 3 (1) \
10) X 7 1 7 (1) yes
11) 4 3 X 2 (1) \
12) 4 X 7 4 (1) \
13) 3 3 X 3 (1) yes

1) tilt ← —— mvt —— → Bounce X (4½)
 " walk "
 ← —— space ——

2) ~~twist~~ twist ← —— mvt. —— → curve (new entrance)
 space

3) pull X arch kneel ← space → assemble

4) lope perch X swoop
 ←"———"——— mvt. ———→ "
 space

5) stretch ← X ~~space mvt~~ mvt. → tiptoe
 " ← time ~~first~~ → wriggle

6) drag ← ~~mvt~~ → leap X (new entrance)
 " ← —— "—— space → stretch

7) lean ← —— space mvt. —— X —— → push
 extend ← —— time —→ "

8) rise ← —— mvt. —— → Bal* X (new entrance)
 space
 stumble

9) X <u>beat</u> ←mot.→ <u>dash</u>
 <u>sway</u> ←——— space ——— " ——— "→

10) X <u>kick</u> ←——— time ———→ <u>shuffle</u> (new entrance)
 " ←— space — <u>crawl</u> ———→ "

11) <u>silent*</u> <u>bal*</u> ←——— X —— space —→ <u>run</u>

12) <u>lie</u> ←——— X ——————— space ——————— <u>turn</u>
 <u>reach</u>

13) <u>fall</u>←mot.→<u>skip</u> X (new entrance)
 " ←——— time ———→ <u>hop</u>
 " ←——— " ——— space ———→ "

<hr/>

<u>Example:</u> 1) (mot.) 3/ <u>tilt</u> ←mot.→ 2/ <u>bounce</u> (1) f. CR.
 fast (mot.) <u>faster</u>
 "/" (mot.) (fine 4/<u>walk</u>) 1st entrance
 (fast)

2) (m) 1/ <u>twist</u> ←— mot.— 5/<u>curve</u> (1) m. CR.
 fast space fast

 (mot.) 7/ <u>arch</u>
 slow
3) (6) 6/ <u>pull</u> (m) 2/<u>kneel</u> ←space→ 1/<u>assemble</u> ? (1) m. CR.
 slow fast fast

4) (f) 2/ <u>lope</u> (mot.) 4/ <u>perch</u> (1st m) 3/ <u>scurry</u> ? (1) m. CR.
 slow slow slow
 ←——————— time ———————→
 space

5) (word) 3/ stretch (sway) 5/ tiptoe (1) m.
 fast ← mvt. → fast CR
 " ←————— time ————→ 7/ wiggle
 slow

6) 6/ drag ← mvt → 2/ leap (M) MC? exit ↗
 slow slow entrance — (1) m.
 ←————— space ————— "→ 1/ stretch
 slow

7) 6/ lean ← mvt → 1/ push (1) m.
 slow space slow
 2/ extend ← timing "
 fast exit
 entrance (1) f. MH

8) 3/ rise ← mvt → 2/ bad (+ ft)
 fast space fast
 4/ stumble entrance (1) f. MH
 slow

9) 5/ sway ← 1/ look-space-3/ dash (1) f. MH
 slow slow slow

10) 1/ kick 7/ crawl 7/ shuffle " ← mvt → exit
 fast slow slow (not together) entrance (7) f. SHC
 ←——— space ———→
 " ←——— time ——— "

11) 4/ silent (other 3/ bal (left)-space-2/ turn (1) f. SHC
12) slow than 2 st) arm (M) MC?
13) ←—— space —→ 1/ turn 1/ reach exit (1) f. SHC
 3/ ... ← mvt → 1/ skip slow fast entrance (1) m. MC

rigorously set. But in between each game there is an informal, relaxed moment. So I made 14 'in-betweens'; one to begin the dance, the others to go just after each game, the last one to be the finale of the piece. These are less complex, involving repetition, and in several of them the dancers are given freedom as to where they go in the space, how often something may be done, and the possibility of exiting.

Canfield had a set by Robert Morris, a narrow vertical gray bar within which lights were fixed, that moved horizontally from one side to the other across the front of the stage, back and forth during the whole dance. The lights were fixed within the bar and moved with it, sweeping the stage slowly, spotlighting the space and the dancers.

J.L. Isn't that very disturbing for the dancers?

M.C. If you looked at it, it would be, because it is a strong light but you just shift your gaze. The bar went back and forth throughout the piece, and depending upon the size of the stage and the length of the dance, it would do this any number of times.

J.L. There was no other lighting?

M.C. Yes, there was general illumination of the stage, but as the bar passed, the lights within it shone on whomever or whatever happened to be in front of it. The side of the bar the audience saw was gray. Originally the costumes and scrim were luminescent gray; they were coated with a kind of paint which would reflect the light. Gradually that disappeared because we had to keep on washing the costumes.

Scramble was originally made for the stage, but we've given it in other spaces. It works very well in a gymnasium. (laughter)

It's a dance that's made up from eighteen separately choreographed sections not all of which are necessarily used in any particular performance. The overall length is around twenty-eight minutes, and when it is presented usually the length is about twenty minutes.

The sections have names. There's one that is called 'Fall/Leap' in which one dancer runs and falls followed by a second dancer who leaps over the first, and succeeding dancers repeat this until

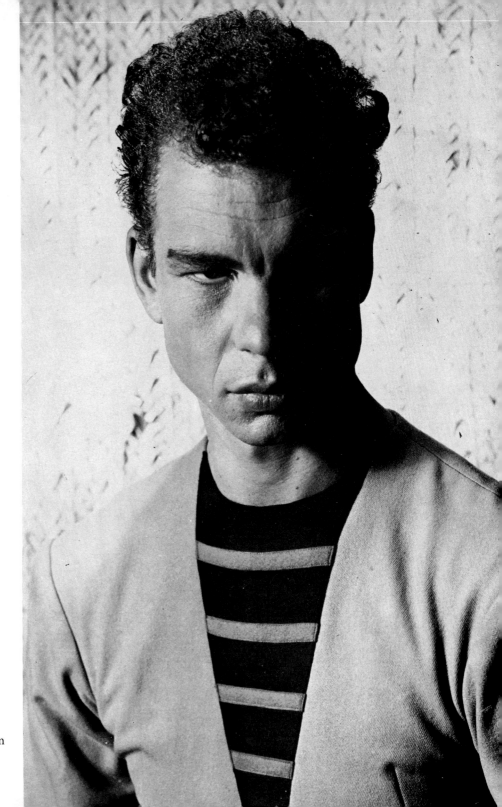

1. Merce Cunningham

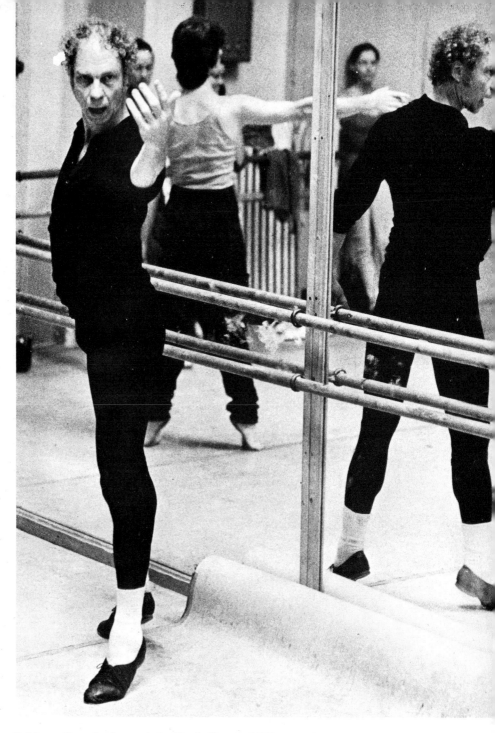

2. Merce Cunningham at the Paris Opera, 1973

3. Merce Cunningham at Black Mountain

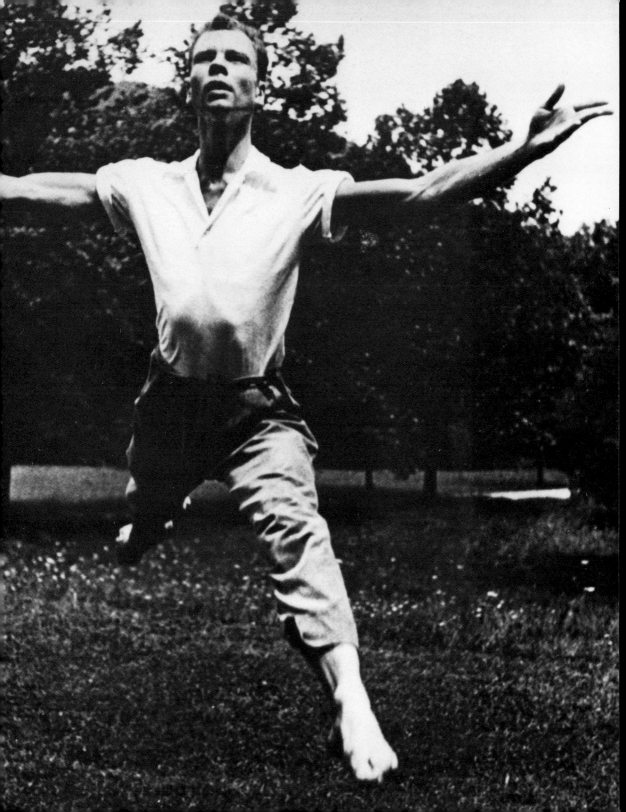

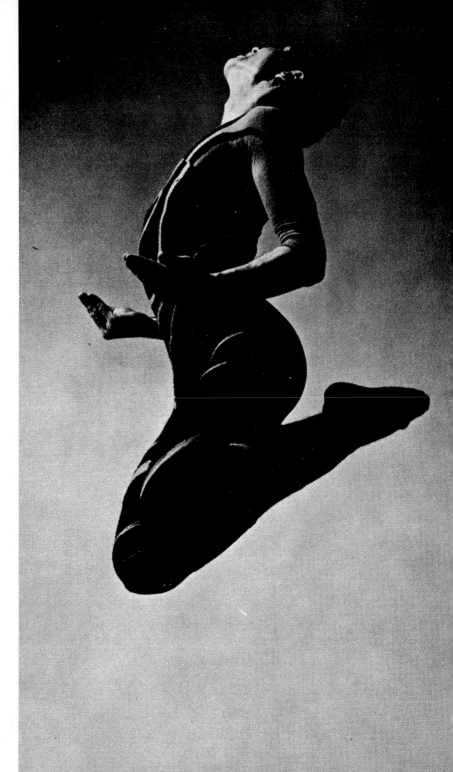

4. Merce Cunningham in
Totem Ancestor, 1942

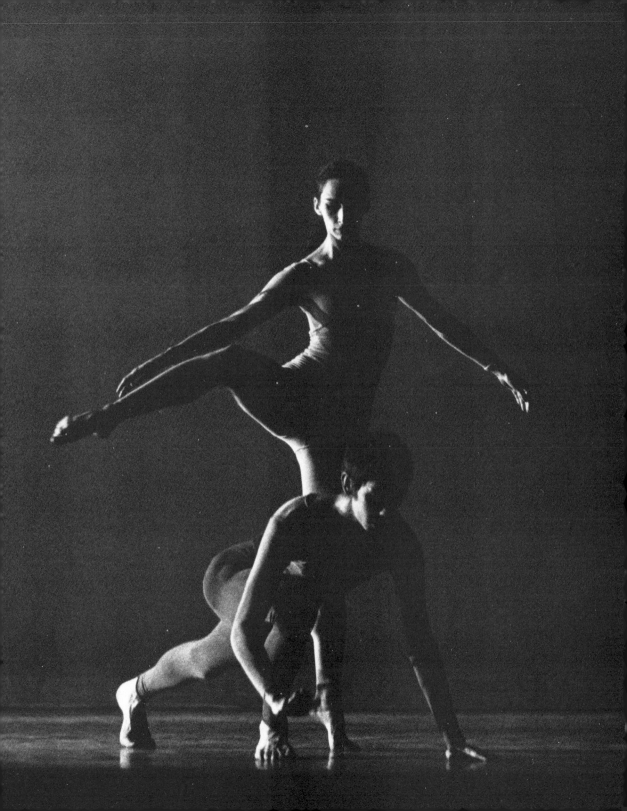

33. John Cage, Merce Cunningham and Robert Rauschenberg

35. Merce Cunningham touring with the Company

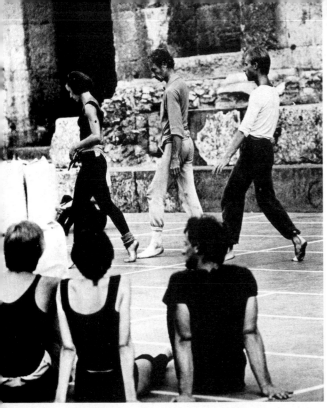

34. Rehearsal of *Squaregame*

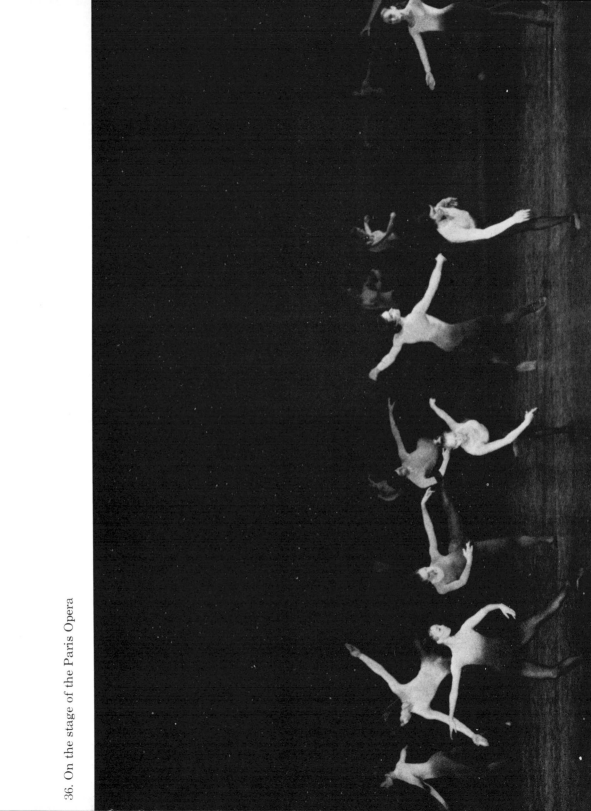

36. On the stage of the Paris Opera

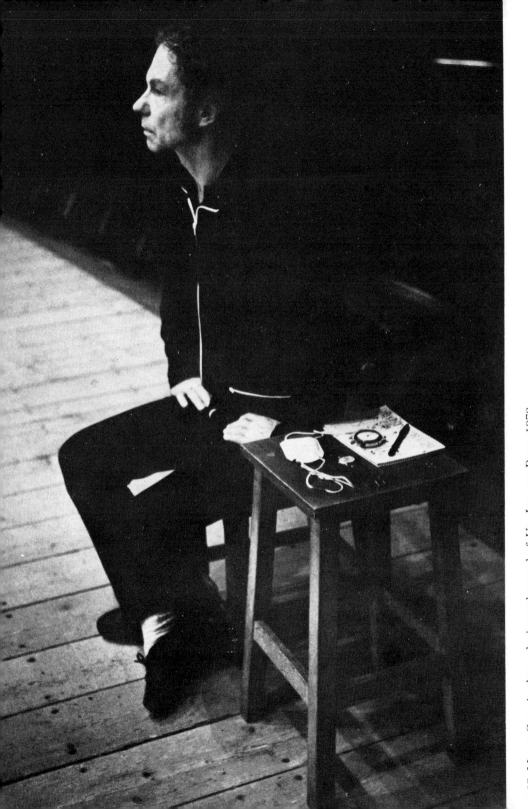

37. Merce Cunningham during rehearsal of *Un Jour ou Deux*, 1973

Ph. Penny-Brogden

38. Merce Cunningham

everyone in the company has done it. There's a trio we call 'Slow Trio' with three women that takes four minutes; it has slow, drawn out phrases of movement in it.

Originally there were nine dancers in the work. So, for a section called 'Separate Movements' I made nine different short sequences, slow in tempo, one for each dancer. The dancers repeated their individual movements through the space, each like a separate animal crawling or moving slowly. Later, as we began to do sections of *Scramble* in Events, each dancer learned all nine movements and then was free to go from one to another of them in any order he or she chose.

Scramble has to do with flexibility in time as well as space. Say we were doing it in Westbeth, [Cunningham's Studio in New York] I tell the dancers, 'Move it through the space until you get to the mirror and then stop.' And it doesn't matter if they don't get there together. The directions they take while doing the movements are free. They start from a point and end at another one. But they don't have to go in a straight line.

In another section in *Scramble* called 'Fast Dance,' there are rapid sequences which they all know. It's been done in a number of ways, sometimes one dancer doing it, sometimes two or three. They may enter and exit during it, but in general it is danced by all of them.

With the 'Separate Movements' I don't have to worry about the dancers' position in space. I can say, 'You start here and end there,' and they will take care of themselves. With 'Fast Dance' I must tell them where to go in the space or they must make the decisions themselves about space prior to dancing it. It must be rehearsed clearly, otherwise there might be a collision.

J.L. In Scramble, *you can change the order of 'Separate Movements', 'Fast Dance' or the other ones?*

M.C. Yes, the order is different each time the dance is given. Also within certain sections we change the directions, if the dance space is large enough, and if, as sometimes happens, the audience is on several sides.

J.L. Is that very difficult for the dancers?

M.C. It's not that complicated. It's just that in the course of a

complex dance, if you have learned it facing in one direction, and you are asked to face in a different direction, all the relationships to outside points are changed. We ought to think less of points outside us, and more about where we are, separately, each one of us, and then be able to shift direction at any moment.

There are two ideas about space I find useful. One is to be clear about where I am at any given moment in the phrase, and to which point in the space I may be going, and the second is how I am facing as I move to the next point. This arises from the fact that instead of facing in the direction I am going, it is possible to face in any other direction. You might, for instance, go backwards. If you compare *Scramble* to *Torse:* from a formal or structural point of view, *Torse* doesn't change, it stays the same. We may do only one part of it, but the continuity remains the same. Second, the density of *Torse* changes very much because you have one group, and usually two, doing complex dance sequences. In *Scramble,* within a single section, the density doesn't change at all. Even when the dancers are doing 'Slow Movements,' you begin to perceive quite quickly what each dancer is doing, and after a while, you can begin to follow each one, you begin to see what the movements are. *Torse* is far more complex in that way. You have to pay close attention at any one time just in order to see what movements are being done.

Scramble has a set by Frank Stella; stretched canvas banners on metal frames fitted with wheels so you could move them around. The problem was that they were so big or so high, that often we couldn't use the tall one in a theater. But they work marvelously in a gymnasium, because there the space is totally free, and they are easily moved. They invade the space but don't fill it because they're two dimensional. There were six of them, of different lengths and heights and colors: purple, blue, green, red, yellow and orange. The tall one, 16 feet high, was only four feet wide. If the stage was small, I had to group them together like a backdrop but in a gymnasium they could be moved freely.

J.L. When Frank Stella did it, did he know of your idea of breaking up the continuity?

M.C. I only asked him if he would do a piece, and he agreed. He went away and eventually brought back a model, a drawing and

said he thought it could move. I was already working on the dance, so I didn't change it because of that, but it seemed interesting.

J.L. How did you make it fit with the different sections you had already when you and the dancers had to move the pieces?

M.C. It has to do with coming into a situation and not deciding ahead of time what you're going to do. If the stage is too small, I move them very little. If it's adequate, then I figure out how they will be moved for that particular performance, which of the dancers will move them, and at what points in time, either at the ends of sections or sometimes in the middle of them, the changes happen. The music, which is also indeterminate, is by Toshi Ichiyanagi.

I did *Sounddance* in 1975 after returning from nine weeks at the Paris Opera where I made *Un jour ou deux* for the dancers there. The work had been so difficult, and trying, that when I got back to my own dancers, it was like an explosion, a tremendous release. I felt like doing something vigorous, fast, complex. The title is taken from *Finnegans Wake:* 'In the beginning was the sounddance.' The rehearsal room at the Paris Opera had been very small. I felt like doing something in the same type of space, something compact, in which to keep up the energy level constantly. It's a very strenuous piece to dance though it takes only seventeen or eighteen minutes. The entrances and exits take place through a tentlike opening in the back, in a canvas decor. At the end, the dancers are swept back into it, as though into a wind tunnel.

The movement itself follows from the fact that the classical dancers had been so rigid, so straight in their bodies. I wanted a lot of movements, twists in the torso. Don't be surprised, if you find it difficult to find words to describe those movements. The situation is very like it was when the musical vocabulary had to free itself from Italian. The ballet vocabulary comes from a time when the torso wasn't used at all. For example, when Margaret Jenkins wrote down *Summerspace* in the Laban notation, certain things in the dance weren't there because they weren't in the notation ...

Sounddance has ten dancers. Unfortunately my notes for it

are not good, but there is a video.

The structural idea is to have the ten dancers enter and exit from upstage center in different ways, one after the other. The footwork and torso movements are complex. The general impression is of a space observed under a microscope.

The music is by David Tudor, sustained and powerful. It's an electronic music that provides a charged environment. The costumes by Mark Lancaster are light yellow and gray, his decor across the back is tent-like and sand colored.

Rebus is a dramatic dance lasting thirty-one minutes, with me as protagonist, in opposition to the young dancers of my company acting as a chorus.

Because of this difference between me and the dancers of the Company, not only in *Rebus* but in *Quartet* and *Gallopade,* and even in *Inlets* and the *Events,* I am obliged to spend more time in rehearsals watching their work and answering their questions than in practicing my own parts. It becomes increasingly difficult, as I grow older, for me to dance with them as one of them. As a matter of course a separation happens.

Rebus was made just before *Torse.* The music is by David Behrman. The costumes, by Mark Lancaster, are tights and leotards with splashes of color on them. I wear a gray shirt and brown pants with brilliant red unitard underneath, and at one point in the dance, I take off the shirt and pants to reveal the red unitard.

The structure is made of a number of long sequences with quite long rhythms; some of them go all the way to seventeen. That was a suggestion by Pat Richter, the pianist who used to play for our class every day, and who observed me trying out these long phrases. I asked her what the rhythm would be the next time, and she jokingly said seventeen. So that's what it was the next day.

J.L. That's almost like a raga.

M.C. Yes, in a way. The dance emerged from working on these long sequences.

Squaregame was finished while we were on tour in Australia. They had asked me to make a new dance. The idea was to define the space, as the title suggests, a sort of arena, with four stuffed

duffle-bags. The situations are very playful, on what seems to be an athletic court where there are participants who can also stop and watch. The dance starts with a quartet, there is also a trio, another couple of quartets. I worked on it during the tour, which I had never done before. I never was quite happy with such a situation, because it was not a comfortable way to work, given everything else I had to do, and the general fatigue and rigors of touring. And it was not finished when we arrived.

J.L. I remember a lovely duet in front with you and one of your dancers.

M.C. Susana Hayman-Chaffey danced it first. It has also been danced by Karole Armitage and Catherine Kerr. There was a lot of moving from upright to sitting positions.

The music is by Takehisa Kosugi. The decor, by Mark Lancaster, is a white floor surrounded by bands of green lawn-like material. The light shining on the white floor is reflected into the house in such a way that the audience is visible from the stage.

Fractions started as a dance for video, and wasn't changed much when it was done for the stage. *Locale,* on the other hand, was changed quite a lot when it was made over from video to its stage version. In making the video of *Fractions* in Westbeth, the space presented certain limitations for taping. The studio is not equipped for television. On the other hand, the dance space was better than most television studios. There were exasperating limitations. We had to push so as to get results; but sometimes these very limitations would provide you with unforeseen possibilities. The taping was done with three cameras and several monitors. It starts with black and white and gradually shifts to color. One limitation was that the cameras could not be focused too high or they would be in the glare of the lighting, since the ceiling isn't as high as in a television studio.

I'm told the tape is not of broadcast quality, but the use of the camera is much more interesting than most of the things you see on television. Where the camera can jump from one dancer to another, on stage you have to find ways to segment the movement differently. And with a camera, the dancers can go off in a forward direction, past the camera, whereas on stage the

exits have to be to the sides or to the back. That changes the movement; it changes the look of the dance, it changes the expression. The title refers to the play of one group of dancers against another. The dance breaks up, it's fractile.

Energy and positions, clarity of
the dances

J.L. The transition from one position to another seems to you the quintessence of dance itself. Is it the impetus of dance that is clarified in positions, or is it the dance positions that dissolve into movement?

M.C. In ballet, about two centuries ago, the positions were very clear, and probably came first.

J.L. I wonder whether the positions in the old language of classical ballet didn't come as a means of getting some fixity (fixed points) into something that was going too quickly.

M.C. I think in court ballet, it must have been positions that were established in the beginning. In folk, or country people dancing, it's the dancing. I mean they have steps to do, but it's the act of doing it, the dancing, however simple or elaborate it may be, that is most important. But in court dancing originally it must have been positions.

J.L. Two different choices: either you make positions and go from one to the other, even dancewise as you say, or you emphasize the energy and the movement, and somehow the positions punctuate it.

M.C. Yes, of course. The trick is to keep them both. They oppose each other but that's what makes them valuable, that's what will keep it lively. If you emphasize activity, steps, a lot of movement, but the *clarity* of the positions is not very great, that isn't very satisfactory. Now, if you keep that energy *in* it, clarify the positions more at the same time, that is especially interesting. Ordinarily what happens is that one or the other begins to get lost. The basic thing about dancing is the energy, and an amplification of it which comes through the rhythm, and if you

lose that you end up in decoration.

J.L. But the energy in dancing, if you look at it through a magnifying lens, you can see it as a series of positions being undone.

M.C. Yes, of course.

J.L. It's a double, antagonistic movement: on the one hand this impulse to undo your position and on the other hand, another impulse to recognize something, fix it in however fleeting a position.

M.C. Isn't that the way life is?

J.L. But if one keeps in mind what you said about the fluidity of dance, it's rather the flow that takes over.

M.C. Yes, you must know how to let go. Produce the rhythm; canalize the energy and sustain it; achieve the positions. It's like constantly trying to *balance,* that's what can be lively in it. Taken alone, none of the three is sufficient. Instead of just thinking: this one is enough, or this one is better, to see that all three are essential and to be considered both separately and at the same time. For example, when we do *Scramble* and we change the order of the sections, what happens to the shapes, to the rhythm, to the energy and the positions? It's a thing that as a dancer you have to constantly concern yourself with.

J.L. That's what dancers sometimes feel is so difficult. Because they have the feeling that they are made to be transported by something larger than them. And when choreography gets complex, the ease and flow of movement is not allowed to happen.

M.C. And yet, in classical dance, in the lyrical movements of classical ballet, when you know perfectly how one thing flows smoothly from another, it might be the effect of time that has made it clear; it might be that when it was first devised as a duo or as a piece, it seemed extremely hard to get from one thing to the other.

J.L. At a given historical moment, there are dance movements,

like swimming strokes, that follow the current and seem easy, and others that seem to go against.

M.C. When pieces are new, when someone makes a piece which is unfamiliar - aside from unfamiliar movement - for instance unfamiliar ways of going from one thing to another, both dancer and choreographer have a chance of finding out something. The instant it gets known it loses its life. So that if you are a performer you must try, constantly, to make it difficult for yourself. I don't mean just technically. It is something about being awkward, that I've already mentioned. That may not be the right word for it, but it's a word that I use all the time. You have to make the movement awkward for yourself, as though you didn't know how to do it, so that when you come back to it, it can be lively again.

When the dance is new (even if it's in a familiar idiom, a classical ballet), when the dancers don't know it, it often has a kind of awkward life, like a colt. As they begin to find ways to do it, it begins to slightly lose its edge. We spoke of *La Bayadère*, and of the famous entrance of the shades. If you see it done in a flat and heavy way, you have every right to feel frustrated. For a similar reason, I feel I have to fight to keep the specific quality and the vigor of each dance so that the spectator really gets the experience he might have.

J.L. You first gave Changing Steps *to the Théâtre du Silence, a company that has a way of living and working completely different from yours. What happens when they undertake to do one of your pieces?*

M.C. Okay! When the Théâtre du Silence, Brigitte Lefebvre and Jacques Garnier at the time, asked me to do a piece for them, I could have said 'No, I won't because you won't do it the way my people do it or the way I think it should be done.' I'd rather say, 'Well, it might be interesting. Not necessarily for anybody else, but it might be interesting for me.' So I say yes rather than no. Then I was confronted with the situation of working with ten or twelve dancers whom I didn't know very well. I knew they were classically trained dancers, some of them, some of them not. I saw them for a very short time. Chris went to teach them the

steps, which he did remarkably well. He's such a good teacher that way. When I came to Paris and watched them do the dances, I could see that they knew exactly what the steps were. Their spirit was different, the way they move, the shape of an arm was different. Even though they did what Chris said, their sense of rhythm or how you go from one step to another, their training had all been different. I tried to talk to them. It's in a language I don't know very well, so that I would do the step and when I got up to demonstrate something and put my arm up, I could see the consternation on their faces and so I immediately said 'If Chris gave you a different arm than I give you, do what Chris did.' (laughter) I was trying to get them to do something about the spirit, so to speak, and I would naturally have the wrong arm or foot.

I know they wouldn't do it the way my company would, it's not possible for them, they're not what we are, so I accept what they do, at the same time it's like this idea about energy and shape. I try to bring them together as much as I can. Now I think – I'm guessing at this, of course, but now that they have performed it a little bit, if I go back and rehearse it – it would be easier because they begin to know more about it, even if it's off the mark.

J.L. One journalist who reviewed their performance noticed there was a choreography *there, totally different from their other pieces, which is remarkable.*

M.C. As it is, they were so rigid about it, about the whole idea, of being free, that was so terrifying.

J.L. Still, that's very nice to feel so strict about the idea of being so free. (laughter)

M.C. But they were! Now I think that I could convey a little more to them. I know it's not going to be like what we do, but I don't see anything wrong with that. Once they do it, it's what they do. I would try to help them in any way I could. Several parts of the dance interested me because they did it quite differently than my dancers do it, different accents came out and yet they hadn't changed the steps. I thought, that's interesting, it's something I had never seen in the dance, and there it is. They hadn't added anything but they'd just come into it a different

way. And that's all right, there's nothing wrong with that. I don't expect one flower to be exactly like the next.

J.L. There is a special kind of energy that shows in your dancing. It can be clearly seen. I remember in the Paris Opera, seeing a class and you in front, all those Paris dancers in the back. Now I remember your telling me that dancing is mostly doing several hours of dancing each day, but when one looks at those people who do hours of dancing a day, and at the kind of energy your dancing develops, one wants to ask you what gives it this specific energy.

M.C. My energy is nourished by motion. That is, thinking that even when one is still one is really in motion, so that one is constantly moving, one does not pose. I use this word specifically because it is a word I often heard at the Opera: 'posé', and it conveyed a static quality to me. Even when we are still we are moving, we are not waiting for something, we are in action when we are still.

I don't know a particular way to do that but I think that if it is to develop, then one develops it by working with that in mind daily, even in class, even in technique class, so that although one comes to positions, positions which must be clear, one does not stay there, one goes on to something else. I think it develops simply, first of all, by being conscious of a possibility of rest, not as rest, but as activity in inactivity, which is like a *koan:* two things going on, so that you are in a sense ready to go, but in a sense going all the time.

One of the things we have now is this enormous technology . . . The immense speed and immense power made possible with technology have given us a totally different idea, from say, the horse, as to how we can move; because with technology, say with going to the moon, you have that enormous movement going on, it's precise yet it's not precise, there is a kind of precise unpreciseness about it which is very different from the idea of metric beat, or metric pulse, or anything like that, and I feel that's very much part of our lives now. Whether we like it or not is something else, but it's just there. It's not that I'm trying to put technology into dancing, but it is one of the elements that exists for us now, and then we should, or I just feel I would like to be

involved with it, that's all.

To come back to a certain accumulation of energy, it keeps on flowing, you have to think that it does, you have to make it keep going, even when you are still.

J.L. How did you realize that was what you were going to lean upon?

M.C. I think there's a process of time, of working. When you do not work to music or to a pulse to push you, you must in a sense push yourself, you must be your own horse rather than have something outside of you be the horse, you must find a way to sustain that, keep it going in the same sense. And you must be precise with yourself at the same time because you have freedom. I think perhaps one of the obvious things that conditions our work would be: we don't dance to a music, it does not push us; we really have to do it ourselves.

J.L. Would that have something to do with a certain American quality of movement? I have the feeling a kind of biography, a kind of experience, a certain kind of life in America might tune into that strongly.

M.C. I think I am as American as anybody else is, as far as that goes, it's possible that in America the climate, by that I mean the situation and everything, conspires to bring this about. Because there are artists and musicians and dancers interested in these new possibilities. New conditions arise that might not have arisen where tradition was stronger. Fortunately for us, or unfortunately as some people may think, but I happen to think it was fortunately, we were not at the time, and I don't think we are yet, pinned by tradition, so that we were free somehow to act in ways that were not conventional. We did not think we had to be bound by certain things, and because of that we permitted ourselves to go along paths that other people might not have thought possible. I have a feeling that what dance needed most was to open up new directions, to explore new possibilities, other than the solution of choreographic problems brought about by classical ballet, beyond the formulae and stereotypes of that tradition. In life, also, we see suddenly that all sorts of things we thought were stable are not so at all, and we can't function that

way any more. In dance as well, that has always interested me and still does: how to place yourself in an unknown situation, and then find a solution, a way out of it; not necessarily the only solution, but a plausible solution. Of course that requires unconventional procedures.

The times we live in force us to rearrangements of all sorts. It's probably like the sixteenth century, when America was discovered, and also printing. At present, electronics has almost changed our mode of thinking. Our daily lives will change even if we're not aware of it, and I'm convinced that that will have many consequences. How can people do all that they do every day in a perfectly natural way and still go to the theater as in the nineteenth century?

It's very likely that the quality of vision is also changing. The eye often picks out what one recognizes. We were playing in a school in New England. There was a little reception backstage afterwards. A girl came, a ballet dancer, and said, 'Your work is just like ballet.' There was a Chinese man standing next to her who either taught at the University or was part of it, and he said, 'Oh no, it looks very Chinese to me.' He was a nice man, and it was not a silly statement. I thought about it afterwards, 'Of course, she sees what she thinks is ballet; whereas he sees other aspects and doesn't see anything about ballet at all.' I realized from that the eye tries to recognize what it already knows. It is like security. Everybody does that. It takes anybody a long time to really see something new. I think of the experience of looking at the paintings of Jasper Johns, the complexity of them. Even though I know them (I think I do), every time I see the paintings again, I see something I hadn't seen before, and I know it was there but I just didn't see it. I think it's the same for dances. It would be different for painting, because a painting could be on exhibition in a given city for one or two months. You might go once and never again, but on the other hand, you might see it several times, and gradually you would begin to recognize it as a painting with which you were becoming familiar. It is more complicated for dances because people don't see them very often to begin with, it passes in front of them and is gone; you don't see it again. If you're lucky to see it again, you see it differently, because dances change.

14–15. *Summerspace*: trajectories

Over the years people have often said to me, 'Why don't you do pieces which are easier for the public first on the program, before you do the more complex ones?' The idea of education doesn't interest me; I don't think that way. Further than that, what they think are the easy pieces, the ones they're more familiar with, were at the time they were made seen differently. For instance, *Summerspace* is absolutely transparent now. When it was first done, at the Summer School in Connecticut, nobody saw the dance, nobody heard the music. It simply passed. There it was going on, among all those modern dances, its turn came and we performed it. Nobody saw it.

J.L. How many years do you think a dance needs to become clear?

M.C. Some dances become clear immediately, you can see them easily. *Summerspace* seemed to me to be always transparent. It was complex for the spectator at the time I made it; now it's simple for people to see. It's not just because it's been done, which is part of it; but also life changes, things change, and people see things differently.

When I danced *Summerspace* with Carolyn Brown, at the very beginning, it was technically difficult, but we began to learn how to dance it. We would tour, we would dance it in colleges, we came to Europe with it. We took it around the world. But we didn't do it often in New York City, perhaps three times. With many of my pieces that was equally true. It has been changing now, of course, we do perform in New York more, and travel much more than we did, but all those early pieces were rarely seen in New York. The New York press paid absolutely no attention to anything I did for years. We would go out the way we could in the United States. We'd drive around in a Volkswagen bus, and present our work in difficult circumstances, mostly on very bad stages, sometimes on good ones, to a public which very often simply didn't know what it was looking at. But happily there were always a few in the audience for whom it was lively. Often they would come backstage to speak to us afterwards. Young people, so often. Once we gave a program in a small school someplace, and the next day I gave a lecture-demonstration, I talked, and I answered questions. A young fellow asked many

questions as if he were irritated by all this: 'Why do you do this? Why do you do that?' I tried to answer, and finally he sighed and he said, 'Well, I'm so glad they brought you. Ordinarily all we are is entertained.'

One reason the dances are particularly difficult to see is that they are not constructed linearly. One thing doesn't lead to another. As a student in dance composition, I was taught that you led up to something, some climax. That didn't interest me very much. I rather liked the idea of things staying separate, something not leading up to something else. The continuity is constantly unpredictable rather than as though you were being led up a path. It makes it harder probably for the spectator to see but that's what I mean about television continuity. All these young kids have grown up with television , they are their own continuity. They jump from one thing to another, and I suspect they can look at our work in an easier way, simply because their eyes have grown up differently. It's not about education; it's simply experience, their experience as children, not only with television but with life. Everything happens so fast that you do have to jump from one thing to another.

Landscapes: 20th century dancing

J.L. There have regularly been attempts in history to try to put together all the arts, to have a celebration of the whole, a kind of totality. In your approach, you call on each art, painting, dance, music, but there is a difference, and quite a fundamental one. Will you make it explicit?

M.C. In most conventional dances there is a central idea to which everything adheres. The dance has been made to the piece of music, the music supports the dance, and the decor frames it. The central idea is emphasized by each of the several arts. What we have done in our work is to bring together three separate elements in time and space, the music, the dance and the decor, allowing each one to remain independent. The three arts don't come from a single idea which the dance demonstrates, the music supports and the decor illustrates, but rather they are three separate elements each central to itself.

J.L. You've described very well the situation you found when you arrived in New York. You had to deal with the cultural situation in which you worked. In dance, it was a kind of accumulation from the past, remnants of things that in their time must have been new and vigorous discoveries, and new approaches parallel to your own. These residues of the past have to be reassimilated constantly by those who are newcomers to the field, now as well as then. The present situation of dance in New York, as in Paris, is both lively and confused. May I formulate a few rough and sketchy hypotheses about what the historical field was in which your work developed? Without going back in time too far, it can be seen as undergoing a succession of waves. By the way, the 'balletomania' of the last few years recalls similar phenomena in the past. I'm thinking of

the enthusiasm of New York audiences for Baryshnikov, very similar to that of Parisian and European audiences for Nureyev fifteen or twenty years ago. The classical ballet that now flourishes in the States first went from France to Russia and then returned spectacularly to Europe in Diaghilev's time. Two world wars and a revolution have directed all that towards America. The New York period of the Ballets Russes de Monte Carlo, Balanchine's career in the States, are direct effects of this. Balanchine made this ballet heritage more American, sharpened it, made it purer, dusted it off (not enough, I think), gave it speed, nervous discipline, and an American allure to the style. It's worth noticing that the fertile and brilliant moments of ballet's history are associated with migrations and with foreign elements and influences assimilated where they arise.

M.C. Yes, it's like new, foreign blood.

J.L. When the wave of the Russian ballet came to Europe, painters and poets were very attracted to it. During the similar flowering and explosion of classical dance in the period before and after the turn of the century, a succession of dancers came from America to Europe and Russia, solitary dancers, mostly women, like Loie Fuller and Isadora Duncan, doing solos, putting themselves on stage, having no consideration for the traditional vocabulary of classical dancing, which for them was already like a dead language.

There is a beautiful book called Les démoniaques dans l'art, *in which Charcot collected examples in paintings of the past, of what is not far removed from the impulse to dance, the expense of energy of a particular kind that you find in popular, folk dancing. At times, this kind of dancing almost acquires a style but mostly it remains local, without consequence beyond being a great pleasure for those who did it and an object of study for amateurs.*

The classical dance language, the classical ballets, have a great effect on audiences, and understandably so. It's a living museum. When it's done well enough it can be very beautiful and it's important to be able to see all that. The Bolshoi came to the Maison de la Culture at Rennes some months ago, and I was told people stayed up all night queuing up for tickets. That's

touching, encouraging, but a little depressing, since what they do now is so worn out, rehashed, hackneyed.

Elsewhere, in the States, Graham has been presented as modern, which I never felt the work was. What she does seems to me a mixture of classical and neoclassical style with very little added that is modern: mainly, it seems to me, the influence of German Expressionism, Mary Wigman in particular. The underlying ideas are quite impoverished and not at all new.

M.C. When I came to New York to join the Graham Company, I had never seen any of their performances, so my first dance impression was formed by the classes that Martha taught and to which her company came.

The sight of Graham moving strong and clear in her demonstrations of an exercise, and the force with which her dancers did the movements, was impressive. Her ideas as to what dancing could be about were certainly not the nineteenth-century ballet ones, and the movements she made at the time were not directly related to classical ballet. The weight with which she herself moved - remarkably clear in the falls she invented - was absorbing to watch. It left me with a vivid sense of the power of human movement.

Her dahce vocabulary was unique, although I agree with you, the forms she used were nineteenth-century, that is, each work built to a climax from which it fell away. Furthermore, the subject of each dance was something that could have been expressed in words, as indeed it was in the program note.

J.L. The modern dancers call themselves modern in opposition to some particular traits of classical ballet, but their works have a content that is not convincingly modern. The forms, the space, the timing have not changed.

M.C. That is because they are not thinking about movement. For me, the subject of dance is dancing itself. It is not meant to represent something else, whether psychological, literary, or aesthetic. It relates much more to everyday experience, daily life, watching people as they move in the streets.

J.L. A word perhaps about the curious relation between Balanchine and Robbins: the Russian line and the American

color. This blend of both in a very official New York City Ballet is amusing: the mixture of the Russian inheritance with a relaxed American dynamism. It is extremely popular, but I must say I think Robbins' choreography is, though very beautiful, quite conventional.

M.C. Balanchine was linked principally and musically with Stravinsky. And he spoke of his connections with Petipa. His point had always been that the music is the basis on which the dance takes place. And his language had always been the classical language as he saw it, inflected it, changed it, and speeded it up. Robbins, whose early work was in musical comedy, has never convinced me in his use of classical forms. He doesn't seem quite comfortable with them. On the other hand, his work in musicals was always excellent. The energy and the imagination were both free and clear.

J.L. If your choreography is hastily and superficially under-stood, and then if a number of musicians and painters group themselves around some dancers, that might give the im-pression of being modern dance, even though it wouldn't necessarily be anything of the sort. No doubt that's unavoidable. What is your feeling about the future of the choice you made of the mutual independence of the music and the dance? Do you think that this is one of the criteria of development in choreography? Young choreographers, who are now at work, have to make a choice about this – or can they avoid it?

M.C. I think it is essential now to see all the elements of theater as both separate and interdependent. The idea of a single focus to which all adhere is no longer relevant. With the paintings of Jackson Pollock the eye can go any place on the canvas. No one point is more important than another. No point necessarily leads to another. In music, the advent of electronics also brought about a great change. The possibilities for both the sounds to be used in composing, as well as the methods of composition, were radically enlarged. Time didn't have to be measured in meter, but it could be measured in minutes and seconds, and in the case of magnetic tape in inches in space. The common denominator between music and dance is time. This brings up a new situation

for dancers. If they are to involve themselves as dancers with a music measured not in beats but in actual time, how to work with it? Many choose to ignore it. I choose to see it as a necessary next step. A number of the contemporary composers were working in this not-metered way, whether they were using electronic sounds or conventional sounds. My work with John had convinced me that it was possible, even necessary for the dance to stand on its own legs rather than on the music, and also that the two arts could exist together using the same amount of time, each in its own way, one for the eye and the kinesthetic sense, the other for the ear.

J.L. It seems to me that the battle over this question isn't over, is only beginning, because for one thing, many dancers are not ready to give up the exhilaration, the elation that comes from the feeling of dancing to music.

M.C. As I said, many choreographers choose to ignore the question, perhaps wanting the support they feel music gives. Recently with several of the young choreographers there has been a use of repetitive music, notably the work of Philip Glass, Steve Reich, and Terry Riley. In the dances of Lucinda Childs, her repetition of movements with small changes in the phrases gives a hypnotic and often beautiful effect. She deals in movement, not movement representing something else, and that is contemporary. Her subject is the dance. The fact that the two, the dance and the music, do the same thing, one repeating the other, suggests the nineteenth century much more than it does the twentieth. I think it is livelier to have more than one activity going on at once, so that the eye and the ear of the spectator are not fixed, but are free to make for each observer his own experience.

J.L. Among the young dancers and choreographers some have opened their eyes to what you've done and try to take up some of its threads; but the fabric of your work is quite complex. And if a young choreographer looks around, he sees your work, Balanchine's, Robbins', Graham's, and the classical ballet repertoire. It's with all this that he can work.

M.C. Well, there are a multiplicity of routes to travel. But I saw

these ideas that were coming up as questions to be asked, to be worked at – that is, in the nature of an adventure along unknown routes. So I attempted to try them out, to ride the horse close to the chasm.

J.L. The danger is to become contemporary in appearance only, in which case the result will be facile and hollow. It fills theaters though. A lot of young companies should be doing new work, but they aren't. Instead of slowly working at ideas and letting them grow, they make use of new ideas as rapidly as they can, without weighing them or carrying them through. You put your work in place by doing it, and I now see the ideas being used but not done, if you see what I mean.

M.C. Even if you take something from someone else, you have to do it yourself. Nobody can bend your knees but you. Someone else can measure the length of your arm, but you have to find out how long it is as it stretches from your back. One of the adventures that I came upon in working with ideas of non-metered rhythms, freeing the movements in time, was how to solve technically the problem of going abruptly from one speed to another, how to do a rapid movement followed immediately by something slow. Dancers had been accustomed to a dance as having a single tempo, a fast movement, the next might be *legato,* another at a medium pace. This no longer seemed the only possibility. One could change tempo more abruptly. So it becomes a technical problem. What kind of exercises to evolve that might be useful for this situation? I assume there are many other possibilities and I try to keep alert.

J.L. What is happening that is new among the young choreographers?

M.C. I enjoy the pieces of Elizabeth Streb. She works within especially constructed physical limitations with an element of risk as a strong factor. One dance is done on a wooden platform roughly twelve-feet square which is constructed on a slant, the top end of the platform being eight feet off the floor, the bottom end resting on it. She discovers and investigates the movement possibilities within this limitation in a continually inventive and vigorous way.

Kenneth King. He has used video imagery and language in conjunction with his dances. He explores the video and word imagery in a way not related to the movement; rather they add separate layers to the whole experience. And Douglas Dunn. I've found his work lively. His own dancing in particular has an elusive character to it. The transitional movements take on a sliding quality that enlivens the rhythm, speeds it up on occasion, at other times allowing it to slur. It gives an off-balance look to the dances.

You see, the multiplicity of directions does a great deal to give the art its present lively state. I always thought you had to attack or question everything. And my own feeling remains the same, that there are many ideas to be explored, a lot of possibilities. At the same time, with dancing we're locked into the fact that it's the human body doing the action. There are two legs; the arms move a certain number of ways; the knees only bend forwards. That remains your limit.

Westbeth

J.L. I find dancers both rather spartan by nature as well as deeply luxurious. The places they have to work in are rarely adequate to their needs. Apart from the last ten years or so in Westbeth – space, light, quiet – I have a feeling that, but for the short periods of residencies at Universities, too often you did not have the kind of space that is necessary. After the 1953 season at the Theatre de Lys, how did things develop from this point of view?

M.C. After that season at the Theatre de Lys, I took a new studio, small but convenient, on Sheridan Square, which I was able to keep without too much difficulty until 1955 because of a Guggenheim Fellowship. I don't think that we had any offers of summer residencies during that time, but we worked on *Springweather and People*, *Minutiae* and I made another solo – *Lavish Escapade*.

In 1955, when we left on a five-week tour, I gave up the studio without knowing what I would find on my return. We went on tour by bus and by borrowed cars, staying over with friends. We went all the way to the west coast.

When I got back I rented a studio by the hour on Sixth Avenue, a beautiful space but badly kept; and three times a week I also gave a class uptown in a theater and dance studio. We would find it full of rubbish, leftover parts of sandwiches, cigarette butts, paper cups, that had to be swept away before beginning. Once a week, every Friday, I took the plane to Boston and returned by the last flight after giving two classes there. We managed to present a few dances. Once, we drove all the way to Notre Dame, in Indiana, to present *Suite for Five* for the first time. At the performance there was practically no one in the audience. All the students had gone to a prom that was scheduled the same night.

The audience consisted of a few nuns and priests and a newspaper critic. When we asked one of the fathers what he thought of the music, he said, 'What music? I didn't hear any music.'

When John won the TV mushroom quiz in Italy he used part of the proceeds to buy a Volkswagen bus, which took the nine of us: him, David Tudor, Bob Rauschenberg, and six dancers including myself. We did a lot of difficult driving, but on the whole we had a very good time, and we met a number of people, some of whom have been fast friends ever since. We did a lot of eating out of doors. John would do the shopping and we would cook in parks rather than eat in restaurants, which were then as now mostly too expensive for our budget, and not as good. I remember once we ate in the rain, that didn't seem to be such a good idea... But the food was good. During the summer there was a school of dance in New London, Connecticut, we were invited there for six weeks in 1958 - myself to teach a daily technique class, and the company was to be part of a festival at the end of the summer. That was the first time since Black Mountain that I had the dancers with me for six weeks, taken care of, and even though I was not at all in agreement with the aesthetics of the school, which was the involved expressionistic style of the Humphrey, Limon, Graham world, still the summer was pleasant, polite... When we gave the two dances we had worked on - *Antic Meet* and *Summerspace* - the first one, because it was humorous, was well received, *Summerspace* made no impression. I think the audience didn't see or hear a thing.

In the fall of 1958, Carolyn Brown, David Tudor, John Cage and I were in Stockholm where Bengt Häger arranged for us to present a program in the Opera House. He suggested it would help the evening if there could be a dance with music by a Swedish composer, so I choreographed a duet, *Night Wandering*, in two days to several piano pieces by Bo Nilsson, and we presented it along with other solos and duets and separate music pieces by John which he and David Tudor played.

That same year, thanks to the support of Margaret Erlanger who was director of the department of dance at the University of Illinois, I had a teaching residency at the University for two months and was able to bring my Company for a period of three

weeks. So I went back and forth between New York and Illinois, giving classes in both places. At the end of the semester, I returned to Urbana with my Company, we worked for three weeks and then presented two new dances. Three days before the performance we had a rehearsal in the theater. The stage was rickety, a canvas cover over wood. Once I landed from a jump into a hole in the floor underneath the canvas and wrenched a ligament in my foot. I continued dancing, but that evening my foot had swollen to what seemed several times its normal size... I spent the next few days in a whirlpool bath in the athletic department. On the night of the performance, I was able to go on.

Between 1959 and 1965 we had a studio on the top floor of a building on Sixth Avenue at 14th Street that the Living Theater had taken over, and where they occupied the second and third floors. They had started their theater a year before and had kept the space for me for a year. We shared the floor with a storage space for their sets. That was by far the best place we had worked in, large, very noisy because we were on the avenue; we froze to death in the winter and it was hot in the summer. But we finally had something like a home; it was not borrowed or rented by the hour; it was our studio. I also liked greatly being in the same building with the theater. After classes, I used to go and watch at the back of the house when they played *The Brig* or *The Connection* or *In The Jungle of Cities*. With all of their difficulties – the ill-kept place, they were involved in politics, non-violent confrontations with government, harassment by creditors – still, they were an alive, and wonderful, theater group.

The following summer, 1959, we went back to Connecticut again and I made *Rune* for the festival. Bob Rauschenberg did the lighting, and the people in charge of the Festival who didn't know who he was, got irritated with me for bringing this fellow who didn't seem to know about lights. He was always asking how things worked. Instead of answering his technical questions they wanted to tell him how to light. So I said, 'Why don't you just tell him what he wants to know.' That didn't improve my relationship with the heads of that organization.

About this time, the building I lived in on 17th Street was going to be torn down. After a long fight, the tenants were able to find other places to live, and for several years after that, I stayed

in an apartment on Mulberry Street in a section called Little Italy, which unfortunately was quite far from the studio. We were touring more now.

Occasionally during those years, John Cage, Bob Rauschenberg, Jasper Johns and I would have dinner together in a bar on University Place, not the old famous Cedar Bar where Willem de Kooning, Franz Kline and the abstract expressionists would go. We would drink beer and play the pin-ball machines. At that time, I was very interested in Oriental techniques, Japanese and East Indian. I'd have especially liked to have the experience of Dervish techniques. But learning one technique thoroughly is already difficult for the body. One is so involved in the intricacies of one technique that it's very difficult to leave it for other things, although I'm sure that's what one should do.

I was also interested in the idea of indeterminacy, of giving dancers a certain freedom, not about the movements themselves but about tempo, direction, and whether to do certain movements or not. Unfortunately, especially on tour, when we were tired both mentally and physically, it's hard to make choices on the spot: even though I think indeterminacy is a good idea it has not proved practical under touring circumstances. Carolyn Brown and Viola Farber were both still with me, two dancers with very different qualities, but both marvelous dancers, with extraordinary and striking talents. Little by little the Company grew. Almost all the dancers came out of my classes, very rarely from the outside.

It was in 1964 that we went on that long tour around the world. We were still in the studio on 14th Street, but alone in an empty cold building, because the Living Theater had been expelled from it by the Federal Government for non-payment of taxes. We left in June of that year and came back in December, exhausted after travelling in Western and Eastern Europe, India, Thailand and Japan. It was a marvelous adventure. When we were in Venice, Bob Rauschenberg was given the Biennale award. Until that tour, we had received very little press attention. For the first time the press wrote about what we were doing*. And when we got back, we felt the difference here in New York. Some of that worldwide attention had seeped back to the U.S.A. People began to pay some attention. One of the first things we did after that

was to put together a piece called *Variations V* for a Franco-American Festival that was held in what is now Avery Fisher Hall (it was then Philharmonic Hall). The score was by John Cage. It was an elaborate mixture of things, what was later called 'mixed media', in which dance, television, film and music were combined. Stan Van Der Beek, Nam June Paik, Robert Moog, Billy Klüver, David Tudor, Max Mathews, John Cage, were all involved. The main idea was that the dancers moving among antennae mounted on poles arranged on a grid all over the stage would trigger the music that the musicians kept in continuous operation, and at the same time films were projected. During the dress rehearsal, when I was supposed to go off-stage hanging on a bar while a bicycle I had been riding rode free, I slipped and fell on my back, and we were to perform the next day! I went home and took a hot bath, tried to rest during the night and got up the next morning and worked very slowly and managed to get through the performance that evening.

In 1968, we were asked by the Second Buffalo Festival of the Arts Today to give a program after a month's residence. We presented *RainForest* and *Walkaround Time.* While we were there, we worked in a large abandoned gymnasium which was often used by an organization that took care of school drop-outs, and those young people weren't happy to see us using the space. They came and hung around the place while we were working, and I let them in to watch. After a few days, one of them said, 'Do you do this every day?' And when I said yes, he said, 'Man, you do a lot of work,' to which I answered that it didn't get any easier but it was always interesting. 'I think I'll think about that,' he said.

After that summer, we moved to a studio near 34th Street, at 498 Third Avenue. Also a crumbling, ramshackle building, but the space was magnificent, very wide and long, double height; always cold, of course, often without electricity, no hot water, and frequent leaks in the roof that I would usually repair, as I had at the 14th Street studio. But we had two floors for very little rent. One day I complained to Viola Farber about the poor work

*In France, the article by Marcelin Pleynet in *Realités* (July 1966), and the note in *Tel Quel* No. 18 (Summer 1964) in praise of the choreographer.

that some repairmen had done on the roof, she said, 'When you fix it the result is better. You have had more experience!' When the dancers jumped, you heard strange sounds in the floor, and I knew we wouldn't stay there forever.

Still, we stayed for five years. One Christmas time, I gave a ten-lesson course to about 35 students. There was ice on the inside of the windows. Since there was no heat, I told the students that I would understand if they left; but most of them stayed. They had to start dancing with as little on as they could manage so they could cover themselves with something when they stopped. A few days later, a good third of the plaster ceiling collapsed during class; fortunately no one was hurt, but one of the dancers said, 'This isn't my day. I was barely missed by a taxi today'. I just decided to leave everything, but the next morning I came back with some students to sweep up.

At that time, some of my students began to be able to carry on the classes when the Company went on tour, so we could keep the studio open continuously. The Company began to change. Carolyn was still with us, but Viola had left us not long after the world tour. She had been injured and didn't want to dance with us any more. As you know, since then she does her own work.

During the 60's some ideas began to develop, especially among the young people, to free dancing from any specialized forms of technique, or the need for training – the feeling that any kind of pedestrian movement was useful as dancing and that once you began to specialize it, it lost its original flavor – which is probably true. Largely, they were the outcome of a class in composition given by Robert Dunn in the 14th Street studio. His wife Judith was in the Company and he had organized the Peters catalog of John's music. But my own feeling is that practice gives another flavor. You can gain an enlargement and an amplification which doesn't take place otherwise. My own ideas about dancing have always included the possibility of both pedestrian movement at one end of the scale, virtuoso movement at the other end and everything in between.

There also began to be more dancers and a proliferation of new dances. Since the dancers felt they didn't have to be trained, they frequently moved from one company to another. Our situation

was different. To dance in my company required a certain training. Every time someone left me I had to find someone else to take over those parts. Replacements are very time-consuming and not very interesting for the rest of the Company who know their parts backwards and forwards. There always seem to be in my work two trends: a constant daily perseverance, at the same time the possibility of change, of allowing different ideas and different dancers to come into the work. All along, I have been working with the possibilities of the human body moving: nature in her manner of operation, if you will. I made the dances, as I always have, giving myself a kind of question to solve: about flexibility and practicality.

You deal with people and they are also your material. I never felt the need to push about expression because in the case of most dancers - if they do the dance fully - it becomes in itself interesting to watch. If you don't make demands as a spectator but you really look, you find that most things are interesting. That's the other side of it, of course. If you have certain fixed expectations, then you look for those and miss something else. If you don't make demands but really look, then more often than not, something is interesting. In my work at dancing, one of the attitudes I've had is that if I just watch and look and don't push or force it, then something may come out of it, something lively. Not that you don't pay attention. You have to do that constantly, be there, watch, look, and when you see something, try to keep it. It's a little like when you're teaching dancing. For me, as I said - a good teacher stays out of the way, a bad one gets in the way. There's always a certain point in dancers' lives, in their studying period, when they reach a plateau. Some of them never get beyond that, because they think that's it, they never realize that's the moment when you have to jump the chasm to the other side. Say that one of them is moving, and falls down. I think, 'Now that's okay, now we can go on!' But it's when they *don't* fall down, when they always stay rigid, secure, safe, when they always think that everything is right, that's where I think it doesn't work.

I've never thought something is right forever - maybe for a particular moment in time and space, but for the next moment, it may not be. I suppose that has made it difficult for many of the

dancers who've worked with me.

About 1970-1971, the creaking in the floor of the studio became so bad that it was time to leave. Jean Rigg, who was then our Administrator, found that there was a space available on the top floor of a housing project for artists called Westbeth, and on first sight I realized it was the ideal place for us, a big, open space, windows looking out on the city and the river. The basic construction was splendid. We made the effort to move there, and it has been a marvel, a warm and wonderful working place. I remember when I was a boy, I would go with my father to visit one of his clients, a Polish farmer, who had built his barn when he first came, before his own house. That's where he did his work. That's where his life began.

In 1972, Carolyn Brown decided to stop dancing. I acquiesced, naturally, but it made a profound change. It was then that I made *Changing Steps* for the Company - she had gone and I'm not in it. This dance intensified a concern I'd always had for everyone in the Company - to let everyone be a soloist.

In 1979 we had a short tour to a summer dance festival in North Carolina where we did a new piece called *Roadrunners*. The music is by Yasunao Tone, a Japanese living in New York, for viola and piano, or two pianos, electronics and ancient Chinese tales which are recited live in English using two separate microphones that gate the musical instruments. Sometimes a recording of the stories in Chinese is heard.

The white costumes that Mark Lancaster made for us have a certain sharpness about them. I wanted to make a piece that was closer to TV than anything I had made before in the way it was cut up from moment to moment: short things that happen and disappear, and other things that come in. The abruptness and swiftness with which they change could be construed as humor, also as a clarity of forms.

The idea for the images in *Roadrunners* came from a visit to the antique Greek museum in West Berlin which I made when we were touring there. The shapes of the figures on the vases were lively and active and I wondered what they could provoke going one to the other. I copied a number of them in stick figure form and added enough hoping to have sixty-four. To get from one of these shapes in its space to another in its allotted space brought

about the abruptness and change of pace. I kept the space in horizontal lines, that is, the figures primarily move right and left from one side of the stage to the other, something like a shadow play.

Exchange, a work made in 1978, was a long, large-scale piece. It was 37 minutes long, divided into three parts, with half of the company in the first part, the other half in the second and all involved in the third. I appeared in all three sections. I've often been struck by the idea of recurrence, ideas, movements, inflections coming back in different guises, never the same; it is always a new space and a changed moment in time. So I decided to use it in making *Exchange.*

After making the gamut of movements for the dance, I used chance operations to find the order of the phrases for each section, then again to find what phrases might reoccur in Section II, again in Section III. When phrases came up as repeats, they would of course occur in a different context in a different space and time and also with different dancers. Further, phrases that had been done completely in one section might only have parts repeated. Again, a phrase done in parallel position in Section I, would be redone in turned-out position in Section II, and if appearing in Section III, could have the element of leaping added to it.

The music is by David Tudor. It is an electronic score which changes its sound parameters during the course of the piece, though not in relation to the dance.

The dance ends with the entire company on stage moving in separate groups of two or three. It does not stop; it stays in process.

Channels/Inserts, made in 1980, was first choreographed as a film and then arranged for the stage. It came after *Locale.* I wanted to find a way to cut down on the amount of space the camera covered in a still shot. Because a great deal of *Locale* moved over a large space the camera was often taking an amount of empty floor not immediately occupied by the dancers. For *Channels/Inserts,* one of the ideas was to limit the space the camera focused upon, and then find out how to move the dancers within this restricted area. For me, it meant going back to the technique class and instead of making exercises which carried

the dancers through the space using large second and fourth positions as intermediate moving steps, change to tighter ones, using first and fifth positions and to work on movements that go out from these positions, and although not large in themselves, would look large on camera. Instead of four directions, only front back and the two sides, I used eight, those four and the diagonals, further adding angles off the eight of them, all precisely made for the camera. I looked for rapid complicated foot action using many changes of movement and direction in a small space - like dancing inside a small circle and hitting different points on the edge of it.

In this work too, the partners stay constant, particularly Lise Friedman and Alan Good. The same couples are seen together whenever they appear in the piece. It's like a constant reminder while going along an unknown path.

Duets was also made in 1980 and we presented it during our season at the City Center that year. It began with the idea of making a duet for Susan Emery and Rob Remley to be included in the Events. Having finished that one, I decided to make a second, and then a third for other dancers in the company, until there were six. I don't remember the order they were made in, but gradually in working on them, the thought to have two dancers do distinct and separate phrases, although in proximity to each other, came up. After the six dances were finished, I decided they could be a work by themselves. I added a brief entrance and exit by one of the other couples in each of the duets; then the ending, involving all six couples. The ending is comprised of three short phrases, each followed by a brief stop, as though a still photograph were being taken. Following the third stop there is a blackout. The music is by John, his *Improvisation III*. The material for it is cassette recordings of traditional Irish drumming, Bodhrans played by Paedar and Mel Mercier.

Duets is also at present in the repertory of the American Ballet Theater. Chris Komar taught the dance to the company.

Trails: The idea of having two people who are dancing together do two things rather than one, is carried further in *Trails* (1981). I made the phrases for each dancer separately. Then, in the rehearsal, I put them together, keeping each phrase as distinct as possible, at the same time allowing for any

cooperation between the dancers that was possible – a lift, or as in one of them, a leaning of the woman on the man.

Fielding Sixes and *Tens With Shoes* were both involved in a limitation concerning numbers. In the *Sixes*, the sixty-four phrases used were all in six and all in the same tempo – rapid. They varied only in terms of movement and accent. Repetition was allowed for. Chance operations gave the continuity, and the spaces to be used, and the number of dancers to appear at any moment. A great many of the phrases involved leaping and rapid crossing of the dance space and sudden reversals of direction. My impression, as I have seen the dancers perform it, is of a country dance in which the formal shapes open out in unexpected ways, the dancers appearing and disappearing and exchanging groups and partners in a fluid manner. It has been presented recently by the Ballet Rambert in England. Again, Chris Komar staged the dance.

Tens With Shoes. The title comes from the original phrases which were counts of tens, later changing to include eights, and my decision that the seven dancers should wear shoes.

The steps are precise; the movement relates in my memory to the 'shuffles' that Mrs. Barrett taught, and to the look of young people now when I see them dancing in the streets, bobbing and shifting. There is a use of the hips, and the shoulders, turned-in feet, and stretched heels, the arms are often down at the sides of the body, but when in use, are articulated at the joints, the shoulder, the elbow and even the wrist in precise counts. The rhythm should look free and exact at the same time.

Gallopade, made in 1981, is a series of non-sequitur situations. It deals with referential movement, in a nonsensical way, made nonsensical by the use of chance operations. At one point, for example, a series of small gestures with the hands and the face are used. These are gestures ordinarily used by various peoples as accents with speech or as derisive gestures. Here, the gestures are removed from context, and further fragmented by using chance to find the continuity. Humor and the unexpected get along together.

Two recent pieces are *Quartet* and *Coast Zone. Quartet,* made in 1982, has five dancers in it. The title was prompted by two possibilities. The first is that two of the dancers act as one in

the sense that they do the same movements at the same time; the second is my role in it which again separates me from the others. I am on stage at the beginning, the shapes I present are different from the others, although occasionally I mirror their movements and interact with them. Essentially there is a different gamut for each dancer, but at times they share phrases. The nature of the work is on the dark side. The action is all confined within a relatively small area. The phrases were planned to have as few and as short transitions as possible from one movement to another.

Coast Zone (1983), made first as a film (it was filmed in Synod House of the Cathedral of St. John the Divine), again with Charles Atlas as collaborator, and then arranged for the stage, is a piece for the Company. The fluidity of waves, the shifting of sands, the changing landscapes a coastal area can present, specifically the rapidity of changes in such an atmosphere are the images that came to mind as I worked on the piece. The choreography and the camera movement were made with chance operations. That is, the sequence and overlapping of movements and the number of dancers to be seen at any given moment, and the space the dancers were to be in as well as the changes of camera positions were initiated by chance means. We used close-ups as an integral part of the film. My starting point for the division of the space was to plan it in three areas, rear, middle and front, that is, full figure to be seen in the rear, full or partial figure in the middle and close-ups in front. Of the dances I have made for film or video, this was the most difficult to transfer to the stage. To attempt to keep the sense of rushing, constantly transforming movement along with the large image the close-up presented in the camera, I found it necessary to add to and in some instances enlarge the 'close-up' movement into held shapes for the stage to make them appear against the continuous flow of the dance.

The music is by Larry Austin. It is called *Beachcombers*. Computers were used in its composition and the realization of the tapes, some of which enter as part of the music; others act as conductors for the performers.

Dance and Power

J.L. Merce Cunningham, it seems that in the very manner of your work, very little place is given to the development or dissemination of your discoveries. And one even feels a sort of implicit negation of any impulse to branch out or develop.

M.C. I don't think I really care if it's developed and spread or not. I am willing to do it in places so that it could develop, but if it doesn't, I don't think that concerns me that much. Either way is alright. I never think of it just as my thing. It's all of us, the dancers, the musicians I have worked with, the artists; we are all involved in it. I remember in a school – another one of these situations where we were answering questions. A student in the audience said in desperation, 'How is it that you people can do what you are doing, go around and present it? We can see that you do it and we find it interesting, and yet no one ever tells us in school how this kind of thing can take place.' John Cage gave a marvelous answer, as he so often does, and described how we work together on a common independent level without somebody over us saying, 'You have to do this, or you have to do that.' Even though, in a sense, I have that role, I try as much as possible to avoid it. Where I have to do it, I do it, but I prefer not to. So that it's a continuing process. It doesn't become an object.

The attitude you describe, the effort to spread the work, to influence others, has to do with power, or ego. Apparently it doesn't interest me, or if it did, I don't care anymore. For so many years there was no interest from anybody. We went on doing it as we could and presented it. Some people were interested enough, but there was no huge interest; so you become rather indifferent to success. We simply continued so as to be able to continue. When we went on that world tour in 1964, it was our first big long tour.

J.L. That was the first time I saw you in Paris.

M.C. Yes, that was the first time we'd come – to the Théâtre de l'Est Parisien. We began to get press, but mostly in languages I couldn't understand. (laughter) It still doesn't make any difference. In fact, I'm interested enough in dancing, so that I can ignore all the things that surround it. I have in a sense tried to avoid any concern with power and ego, self-expression and all that.

J.L. After a certain time, new art forms are taken up by national or international institutions, just as happened to Martha Graham. From what I've read, it seemed that after a while, the American Government made her a kind of national symbol or roving ambassador. Her foreign tours were eagerly supported by American institutions. With you I see nothing of the kind happening, which I think is great, but still . . .

M.C. The American Government mostly didn't understand what we were doing. They have rarely had anything to do with us: if we happen to go some place and they can use us, they will do that, but they will not send us – it might be that we represent a part of American art that they think should not be.

That was certainly the case in Buenos Aires where the Embassy kept our presence a secret so that on the opening night the auditorium was practically empty. By word of mouth we began to have houses and the audiences were wildly enthusiastic at the end of the week. We represent anarchy so to speak. John Cage does more than anybody else. He speaks out so openly against all governments. On the other hand, the bright people in the embassies where we tour recognize this attitude. For instance in Poland, when John was talking, there was one of our Consular people there, I saw him smiling. John was speaking against governments, not just communism. I realized that John was involuntarily supporting the American Government, because here he was, allowed by the American Government to speak about getting rid of government.

J.L. In Paris the Bolshoi has been presenting some new things recently. They are so far away from contemporary thinking and so much in the nineteenth century. They ought to get a real shock

from what is sent there to bring them into the twentieth century. Roland Petit, who went there with the Paris Opera, is not a shock and is not the twentieth century. So maybe you would not like it, but for the young Russian people that would be very important if you went there.

M.C. Actually, I'd like to go to China with my Company. John had a letter from artists in Moscow a year ago that came by way of Germany originally. I remember the pathetic letter from these young people who had not much knowledge of John's music, but were very interested in it . . . and would he write to them? Which he did. Eventually another letter came from Moscow, with some photographs, and these people described something they had done, like a happening. They had made a big balloon, not as big as this room, I don't know what it was made of, paper probably, and they launched it on a river and let it float down. They sent photographs of the launching and of the making - which were most beautiful. Then we saw these eight or nine people standing on the river, one of them holding an umbrella and the balloon going down the river, it looked just like Tchekhov (people standing and watching). It was very touching. They said many good words about his work, hoping something would happen.

J.L. The process of your work is indeed a challenge to the way artistic events are usually organized.

M.C. Yes, administrative or governmental people can't hang on to it the way they could to another kind of organization. It makes them nervous. Our reception abroad has been quite different. Not so much that the public was bigger or smaller, but the idea of people going to see something in a theater is greatly different abroad than it is, or was, in the United States, though it's beginning to change. In the United States, we have less political involvement with the arts. People outside of universities go to the theater for entertainment; and on our side, we have been continuing to do this work which doesn't seem to have to do with politics either; but when we take it abroad, there is very often a political connection brought in, not by us but by the audience. I don't mean something specific, but it enters into it, because in a sense we are dealing with a different idea about how

people can exist together. How you can get along in life, so to speak, and do what you need to do, and at the same time not kick somebody else down in order to do it.

In the United States, the support for the arts didn't come at first through the government, but through the universities. For instance, all my early touring was never done through any government support. It was always done through the universities which were not then as politically orientated as they may be now. So when we went to a country where the audiences assume a connection between the arts and politics, I didn't understand at first. They kept asking, 'What are your politics?' Now I begin to understand. But what we represent is in a sense no government. We do represent a kind of individual behavior in relation to yourself doing what you do and allowing the other person to do whatever he does. As Christian Wolff once said, it does imply good faith between people.

I don't know whether this could ever function on a large scale. This is the biggest company I've ever had: 14 dancers, on the whole 23 people that we travel with; and so far we manage. Everybody realizes the situation may be good or bad, and rather than immediately start to complain about it, tries some way to see how it can be dealt with.

I don't know what the next step is, but people might realize – whether from what we do, or just by themselves living their daily lives – instead of thinking that everything is uninteresting, that there are many things to look at and listen to. If there's any opening in people's lives, that's where it has to be, in their daily existence from moment to moment, because so many lives are just caught up in some kind of routine. One of the things that dancers have to do all their lives is do a class every day. This hour and a half, you can call it drudgery or you can call it something else. If you think of it as exercises, then it remains that, something you have to go through in order to do something *else*. Long ago, I thought that wasn't a very good way to think about it, so I decided that each day, it could be something new so that you might see it as new, as something fresh and interesting, rather than simply something you have to do. So much of our lives anyway is spent not doing things, but waiting to do something else. I think it's better for the moment, for example, to

look at these flowers that are on the table and realize how beautiful they are, how interesting, rather than to think, 'Oh, I have to get ready for lunch.' What that eliminates is the whole idea of building moments toward a *climax*, building up to some kind of huge event that's going to take place. I don't think you have to do that. It's going to happen anyway, one way or another. It always seemed to me that life was full of climaxes - it's constant. (laughter) It's enough to try to keep your eyes and ears constantly open.

J.L. On top of that, most of the people who say, 'I'm going to get ready for that,' when they get to it, nothing happens ...

M.C. Exactly, and then they have to think about, well, what do we do next? (laughter) Isn't that basically a western idea, going from *cause to effect*, whereas there are oriental ideas which allow for a much larger kind of sense about the world, about the spiritual world, other ways of thinking; for instance, that you aren't the only thing. This chain of cause and effect mostly has to do with the idea of the ego being pushed somewhere, or pushing itself. And if you, just once, could get outside of yourself ... though for dancers that's very hard because they are so much concerned with themselves. (laughter) But they have to be!

When I'm working on a new piece, I'm always convinced that there's something that I'm missing, as though I can't quite see around the corner. I *know* that there's something else, that I'm *not* getting at, which I would be interested in; that *this* is not the only way to do it. I finally make a choice, however it's made, by chance means or by some other means, because I finally come down to being practical. Say I have a deadline, the date of a performance. (laughter)

What worries me most is that I might be missing some very large idea ... Look, it must be children coming from school ...

J.L. Where does your sensitivity to oriental art come from?

M.C. Probably it comes from the Northwest. In Seattle, I remember a quite large Japanese quarter and a rather smaller Chinatown. The Japanese influence is clearer in the Northwest than the Chinese. Nellie Cornish invited the dancer Uday Shankar. At the museum in Seattle, the collections of oriental art

are magnificent. And after all, India is the only culture where a dancer is one of the gods. The idea of art as a process rather than an object is more oriental than occidental. I think it's important to notice the double aspect: in the West, space is linearly oriented from the inside outward, whereas in the East, space is conceived as circular. The Chinese language, too, is more flexible, more fluid. English, I think, is the only language that can stand up to it, because of its ambiguity.

Stages – Audiences – *Events*

<u>allowance for all elements of theatre</u>:

movement / stillness

sound / silence

lights / no lights (white or bare or darkness)

costumes / no costumes

Set / bare stage

Tao teh Ching

we put 30 spokes together and call it a wheel
but it is on the space where there is nothing
that the utility of the wheel depends,
we turn clay to make a vessel,
but it is on the space where there is nothing
that the utility of the vessel depends.
We pierce doors & windows to make a house,
and it is on these spaces where there is
nothing that the utility of the house depends,
therefore just as we take advantage of what is,
we should recognize the utility of what is not.

16. *Text on Tao teh Ching*

J.L. What is it for you to get on stage in front of people? What is the stage experience made of?

M.C. For me - I'm talking in terms of dancing here, though it would apply to all other stage activities - it's an enlarging or amplifying of energy that only dancing can do. I don't mean that sports don't do that, but they do it in their way, whereas dancing is an enlarging of a kind of energy which can only happen the way dancing operates. Now, when you put that together with sound, and again with a visual scene, you are attempting to enlarge the energy in three different ways. You put those together and it becomes something which need not be witnessed by anybody. Nobody sees our rehearsals for instance except rarely. There are other things in life that are not necessarily seen by people, but that nevertheless take place.

This leads to seeing theater as part of life. Not as something separate from it, not as something special, only to be seen in certain circumstances, but rather theater as everything around us; everything you see, as well, as we just said, those people around us here. If you take that as a sort of starting point, anything you do might be theater. Go further and say if that is true, then any place can be theater, so you are not stopped by the idea of a particular place.

In the States in the '60s, and late '50s, there were a great many young people who began to question the old structures that we learned at school: there must be other possibilities, so you begin to wonder what those other possibilities are. Since we know that the way society is constructed is not working, at least nowadays, then obviously there must be other ways, other possibilities to think of. In the meantime, I'm going along doing dancing, teaching, traveling, to keep doing whatever I'm doing: but all

these ideas enter into the way I work. I began to see that dancing could as well be done another way; it makes perfectly good sense, it does not have to go only in one direction; it could go differently, and why not?

J.L. I have sometimes observed people looking at your pieces, especially in France. It is clear that when they see other shows or other choreographies, done on a completely different basis, they are challenged to share in some exploits or built-up emotions. They recognize themselves in it, put themselves in a role, in the classical role of people coming to a show and being spectators, so when they are faced with your pieces, wherever they see them, they just don't know where they are, and so they try to figure out something to think.

M.C. It's different for young people. They might not seem to acknowledge or understand completely the basis of it, but it is obvious that they feel it is different.

J.L. The idea of concentrating on performance in a given space and time, with specific means, does give it a distilled, perhaps even the pharmaceutical quality of a dose or pill. At the same time, even though this is changing, I have the feeling that the new ways of looking are often just superimposed on the old ones so that people just become hectic and frantic for fear of missing something. Things appear to them more numerous, more fragmented but in the same spirit, which makes them very nervous.

M.C. They probably try to make deliberate connections whereas what they see can only be what it is. People can't help making connections, but when you try to tell them how to make them, you put something in their way, and they start feeling nervous and thinking they're missing something.

J.L. I've seen the public sometimes slightly angry at you, because they felt somehow that in the conditions they were in as an audience, they had no easy access.

M.C. That's true!

J.L. They had to come a long way to get there, nothing was

made easy for them, and they would say, 'What about us?'

M.C. Yes, but what they often didn't recognize, was that they were having an experience, which they may have decided they didn't like, but which was an experience just the same, because they were in some way a part of this, even by leaving, and going out of the theater. I would hope that they might in a sense become part of the experience that we are presumably all sharing at the time of the performance. I like to think of the spectator as someone who comes to the theater, as was once said, to exercise his faculties. I like this idea much better than that the spectator comes after dinner on a full stomach and sits and goes to sleep, and expects to be awakened. I don't mind if people go to sleep, and I don't mind if they leave. But I would prefer to give the opportunity to people to exercise their individual faculties in the way that each one might choose to do.

J.L. When people come to a theater, usually they are offered some moments of excitation and pleasure, which are very funny moments, when one thinks of it.

M.C. We see it differently. The musician was involved with the sound he was making, the visual artist was involved, I was involved in the dancing, and these things happen together. We have to have a place to make it happen, and ordinarily one thinks of that in terms of a theater. Further than that, theater involves spectators, at least it can involve spectators. I suppose we put the spectator in a position of no support. But there are all kinds of events in life where you don't have any support. We are involved in a complexity similar to the one life has, the life each one of us is living.

J.L. It seems that in what you describe, a very strong emphasis is given to the process of thinking *it, of* doing *it, and of* bringing *it to the public, to a public place, any place where it can happen, and much less importance to the effect produced.*

M.C. We don't attempt to make the individual spectator think a certain way. I do think each spectator is individual, that it isn't *a public*. Each spectator as an individual can receive what we do in his own way and need not see the same thing, or hear the same

thing, as the person next to him.

J.L. It's a strong shift to think that way, as this ritual of concentration, in time and space, is supposed to bring out the same feelings in everybody. The fact that you consider it so related to each particular person (either the one making or the one seeing it) means you don't want to play on an interrelation, or influence, or complicity with the audience. In the stage situation, usually there is a kind of mirroring position and identification: the excitation mounts. When you present your work, what do you think happens to the spectator? Does he identify?

M.C. I can't really answer that for someone else. What the individual spectator brings to this particular experience, or the situation he's got himself involved with, depends on him. I can only think of the dances as pieces, they start there and end over here. On the other hand, someone unfamiliar with this kind of work, with things being separate that way, maybe can't make a continuity out of it. But if you accept it as it is and go along with it as it happens, moment by moment, then it doesn't have to be cohesive in that ordinary sense. It becomes what it is the moment you are looking at it. It is probably difficult for an ordinary theater spectator. I understand that. Though I think that the way people pay attention now is gradually changing. Young people don't think in terms of linear thinking. They can follow a *field*. They don't have to go from one thing to another. They can see it all, it doesn't have to be linear. That's part of what we've been involved with, allowing something like a field situation.

J.L. There is quite a discontinuity between what the ones who practice this kind of art are doing together and what is left to the public, individually, to grasp.

M.C. The dance isn't *directed* to them, or done for them. It's presented for them. Suppose that even in the dancing I directed something towards something special, the sound would not do the same. It accents in its own way. The visual part might conceivably accent something totally differently, so that what is left for the public is to look at these three things and make

something out of it. But, as I say, they have a choice. They can get up and leave. Or they can stay and attempt to make something out of it.

J.L. You've danced on all sorts of stages in the most unexpected places. How do you see contemporary spaces changed?

M.C. They seem to change in cycles. Stages that are on the eighteenth century model are all deeper than they are wide, like that of the Paris Opera. The reason for this is probably that décor was important, as well as the idea of perspective. Classical dancing from Petipa was coming from the back of the stage towards the front, ordinarily on diagonals, but opening out towards the audience. It was perhaps not originally constructed for dancing, naturally, but you have a sense of distance that way. We have a different idea about space now and a different use of it, wider, but also not just from front to back. Recent stage spaces are almost always wider than they are deep. Your eye can jump from one point to another, you don't have to be led any longer from one point to another.

J.L. Working with painters gives a very special quality to the lighting in your pieces.

M.C. Yes. Well, the general idea always has been with me that you should just light (laughter). By that I mean the way sunlight lights the day; like, if you look out here [Scheveningen, near the Hague], you see it's lit, though it doesn't vary as much as in Rennes where the light was *so* beautiful, constantly changing because of the clouds. We never like lighting to focus, to dramatize something.

When Bob Rauschenberg came with us on tour, his lighting was remarkable, he lit as a painter lights, as a painter paints. He would *wash* something with light, but not in respect to some drama. He would just *light*. And I always thought that simply marvelous, the way a day is. We use no gelatins or very few colored lights. I think Charles Atlas changes the light more, but it's always just light. So as Jasper said, 'I want to *see* the dancers.' (laughter)

Whoever regulates the lights, when it's not the painters, is in the same position as the musicians and the other artists; the

lighting isn't meant to support the dancers and their movements. They light a field rather than any specific parts of it. They light the area.

For instance in *Torse,* there are almost no changes of light. It simply goes up and down. At the end, most of the time, we just bring the lights down. It depends on the piece. *Sounddance* ends in a sudden black-out. In other dances sometimes it's slow and then we end by closing the curtain. Sometimes we don't use the curtain because curtains are too slow. Openings are also varied. *Sounddance,* again, starts in the dark. As I come out the light comes up, but not in a dramatic way. The lighting is there, always, to light the area, not to emphasize anything, nor to focus on what you think people should see. With my work, we're over here, but the next second we might be over there, so it wouldn't work anyway ... (laughter)

When we first did the *Events* in New York, they were difficult for people to see. In the Brooklyn Academy there was a great difficulty with the audience - the public just walked out and made a big uproar - and I decided we wouldn't go to Brooklyn any more after that. But I wanted a place to do the *Events* in New York, so we began to do them in our studio in Westbeth, which is a lovely big space to dance in, but where we can't have many people sitting. We can have about a hundred. They sit on two sides, one of which faces the city through six large windows and the other faces a wall mirror that can be covered over with a curtain. It's adequate. It gives the dancers a chance to perform. When we started to do *Events* in the studio we did them on weekends. More and more people began to come. And there began to be complaints that there wasn't enough room for the public. But what we had started to do happened simply because of the circumstances we were in. I remember once on the street I met an elderly lady with her umbrella, it was a rainy day. I recognized her, so I said hello and smiled, and she said, 'I could not get into your show. I can never get in, it's always so full.' 'Oh, I said, 'I'm sorry.' Then she raised the umbrella in my direction and I had to withdraw while assuring her that I was sorry ... We do as many of them as we can. We can't manage any more ...

I think that from our point of view, with this Company, the best way to present the *Events* is in unconventional sur-

roundings, such as gymnasiums, museums, even armories. I remember once in New York we did a short *Event* for school children down the street from Westbeth. We did it in a school gymnasium and they sat around on the floor and watched us. I think I talked a little bit, too. It took about half an hour and the children seemed to like it very much, asked some questions afterwards, and we answered them. A reporter from the *New York Times* was there. She told me she had asked a girl if she'd enjoyed it, and the girl had said, 'Yes, it was like looking at the inside of a watch.' But that doesn't answer the question. It starts it. Because we go away and the teachers have no way of pursuing that, of letting the children know it could go on in their lives.

The *Events* were numbered for a time, from 1 to about 200. But I am going to give up the numbers, that does not seem to make any sense. When we were on a tour in 1964, we were going through Vienna and the people there asked us to give a performance. The only place available was the Twentieth Century Museum. We said yes, if we can. So they opened the Museum which is a big open space, with a beautiful glass wall in the back of it. They said they would make a platform for us, and could we give a performance there? I said yes, but I knew we could not do three dances there, a regular repertory program; it would not make sense. The audience had no place to go at the intermissions, there was no curtain, no wings, no lights, no place to put scenery. So I thought we'd just do the pieces that we had with us, one on top of another, for an hour and a half.

We did parts of pieces, sometimes we doubled, we had two dances going on at the same time. Bob Rauschenberg who was with us on that tour made an object, to be put up for the performance and taken away. Everyone sat on one side. The music had four players, as I remember. It was the percussion parts of John Cage's *Atlas Eclipticalis*.

Before we did this, they said, 'Now you have to have a name for it'. I thought, let's just call it 'Museum Event'. Later on in that tour we were in Stockholm. They asked us to perform in the Modern Museum where Pontus Hulten was at the time. We did two different evenings. Those and the one in Vienna were the first *Events*.

When we got back to the States after that, now and again on tours we would give them in places where regular programs were not feasible. Or where the stage was too small, we would ask for the gymnasium. Gradually we did *Events* more and more frequently. Finally I was asked to put numbers on them. By this time, it's at two hundred and something, and I'm tired of numbering them.

There were mainly two reasons for the *Events*. One was to break away from the idea that the only place you could perform, so to speak, was in a theater, which has never been true, because people have done plays for thousands of years outdoors. So far as that goes, we played indoors. The other reason was practical because it allowed us as performers to do things in places where otherwise we might not be able to do anything at all. We could show that theater need not be thought of as theater, but could be something seen in the street. Life was like theater, theater like life, you could watch it as you watch people on the beach. As we played in these different situations, it became paramount that the pieces were not to be made to fit into a given space, but rather that you could simply look at each new situation and see how to deal with it.

I remember once we were in New Mexico on a trip, they had given us the gymnasium to perform in and we were very happy with that. But they put up a stage in the gym with platforms and curtains, and it was ugly. The workmen hadn't finished putting them up, and I asked, 'Couldn't you take these curtains down?' The workmen were delighted because it was much easier to get rid of all that than to finish putting it all up!

In St. Paul de Vence, we used the whole museum area of the Fondation Maeght, even the roof. I remember going up and doing part of *Winterbranch* on top of the roof somewhere. There was some sculpture in the courtyard where we were dancing and in the museum itself. People could look through windows so that some sitting in one place could look through to dancing in other areas, out here, up there.

In the Piazza San Marco in Venice, the *Event* was fabulous, fascinating; it must have been late afternoon. I knew that if we got out there and started, people would come around, and I wanted us to go from one place to another. I had to figure out how

to do something in one place with people all around, and then go someplace else. The musicians, I remember, were on fixed platforms. We were in sneakers and sweat pants. What I did was provide each of us with a chair and a broom. We went out, all the dancers sat down close together and then we would gradually push the chairs out to give some space. Then we would sweep the space and do something there. Then one of us would pick a chair up and we would all put the chairs over our heads and go someplace else, sit down and start all over again. We did that about four or five times; it lasted about an hour or so, and we were sweeping the dirt from one place to another. I remember one lady in front who was just delighted with the whole procedure. I am sure she felt the square must not have been swept for years...

At the Paris Opera: *Un Jour ou Deux*

J.L. In 1973 for seven consecutive evenings at the Paris Opera, you presented a dance called Un jour ou deux. *You've danced in the most varied spaces, and there you were suddenly confronted with one of the most beautiful and most traditional stages. Those of us who were astonished told ourselves that Merce Cunningham was interested first of all in dancing and that after all, an opera stage is also a space where you can dance ... How did this event originate?*

M.C. Michel Guy who was then as now the head of the Festival d'Automne asked me if I wanted to do something sponsored by the Festival for the dancers at the Paris Opera. This was a very strange thing for me to be asked, but as is my usual tendency, I said yes. He asked me if I would prefer to do a piece on a program with others or a whole evening, and I thought if I did something, I might as well go the whole way, and later the idea occurred to me to make a piece without intermission.

So during the summer before the festival, I came to Paris to choose the dancers, and I began to see the difficulties of the situation I was getting into. Michel Guy was strongly behind me. I think Lieberman was not radically against it, but didn't seem to care one way or another. I sensed there would be an enormous inertia, so much hierarchy, everyone powerless to get anything done. Then coming back to New York, Wilfriede Piollet, Jean Guizerix, Michael Denard, around whom I was going to build the dance, came to Westbeth for two or three classes and we talked about it, and in the fall I returned to Paris for nine weeks.

The rehearsal room was small. By giving a class every day, which I did on rehearsal time, I tried to make things clear for the dancers. The lead dancers often had to be elsewhere. Constantly something didn't work, which is all right - most things don't -

but usually you can think of something to do about it. In that labyrinth, no one could. Some of the dancers slowly came to see that there was something worthwhile happening. I just decided I would plug on whatever happened. It was very trying to work so slowly.

Around the three dancers I mentioned, I had a group of young dancers (twenty-six in all), most of whom came from the Favart troupe at the Opéra Comique. There were two ballet masters who watched the rehearsals, one of whom came to realize that what was going on might be interesting. But we were working in such a minuscule room, and one day the other ballet master asked my assistant, 'Does Mr. Cunningham realize that the opera stage is very big? . . .(!)'

Michael Denard was hardly ever there. Finally I decided to work with whomever was there. Among them, I noticed Charles Jude in whose dancing there was a strong and interesting quality.

Meanwhile, Jasper Johns did the decor, which had two gray scrims, one across the front of the stage, the second not quite halfway back. Both could be opaque or transparent. The front scrim was briefly opaque at the beginning of the dance, shortly became transparent and remained transparent. The second scrim was first opaque and after a while became transparent revealing the full depth of the stage. At the end of the dance it again became opaque. The dance is built that way, based on a coming and going, a play between the different volumes, the two spaces. The title plays on the same idea as the space. The dance's structure shifted as we went along because of the enormous difficulties, people missing, bad organization; at the end, things were pretty desperate. But I just persevered.

J.L. Let me recall the opening sequence: the curtain, a splendid graded gray, becomes transparent by the mere play of the lighting, while behind, one by one the dancers enter and take their places apparently at random, without reference to a spatial symmetry or their own configuration, and begin their sequence each in a different rhythm.

M.C. Yes, this entrance seemed scandalous to one of the ballet masters. I had told the dancers to come out and take their

positions simply by walking, and the ballet master said, 'That's impossible, you can't do that.' I said, 'I want to show how the French walk.' And he repeated, 'You can't do that!' ...

J.L. For the pleasure of recalling them, some of the more astonishing sequences: all the dancers on stage in their tights colored from white to gray-black, none all white or black, graduations of gray to white from bottom upwards. One and the same sequence for all the dancers, slightly displaced rhythmically in each case, and the movement in space that that entails.

The series of leaps and falls by Jean Guizerix, his runs and exits through the other dancers, ending by the loveliest, most unexpected volte-face. The very beautiful duet by Wilfriede Piollet and Guizerix soon after the opening. The superb entrance by Michael Denard: the walk, the crossed arms caressing his ribs ... The jumping sequence by the young boys so lightly juvenile and playful. The black solo by Claude Ariel and the moving diagonal by Wilfriede Piollet. Amazing balances, the continuity of the sequences, stops and turns through the trunk that Denard had to do without quite realizing how beautiful they were: nothing artificially brilliant, much more than that, a superb quality. And when Un jour ou deux *was done without him, something important was missing. The Giacometti-like line of dancers going diagonally through the scrim across the entire stage. The very elaborate overlapping sequences at the end with the many immobilized* relevés *that bring the work to a close. All of it took ninety minutes, some sequences very short, others long, but always giving the feeling of being extended as well as being a part of a whole that gradually opened out.*

M.C. I had figured out ahead of time a number of ideas for sections, knowing full well they obviously would change when I got there; something about the time of each section. I followed that in general. I tried out movements each day, I would try something with the dancers, to see where their facilities lay, because I didn't know. There was a great problem about rhythm. I had to repeat utterly simple things endlessly; but like many dancers everywhere, if they didn't see the movement right away they would back off. So I tried to find the ones I thought could do

something. In general, they were very conscious about positions, which is proper; but they were not conscious about what goes on between. So it was extremely difficult to get something big. On the whole, the piece follows the original layout.

The only thing to do was to continue in spite of all the difficulties, and try to make the movements as clear as possible according to how well the dancers understood them, by starting from what they could do, and by using the ballet vocabulary, only slightly stretched.

J.L. The music was not easily accepted by the musicians ...

M.C. I know. Still, those tapping sounds from the pit were done on French cardboard boxes, so as someone said, it was a very French sound, and for full orchestra! John Cage's music is light, like rain. Sometimes on the tape, you hear a bird singing or the drone of an airplane. The dancers were very scared of having to move about without musical support, but they quickly realized after the first night that it wasn't a problem. The lighting was designed by Jasper Johns.

J.L. Imperceptibly changing, daylight of a rare subtlety in which the dancers gradually became visible. What an amazing evening and what beauty!

From notation to video

J.L. No doubt some notes from the old classical choreographies have survived?

M.C. I'm not sure how complete the notes are, but a Russian whose name I don't recall came to Western Europe in the early 'twenties. He had been with the St. Petersburg Ballet. He brought quite complete notes for the major ballets including *Sleeping Beauty*.

When Diaghilev had this man revive *Sleeping Beauty,* it was by means of those notes and his own memory that the work was done. That was the first production outside of Russia, it was a fairly large mounting of the piece which had never been seen before in Western Europe.

J.L. In other theatrical arts, and in film, there are notes and important books, Stanislavsky, Eisenstein, for instance; but there is almost nothing on choreography.

M.C. It's true that it has not been investigated until recently though looking at the history of dancing, there have been important figures in it, like Noverre; everyone knows of his letters on the art of dancing in the eighteenth century. And I'm sure that there were many writings in Russia that have never been translated. I suspect there are notes and descriptions more detailed than anything we have. You don't have many books that detailed the steps because it was impossible to do, and except for isolated individuals there was not that much interest in a detailed description of a dance. Theatrical dancing was thought of – and still is – more as an elaborate entertainment on a grand scale. A great deal of the dancing itself was passed down from dancer to dancer. Mostly it has been passed from person to person as song is in any primitive society. The oral poetry was

passed down, not written down, although there are books in the Orient, of classical Indian dancing for example, that are quite detailed as to how the steps are done.

J.L. Aside from Noverre's letters, there is the beautiful book by Carlo Blasis, the booklet by Vaganova and some small publications by Cecchetti that are very detailed ... In fact the library is quite small, but there are some books.

M.C. Video will change all that. I don't think that video is essentially the answer to all problems, but it will cause as many changes as recording has for music. With recording, so much music began to be disseminated in a way which was not possible before, and the same is beginning to happen with dancing. That is why I think that a possible direction now would be to make an electronic notation that could be played simultaneously with a straightforward video recording of the dance. For if you want a clear and complete record of a dance, video is not sufficient. You cannot have only the video which is really what a recording is for a piece of music; you need a notation just as music requires a score. However, I don't think the answer lies in the various notations like the Laban or the Benesh (which are the best known and are reasonably good). Dancers don't operate that way. They don't look at a symbol, they look at somebody doing something, then they do it or they make it up themselves, which is alright too, but it is a question of looking at what there is, not looking at an intermediate thing which represents something else. I don't find notation interesting for myself because it's too tedious. Others can manage it, I know, but I can't.

I think the answer lies in having two screens, on one of which there is a video of the dance, on the other there is a sort of notation that accompanies, moves along with the dance and is three-dimensional. It can be stick figures or whatever, but they move in space so you can see the details of the dance; and you can stop it and slow it down. This can certainly be done, it would just take a lot of time and money! I once asked a computer specialist about it and he said, 'Oh it's perfectly possible, it would just take one month and one million dollars' (laughter). On one screen you would have the notation which would indicate where in space each person is, the shape of the movement, its timing.

On the other screen you would see what it looks like when a dancer does it. How to use it is another problem, but you could stop the score and look at it, slow it down to see what the details were. It would not have to run simultaneously.

J.L. Do you sometimes bring back some of your earlier pieces?

M.C.. I don't mind keeping up some old pieces, bringing them back, but I'm not very concerned about it. It takes a lot of rehearsal to bring a piece back, and for lack of time I have to make the choice between giving rehearsals to old pieces or making new ones. Basically I feel more interested in working on new pieces. Of course we do keep some old pieces, we brought back *Summerspace* and *Rune,* and we do parts of *Winterbranch* and *Scramble* in the *Events.* Now we have almost all the parts of *Scramble,* so that we could re-do it as a piece in itself.

J.L. You must have a very strong visual memory.

M.C. Well, I remember some things and not others, sometimes details and sometimes the overall shape. But there are individual dancers who have amazing dance memories, not only for details of anything they did, but of what somebody else did. Chris Komar is like that. He has an astonishing memory about details or shapes, how it felt, the proportion, the look of it, the transitions.

J.L. I suppose you allow some modifications when you take up a dance again.

M.C. No, not really. If it happens because of something I understand, I let it go, if it's alright; but I try not to just change, that would be easy to do, but what's the point of bringing it back if you are just going to change it?

J.L. How many dances do you do now? That depends of course on the number of dancers and on the time you have. But for the Events *that you do now, you use parts of how many dances?*

M.C. That depends on what is in rehearsal of course. On this tour [1977], for the *Events* we had parts of six dances which we do only in the *Events.*

J.L. What is your repertoire right now? [1984]

tapes of angles made; [↘ ↓ ↙] ∇ 19/76
‾‾‾‾‾‾‾‾‾‾‾‾‾‾‾‾‾‾‾‾‾‾‾‾‾‾‾‾‾‾‾‾‾‾ 5g

tapes of angles furthewi: [with bags almost constant]

 c!
 ↓
1] [· ↙] c¹ 2] [· · ·]

 c 3
3] [↗ · ↗] c 2 c 2 4] [→ · ·]

[bags in rear are constant of 25]

 angles 1] 2] 3] / or angles 2] 3] + 4]

 [bags seen only from angle 2] + angle 3] + angle 4]]

tapes from all 3 cameras; ∇ 10 76
 Bags [·· ·] 5g

 ·/· above ∇ 11 76 5g

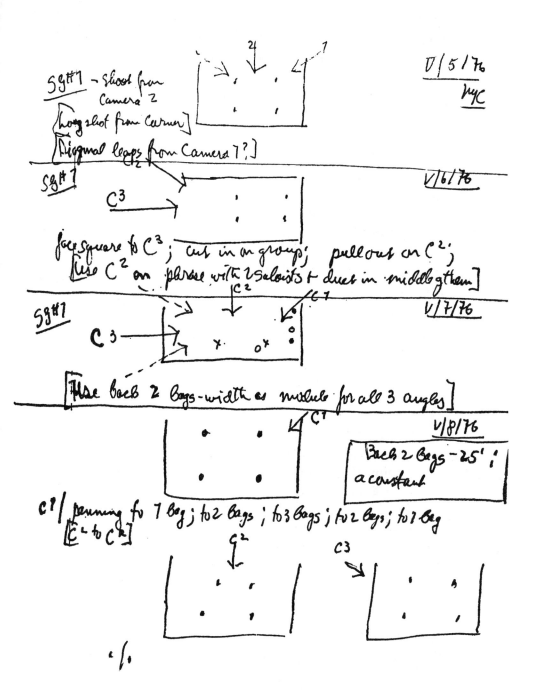

Sg#7 – shoot from
Camera 2

[long shot from Corner]

[Diagonal leaps from Camera 1?]

0/5/76

NYC

Sg#7

C³

0/6/76

face square to C³; cut in on group; pull out on C²;
[use C² on phrase with 2 soloists + duet in middle of them]

Sg#7

C 3

0/7/76

[Use back 2 bags-width as module for all 3 angles]

0/8/76

Back 2 Bags – 25'; a constant

C⁷| panning for 1 Bag; to 2 Bags; to 3 Bags; to 2 Bags; to 1 Bag
[C² to C³]

C²

C3

18. *Squaregame*: preparation for takes by three cameras

M.C. Complete dances? *Cross Currents, Rune, Torse, Fractions, Tango, Scramble, Signals, Locale, Changing Steps, Roadrunners, Channels/Inserts, Fielding Sixes, Duets, Tens with Shoes, Trails, Gallopade, Quartet,* and *Coast Zone, Inlets 2, Roaratorio, Pictures, Doubles, Phrases.* Well, that seems enough ...

J.L. How do you use video in rehearsing an earlier dance? Do you look at the whole tape before rehearsing?

M.C. I send the dancers to look at the tape, then they come out and try it. They look again, I look at it, and gradually we get it back. The tapes are very helpful. They are most helpful to dancers who know the parts, and who have not done them for a while; it refreshes their memories. But they can help even the people who have never done it.

J.L. Can they really learn it through a tape?

M.C. Not entirely, but a great deal of it, the general shape of it, the quality of the movement, where they should be. And then we all have to work at it together.

J.L. There are many clichés about the uses of video. Will you say how you came to be interested in it and to use it?

M.C. About ten years ago, it struck me that there was bound to be a close connection between dancing and TV, because dancing is visual. As soon as it became possible to see what had been taped immediately after the taping, I realized that it would be interesting for dancing. Our actual work on video began with the arrival of Charles Atlas as an assistant stage manager. His work had been in movies. We bought one camera to begin with, I had to learn how to switch it on and off; that was my level. We began learning about video while doing a first piece, which we called *Westbeth* because we made it here. By that time we had two cameras. For each dancing section of *Westbeth* we asked questions about video. The first one, for example, was concerned with the changing distance from the camera of each dancer, ranging from close-ups to long shots. These changes were made involving movement so that the dancing did not stop. In another section we asked how to cut from one camera to the other, making these cuts on the dance rhythms in such a way as not to

interrupt the flow of the dancing; a cut is at a single instant. Or another question: how to tape five dancers each doing different movements in different directions and keep all five in full figure.

We took several months over these questions, it was the only way to get involved with video.

A year later it occurred to me that we could turn the dance *Squaregame* into a video. We always worked ahead to set up the shots, to transpose the dance from the stage to the screen. For example, we had to position the bags diagonally. Because of the camera they looked like they were on a square but in fact that was an illusion.

Right after these first experiments we prepared a program for a television series called *Dance in America*. We prepared the shots here, knowing they would be changed of course at Nashville, in their studio. The shooting itself took a week, with four or five weeks' work ahead of that. We wanted to make a TV piece. We chose parts of the repertory that we looked at and thought about in terms of TV. Not every dance allows that. In the program I didn't want to start by talking. I agreed to talk in the middle at some point, but there had to be dancing before and after that, and at the end. One question that arises is this: if you look at a television screen, and you see someone on it, and suddenly he appears elsewhere, you get lost. You have to try to anchor what appears on the screen. We tried to get a sense of space by coloring two walls differently.

J.L. I wonder if the fact of not having a linear structure in your dances helps you in TV or not. Even classical structures are not well done on TV, but with your structure, is the problem made more difficult?

M.C. Using the space as a field makes it easier to shift the direction of the camera. And the dance not being fixed to the music is free to be changed in any way.

The next experience for us was *Blue Studio* which we made in an extremely small space. If I raised my arms I touched the lights, there was a cement floor, and we had two days in which to do it. Everything we had planned here didn't work, *Blue Studio* was for a thirty-minute program that Nam June Paik had asked me to share with him, each of us having fifteen minutes. I

originally wanted two dancers, but when I saw the studio and the conditions, I decided to do it myself.

Next we did *Fractions I,* here in Westbeth, which started as a video piece.

J.L. Do you expect increasingly to do pieces for video first and then for the stage?

M.C. That was the case for *Fractions I* but *Roadrunners* was made for a specific stage. I'd like to turn it into a video dance. Video will be used to record all the dances; we do that anyway, so we can remember them. We put the cameras in front and on the side. *Locale* was done first for video and then for the stage, and the two versions are quite different. The cameras select what you see; on stage you see everything. I have a feeling video will change and develop far more than film. The time is not far away when screens will be better and bigger; then the energy is very different. We danced in a gymnasium with screens that gave a life-size image. We did the dance three times, the dancers began after the video image, in counterpoint rather than synchronized with it. The third time they were in synchrony. It was like a game, amazing. I had seen this on a small screen and now the total energy came out in a very different way.

J.L. Do you use the video with your dancers to make a dance?

M.C. No, they would just sit there looking, we would not have time for learning the dance. You have to learn not only to use video but to look at it. In the revival of a dance we use it to facilitate the recall of something we already know.

Locale

J.L. Locale was made for video in January of 1979, in the studio at Westbeth. You have since done a version of the dance for the stage, and your dancers included parts of it in an event that was given in Angers. I'd like to look at the way you were led to make Locale. Perhaps that way we could appreciate the effects of video on your work as choreographer.

M.C. Since this dance began as a dance for video, we had to think in terms of the camera from the start. Charles Atlas and I wanted to use mobile cameras, which we had never done before. Therefore we used three types of camera: fixed, dolly and crane. Immediately another problem came up: we could pay all the dancers for some of the weeks, or some of the dancers for all of the weeks. We decided to pay all of the dancers for some of the weeks. So the first section everybody's in, the second section seven of them are in, the third section another seven, and all of them in the last section again. That's the way the structure comes about. It's like years ago when people said: 'How many dancers do you have?' and I said, 'Six. That's what the Volkswagen bus will hold.' They all thought that funny. But I thought that perfectly reasonable.

Then I had the idea that the two middle parts would be the longest (the ones with seven and seven). I think roughly it came out to be about 28 minutes long, the first part and last part about four minutes each. It's not exactly even because I always give and take on it.

Now there was the structure to work with and I began to make the movement. Since it was made originally as a video piece, it was done with the idea that it would be seen in the camera. But they were moving cameras, so when I chose to remake it for the stage, a problem came up. With the camera you select what you

take, but on the stage, everything is there.

So I had to do the selecting for the stage piece another way, although basically it's the same piece. Everybody is always visible and not off camera, so I had to add certain things in situations where instead of being invisible, they were in position while somebody else was moving.

Also I wanted a piece where changes happened very quickly, because you see things fast on television and I wanted to keep that in the stage piece, keep that idea of a multiplicity of images happening. Also try and get something which seemed to move and then suddenly stopped, that you could see very rapidly, seize very quickly. It's not consistent in the piece, but that was one of the ideas that came out of the video. I tried to keep that in the stage piece. The stage, of course, opens it out, changes the space very much. I introduced certain kinds of traveling movements, in order to facilitate the exits and entrances. Or, between sequences in the video they could get off camera and come in again, but on stage I had to make something so that they could get dancewise to the next place. That seems to be part of shifting from the video to the stage situation. But I didn't change any more than was absolutely necessary.

J.L. Why 28 minutes, and why the title Locale?

M.C. Oh, that was very strict. That comes from the video. We wanted to make it a half-hour show, and we inquired what the nature of a half-hour show is in, say, the New York circumstance, and Channel Thirteen, the public supported station, said it's 28'45", so the video version is 28'45"- Usually 'Locale' implies a specific place. I like words, but for titles I like to find words that leave it open, that don't impinge in some way, that don't pressure someone into thinking something particular. I've noticed that lately I've used very short titles. Earlier they were slightly longer.

J.L. I was very struck with what you said about space and time, because in trying to make notes, trying in particular to look 'inside the watch' and understand its composition, either I could follow the grouping, the spacing, but then missed the rhythm completely, or turn to the rhythm and try to keep track of it, but

then I lost the grouping (laughter). Now that there's video, it will not much encourage that kind of gymnastics! Now we know the parts of Locale, *their duration, the number of dancers in each one, the general quality of the dance, its tempo; and now ...?*

M.C. You mean, what's next? Okay. In the first part of *Locale,* they come out in twos or threes. For each one of those, duet or trio, I had devised with chance means a series of positions for the legs and for the arms, among about twenty possibilities; for each person, what their legs did at any given moment, and what their arms did. And I figured who would be with whom. This is all before the dancers were ever there. When it got to them, naturally it changed, but it gave me a way to start. The duets and trios run all the way through the first section which is exactly four minutes. Also, because it was for video, I had to keep in mind, when we were using the studio, where they went in the space, so that a moving camera could follow. When it came to the stage they did the same things, but I had to put them in slightly different places because of the relationship to the wings and there were some doublings which don't happen in the video.

J.L. The material for that part, four minutes, is clear. As you have emphasized before, for you the dance is what comes in between, what leads from one point to another. At what moment do you take that in hand and how?

M.C. When I give cues to the dancers, I begin to see differently. I think, for example: look, now it would be better if Robert Kovich went faster or slower; or it would be better if he turned another way to get into the position. I sift through each thing that way. When Robert gets to Karole for example, I say, 'It would be better if your leg went across her rather than away from her, in the same position; but then you have to be closer to her.' So we try it out and see, patiently. Sometimes it doesn't work because it's not physically possible. You see how to get from one point to the other from dancing it, you figure it out *dancewise.* And sometimes it would happen that one of the dancers would do something else which would work very well in that circumstance. Having figured out some possibilities of how one might get from one position to another, the next thing is to figure out

the rhythmic possibilities so that you don't simply accept, so to speak, the first thing that comes into your head, but rather see if there might be other ways. Sometimes the rhythm is dictated by the nature of the movement and it can't really be done otherwise. But very often there are other possibilities, so I would work on those. Mostly the rhythm is dictated by the quality of the movement, but sometimes by where someone needs to be at a given time in reference to another group of dancers.

The limitations of the space are clear: what the camera will take; in this case, the possibilities given by several cameras, so that they focus on space differently. Then I began to isolate the dancers into couples and trios so that the camera could go from one to the other. Groups of people large enough to make an image, small enough so that the camera could come close, entirely close, giving the specific quality of the close-up. Then one must take care of the size of the person in relation to getting in the camera; what works, what might work. I devised a series of arm positions: if during the filming one of these did not work, the dancer could do another one. If the arms were fully stretched, they both might not be in the camera fully, so one arm would be bent which would allow the whole dancer to be in the camera. I had made a gamut of positions, each one made so that if one did not work it could be changed to another. I had to figure those out for each dancer. For each dancer, there was a separate continuity of both positions of the arms and the legs. This was done by chance means. On stage, as opposed to video, the dynamics do not depend on the camera; it's in the look of the dance. When the dancers finish a sequence, you have to decide whether they run off stage or stop, or whether they keep doing the kind of movement they were doing. With the camera you can just change. At one point in *Locale* there are fourteen dancers on stage. Needing to make an abrupt change to a sequence involving only four, I had to keep ten near the wings so the change from fourteen to four could take place suddenly.

J.L. In your choreographies, you have integrated so much of the knowledge brought out by visual techniques, developed by movie as well as TV or video. By doing so, you have invented for dancing stage equivalents for close-ups, dissolves, and shifts from one camera to another. I have not seen any other

choreographer so aware of that, and doing it so much.

M.C. People have looked at the movies for so many years. They are perfectly accustomed to it now, and there is no reason not to attempt to bring it out. It seems to me reasonable, since it exists in the movies. It would not be the same on stage, of course, but it brings back to it another sense of space. In a way, it opens up the conventional stage space.

J.L. How do you decide on the programs?

M.C. Forming a program has both a conventional and unconventional aspect to it. If it's to be a repertory program, that means pieces with intermissions. First of all, I have a tendency to try to be sure that everybody gets to dance in the program. Then I try to make some kind of program that will work in terms of their energy and in terms of what piece comes first. That's the conventional way. On the other hand, even in a conventional program, if we do a piece like *Changing Steps* that can have everybody in it, or half of them - because it's flexible, it's called *Changing Steps* - there are parts of it which we do or don't do, depending on the situation, depending on whether there's enough space, depending on the people, etc . . . For example, Lisa Fox, one of the dancers, had a bad toe - she'd sprained her toe - so we tried to figure out what she could and what she couldn't do. She could be in the second piece, but she wouldn't be in *Torse* because I could leave her out. That was alright and I also left her out of *Changing Steps*. That's a practical thing but that has to be taken into consideration for the program. The piece we did yesterday was actually *Locale*. We had no chance to perform it, previous to this, so I do it in *Events* for the dancers, in order that we won't lose it. We don't have the music yet. All we have is the dance. We're doing an event in Angers and although I have a general idea, I wait to see the set up, the space, before I decide what we do. I do wait until I see, because often I've had some more specific idea and gotten to the place only to realize it would never work, and consequently have had to change it all. I simply wait now. I know what our whole mass of material is, but what we will do exactly and in what order, I leave it to the moment, I wait and see. That's the unconventional part! (laughter)

Chronological List of
Merce Cunningham's Choreographies

MCDC = Merce Cunningham Dance Company

DANCE	MUSIC	DESIGN	DANCERS	DATE AND PLACE OF FIRST PERFORMANCE
Seeds of Brightness Choreographed with Jean Erdman	Norman Lloyd	Charlotte Trowbridge	MC Jean Erdman	Bennington VT 1 August 1942
Credo in Us Choreographed with Jean Erdman	John Cage	Charlotte Trowbridge	MC Jean Erdman	Bennington VT 1 August 1942
Ad Lib Choreographed with Jean Erdman	Gregory Tucker John Cage 1943	Charlotte Trowbridge	MC Jean Erdman	Bennington VT 1 August 1942
Renaissance Testimonials	Maxwell Powers	Charlotte Trowbridge	Solo MC	Bennington VT 1 August 1942
Totem Ancestor	John Cage	Charlotte Trowbridge	Solo MC	New York NY 20 October 1942
In the Name of the Holocaust	John Cage	MC	Solo MC	Chicago IL 14 February 1943
Shimmera	John Cage	MC	Solo MC	Chicago IL 14 February 1943
The Wind Remains Zarzuela in one act after Federico Garcia Lorca	Paul Bowles	Oliver Smith Kermit Love	MC Jean Erdman et al	New York NY 30 March 1943
Triple-Paced	John Cage	MC	Solo MC	New York NY 5 April 1944
Root of an Unfocus	John Cage	MC	Solo MC	New York NY 5 April 1944
Tossed as it is Untroubled	John Cage	MC	Solo MC	New York NY 5 April 1944
The Unavailable Memory of	John Cage	MC	Solo MC	New York NY 5 April 1944
Spontaneous Earth	John Cage	MC	Solo MC	New York NY 5 April 1944

Title	Composer	Designer	Performers	Location & Date
Four Walls A Dance Play by MC	John Cage	Arch Lauterer	MC Julie Harris et al	Steamboat Springs CO 22 August 1944
Idyllic Song	Erik Satie arr. John Cage	MC	Solo MC	Richmond VA 20 November 1944
Mysterious Adventure	John Cage	after David Hare	Solo MC	New York NY 9 January 1945
Experiences	John Cage Livingston Gearhart	MC	Solo MC	New York NY 9 January 1945
The Encounter	John Cage	MC	Solo MC	New York NY 12 May 1946
Invocation to Vahakn	Alan Hovhaness	MC	Solo MC	New York NY 12 May 1946
Fast Blues	Baby Dodds	MC	Solo MC	New York NY 12 May 1946
The Princess Zondilda and her Entourage	Alexei Haieff	MC	MC Virginia Bosler Katherine Litz	New York NY 12 May 1946
The Seasons	John Cage	Isamu Noguchi	Ballet Society with MC	New York NY 18 May 1947
The Open Road	Lou Harrison	MC	Solo MC	New York NY 14 December 1947
Dromenon	John Cage	Sonja Sekula MC	MC and group	New York NY 14 December 1947
Dream	John Cage	MC	Solo MC	Columbia MO 8 May 1948
The Ruse of Medusa a lyric comedy in one act by Erik Satie, translated by MC Richards, directed by Arthur Penn	Erik Satie	Willem and Elaine de Kooning Mary Outten	MC et al	Black Mountain NC 14 August 1948

DANCE	MUSIC	DESIGN	DANCERS	DATE AND PLACE OF FIRST PERFORMANCE
A Diversion also given in quartet and solo versions	John Cage	Mary Outten MC	MC, Sara Hamill, Louise Lippold	Black Mountain NC 20 August 1948
Orestes	John Cage	MC	Solo MC	Black Mountain NC 20 August 1948
The Monkey Dances from The Ruse of Medusa	Erik Satie	Mary Outten Richard Lippold MC	Solo MC	Black Mountain NC 20 August 1948
Effusions avant l'heure later called Games and Trio	John Cage		MC, Tanaquil LeClerq Betty Nichols	Paris summer 1949
Amores	John Cage		MC Tanaquil LeClerq	Paris summer 1949
Duet			Betty Nichols Milorad Miskovitch	Paris summer 1949
Two Step	Erik Satie	MC	Solo MC	New York NY 18 December 1949
Pool of Darkness	Ben Weber	MC	MC Dorothy Berea Mili Churchill Anneliese Widman	New York NY 15 January 1950
Before Dawn		MC	Solo MC	New York NY 15 January 1950
Waltz	Erik Satie		Student group	Baton Rouge LA 27 June 1950
Rag-Time Parade Revived by MC and Company, 1950	Erik Satie		Student group	Baton Rouge LA 27 June 1950

Title	Music	Décor	Dancers	Place and date
Waltz	Erik Satie		Solo MC	New York NY 24 November 1950
Sixteen Dances for Soloist and Company of Three	John Cage	Eleanor de Vito John Cage Remy Charlip MC	MC Dorothy Berea Mili Churchill Anneliese Widman	Millbrook NY 17 January 1951
Variation	Morton Feldman	MC	Solo MC	Seattle WA 12 April 1951
Boy Who Wanted to be a Bird			Solo MC	Martha's Vineyard MA summer 1951
Suite of Six Short Dances	Recorder pieces		Solo MC	Black Mountain NC spring 1952
Excerpts from Symphonie pour un homme seul Revived by MC and Dance Company, 1953, under the title Collage	Pierre Schaeffer with Pierre Henry		MC and group	Waltham MA 14 June 1952
Les Noces	Igor Stravinsky	Howard Bay	MC Natanya Neumann and group	Waltham MA 14 June 1952
Theater Piece by John Cage; poetry by Charles Olson and MC Richards, film by Nicholas Cernovitch	David Tudor	Robert Rauschenberg	MC	Black Mountain NC summer 1952
Suite by Chance	Christian Wolff	Remy Charlip	MCDC	Urbana IL 24 March 1953
Solo Suite in Space and Time	John Cage	MC	Solo MC	Baton Rouge LA 23 June 1953

205

DANCE	MUSIC	DESIGN	DANCERS	DATE AND PLACE OF FIRST PERFORMANCE
Demonstration Piece			Student group	Baton Rouge 23 June 1953
Epilogue	Erik Satie		Student group	Baton Rouge 23 June 1953
Banjo	Louis Moreau Gottschalk	Remy Charlip	MCDC	Black Mountain NC 21 August 1953
Dime a Dance	The Whole World 19th C piano music selected by David Tudor	Remy Charlip	MCDC	Black Mountain NC 21 August 1953
Septet Revived by Rambert Dance Company, 1987 Pacific Northwest Ballet, 1989	Erik Satie	Remy Charlip	MCDC	Black Mountain NC 22 August 1953
Untitled Solo	Christian Wolff	MC	Solo	Black Mountain NC 22 August 1953
Fragments	Pierre Boulez	Remy Charlip	MCDC	New York NY 30 December 1953
Minutiae	John Cage	Robert Rauschenberg Remy Charlip	MCDC	Brooklyn NY 8 December 1954
Springweather and People	Earle Brown	Remy Charlip Robert Rauschenberg 1957	MCDC	Annandale-on-Hudson NY 24 May 1955
Lavish Escapade	Christian Wolff	MC	Solo MC	South Bend IN 18 May 1956

Galaxy	Earle Brown	Remy Charlip	MCDC	South Bend IN 18 May 1956
Suite for Five in Space and Time later called Suite for Five	John Cage	Robert Rauschenberg	MCDC	South Bend IN 18 May 1956
Nocturnes	Erik Satie	Robert Rauschenberg	MCDC	Jacob's Pillow MA 11 July 1956
Changeling	Christian Wolff	Robert Rauschenberg	Solo MC	Brooklyn NY 30 November 1957
Labyrinthian Dances	Josef Matthias Hauer	Robert Rauschenberg	MCDC	Brooklyn NY 30 November 1957
Picnic Polka	Louis Moreau Gottschalk	Remy Charlip	MCDC	Brooklyn NY 30 November 1957
Antic Meet	John Cage	Robert Rauschenberg	MCDC	New London CT 14 August 1958
Summerspace Revived by New York City Ballet 1966:Cullbergbaletten 1967: Boston Ballet 1974: Théâtre du Silence 1976	Morton Feldman	Robert Rauschenberg	MCDC	New London CT 17 August 1958
Night Wandering Revived by 5 by 2 Plus, 1977	Bo Nilsson	Nicholas Cernovitch Robert Rauschenberg 1960	MC Carolyn Brown	Stockholm 5 October 1958
From the Poems of White Stone	Chou Wen-Chung poems by Chiang Kuei	Robert Rauschenberg	MCDC	Urbana IL 14 March 1959
Gambit for Dancers and Orchestra	Ben Johnston	Robert Rauschenberg	MCDC	Urbana IL 14 March 1959
Rune	Christian Wolff	Robert Rauschenberg Mark Lancaster 1983	MCDC	New London CT 14 August 1959

DANCE	MUSIC	DESIGN	DANCERS	DATE AND PLACE OF FIRST PERFORMANCE
Theater Piece	John Cage		MC Carolyn Brown	New York NY 7 March 1960
Crises	Conlon Nancarrow	Robert Rauschenberg	MCDC	New London CT 19 August 1960
Hands Birds	Earle Brown	Robert Rauschenberg	Carolyn Brown	Venice, 24 September 1960
Waka	Toshi Ichiyanagi	Robert Rauschenberg	Carolyn Brown	Venice, 24 September 1960
Music Walk with Dancers	John Cage	Robert Rauschenberg	MC Carolyn Brown	Venice, 24 September 1960
Aeon	John Cage	Robert Rauschenberg	MCDC	Montreal 5 August 1961
Field Dances	John Cage	Robert Rauschenberg Remy Charlip, 1967	MCDC	Los Angeles CA 17 July 1963
Story	Toshi Ichiyanagi	Robert Rauschenberg	MCDC	Los Angeles CA 24 July 1963
Open Session		MC	Solo MC	Hartford CT 19 March 1964
Paired	John Cage	Robert Rauschenberg	MC Viola Farber	Hartford CT 21 March 1964
Winterbranch Revived by Boston Ballet, 1974	La Monte Young	Robert Rauschenberg	MCDC	Hartford CT 21 March 1964
Cross Currents Revived by US Terpsichore, 1980 Werkcentrum-Dans Rotterdam, 1984	Conlon Nancarrow arr John Cage New score John Cage Oct 1964	MC	MCDC	London 31 July 1964

Title	Composer	Design / Artist	Company	Location & Date
Museum Event No 1 followed by many others		Robert Rauschenberg	MCDC	Vienna 1964
Variations V	John Cage	Film: Stan VanDerBeek TV images: Nam June Paik	MCDC	New York NY 23 July 1965
How to Pass, Kick, Fall and Run	John Cage		MCDC	Chicago IL 24 November 1965
Place	Gordon Mumma	Beverly Emmons	MCDC	Saint-Paul de Vence 6 August 1966
Scramble	Toshi Ichiyanagi	Frank Stella	MCDC	Chicago IL 25 July 1967
RainForest	David Tudor	Andy Warhol	MCDC	Buffalo NY 9 March 1968
Walkaround Time	David Behrman	after Marcel Duchamp	MCDC	Buffalo NY 10 March 1968
Canfield	Pauline Oliveros	Robert Morris	MCDC	Rochester NY 4 March 1969
Tread	Christian Wolff	Bruce Nauman	MCDC	Brooklyn NY 5 January 1970
Second Hand	John Cage	Jasper Johns	MCDC	Brooklyn NY 8 January 1970
Signals Revived by Ohio Ballet, 1981	David Tudor Gordon Mumma John Cage	Richard Nelson MC	MCDC	Paris 5 June 1970
Objects	Alvin Lucier	Neil Jenney	MCDC	Brooklyn NY 10 November 1970
Loops	Gordon Mumma	Jasper Johns	Solo MC	New York NY 3 December 1971

DANCE	MUSIC	DESIGN	DANCERS	DATE AND PLACE OF FIRST PERFORMANCE
Landrover	John Cage Gordon Mumma David Tudor	Jasper Johns	MCDC	Brooklyn NY 1 February 1972
TV Rerun	Gordon Mumma	Jasper Johns	MCDC	Brooklyn NY 2 February 1972
Borst Park	Christian Wolff	The Company	MCDC	Brooklyn NY 8 February 1972
Un Jour ou deux	John Cage	Jasper Johns	Paris Opéra Ballet	Paris 6 November 1973
Exercise Piece		Mark Lancaster	MCDC	New York NY 14 February 1975
Rebus	David Behrman	Mark Lancaster	MCDC	Detroit MI 7 March 1975
Changing Steps Revived by Théâtre du Silence, 1979 Revived by Purchase Dance Corps, 1987 Video version directed by Elliot Caplan and MC, 1988	John Cage	Charles Atlas Mark Lancaster 1978	MCDC	Detroit MI 7 March 1975
Solo	John Cage	Sonja Sekula	Solo MC	Detroit MI 8 March 1975
Sounddance	David Tudor	Mark Lancaster	MCDC	Detroit MI 8 March 1975
Torse	Maryanne Amacher	Mark Lancaster	MCDC	Princeton NJ 15 January 1976

Title	Music	Design	Company	Location / Date
Squaregame	Takehisa Kosugi	Mark Lancaster	MCDC	Adelaide, Australia 24 March 1976
Travelogue	John Cage	Robert Rauschenberg	MCDC	New York NY 18 January 1977
Inlets new version, Inlets 2, 1983; revived by Paris Opera Ballet, 1983 Revived by Concert Dance Company of Boston, 1985 Sharir Dance Company, 1988	John Cage	Morris Graves Mark Lancaster, 1983	MCDC	Seattle WA 10 September 1977
Fractions A work for video directed by Charles Atlas and MC stage version 1978	Jon Gibson	Mark Lancaster	MCDC	New York NY Nov-Dec 1977
Exercise Piece I	Meredith Monk	Suzanne Joalson	MCDC	New York NY 25 March 1978
Exercise Piece II	John Cage	Mark Lancaster	MCDC	Toronto, Ontario 18 August 1978
Exchange	David Tudor	Jasper Johns	MCDC	New York NY 27 September 1978
Tango	John Cage	Mark Lancaster	Solo MC	New York NY 5 October 1978
Locale Videodance directed by Charles Atlas & MC stage version 1979	Takehisa Kosugi	Charles Atlas	MCDC	New York NY January/February 1979
Roadrunners	Yasunao Tone	Mark Lancaster	MCDC	Durham NC 19 July 1979
Exercise Piece III	John Cage	Mark Lancaster	MCDC	New York NY 23 February 1980

DANCE	MUSIC	DESIGN	DANCERS	DATE AND PLACE OF FIRST PERFORMANCE
Duets revived by American Ballet Theater, 1982	John Cage	Mark Lancaster	MCDC	New York NY 26 February 1980
Fielding Sixes revived by Ballet Rambert, 1983	John Cage	Monika Fullemann Mark Lancaster, for Ballet Rambert William Anastasi. 1986	MCDC	London 30 June 1980
Channels/Inserts Videodance directed by Charles Atlas and MC Stage version 1981	David Tudor	Charles Atlas	MCDC	New York NY January 1981
10's with Shoes	Martin Kalve	Mark Lancaster	MCDC	New York NY 17 March 1981
Gallopade	Takehisa Kosugi	Mark Lancaster	MCDC	London 10 June 1981
Trails	John Cage	Mark Lancaster	MCDC	New York NY 16 March 1982
Quartet	David Tudor	Mark Lancaster	MCDC	Paris 27 October 1982
Coast Zone Videodance directed by Charles Atlas & MC Stage version 1983	Larry Austin	Mark Lancaster Charles Atlas	MCDC	New York NY January 1983
Roaratorio	John Cage	Mark Lancaster	MCDC	Lille-Roubaix 26 October 1983
Pictures	David Behrman	Mark Lancaster	MCDC	New York NY 6 March 1984

Work	Takehisa Kosugi	Mark Lancaster	MCDC	Durham, NC 28 June 1984
Doubles Revived by Rambert Dance Company, 1990				
Phrases	David Tudor	William Anastasi Dove Bradshaw	MCDC	Angers 7 December 1984
Deli Commedia videodance directed by Elliot Caplan	Pat Richter	Dove Bradshaw	Student group	New York January 1985
Native Green	John King	William Anastasi	MCDC	New York NY 12 March 1985
Arcade revived by MCDC 14 November 1985	John Cage	Dove Bradshaw	Pennsylvania Ballet	Philadelphia PA 11 Sep 1985
Grange Eve	Takehisa Kosugi	William Anastasi	MCDC	New York NY 18 March 1986
Points in Space videodance directed by Elliot Caplan and MC Stage version 1987; revived by Paris Opera Ballet, 1990	John Cage	William Anastasi	MCDC	London May 1986
Fabrications	Emanuel de Melo Pimenta	Dove Bradshaw	MCDC	Minneapolis MN 21 February 1987
Shards	David Tudor	William Anastasi	MCDC	New York NY 4 March 1987
Carousal	Takehisa Kosugi	Dove Bradshaw	MCDC	Jacob's Pillow MA 18 Aug 1987
Eleven	Robert Ashley	William Anastasi	MCDC	New York NY 9 March 1988

DANCE	MUSIC	DESIGN	DANCERS	DATE AND PLACE OF FIRST PERFORMANCE
Five Stone	John Cage David Tudor	Mark Lancaster	MCDC	Berlin 17 June 1988
Five Stone Wind	John Cage Takehisa Kosugi David Tudor	Mark Lancaster	MCDC	Avignon 30 July 1988
Cargo X	Takehisa Kosugi	Dove Bradshaw	MCDC	Austin Texas 27 January 1989
Field and Figures	Ivan Tcherepnin	Kristin Jones Andrew Ginzel	MCDC	Minneapolis MN 17 February 1989
August Pace	Michael Pugliese	Afrika (Sergei Bugaev)	MCDC	Berkeley CA 22 Sep 1989
Inventions	John Cage	Carl Kielblock	MCDC	Berkeley CA 23 Sep 1989
Polarity	David Tudor	William Anastasi Merce Cunningham	MCDC	New York NY 20 March 1990

Films and Videos

F film-maker S sound C color B/W black and white
VT videotape

1939 DANCERS AT BENNINGTON SCHOOL AND MILLS COLLEGE

F Betty Lind Thompson 14½ min C 16mm
Dancers at Mills College, 1939, including Merce
Cunningham

1941–1944 MARTHA GRAHAM AND COMPANY

F Ann Barzel 13½ min B/W
1 El Penitente and Letter to the World
with Martha Graham and Merce Cunningham
Boston 1941
2 Every Soul is a Circus
with Martha Graham and Merce Cunningham
Civic Theatre, Chicago, 1944?

1944 FOUR WALLS (in INTEGRATION OF DANCE AND DRAMA
1952)

F Portia Mansfield approx. 5 min S C 16mm
With Merce Cunningham, Julie Harris, and Leora
Dana
Perry-Mansfield Workshop, Steamboat Springs, Colorado,
August 1944

1953? MERCE CUNNINGHAM AND DANCE COMPANY

F Marianne Preger Simon C 8mm
Rehearsal shots of Merce Cunningham Dance Company

1955 SEPTET and BANJO (excerpts)
F Carol Lynn 6 min B/W 16mm
Jacob's Pillow, summer 1955

1958 SUMMERSPACE (excerpts)

F Helen Priest Rogers 11 min B/W 16mm
Performance and rehearsal scenes, American Dance
Festival, Connecticut College, New London, 17 August
1958

1961 SUITE DE DANSES

F Jean Mercure Choreography: Merce Cunningham
Music: Serge Garrant Costumes: Jasper Johns
Commissioned by Canadian Broadcasting Company –
TV Montreal, Canada, 9 July 1961

1961 CRISES

F Helen Priest Rogers 22½ min S B/W 16mm
Rehearsal, American Dance Festival, Connecticut
College, New London, 14 August 1961

1964 IMAGE ET TECHNIQUE/MERCE CUNNINGHAM

F Etienne Becker S B/W 16mm
Includes excerpts, often fragmentary, from: Septet,
Suite for Five, Nocturnes, Changeling, Antic Meet,
Summerspace, Rune, Crises, Aeon, Story, and Paired,
in rehearsal and performance at Theatre de l'Est
Parisien and Comedie de Bourges, June 1964; also
interviews with Merce Cunningham and John Cage

1964 ANTIC MEET, CRISES, NIGHT WANDERING

D Arne Arnbom
Sveriges Radio Television, filmed at Moderna Museet,
Stockholm, 9 September 1964

1964 STORY*, SEPTET, NIGHT WANDERING, ANTIC MEET

Yleisradio/TV, Helsinki, Finland, 18 September 1964

1964 CRISES

Belgische Radio/TV, Brussels, Belgium, 5 October 1964

1966 ART SCENE

USIA 17 min C
Martha Graham Dancers, The Once Group (A
Happening), Erick Hawkins and Co., Merce
Cunningham and Co., and Alvin Nikolais Dancers

1966 VARIATIONS V

F Arne Arnbom 48 min S B/W 16mm
Norddeutscher Rundfunk, Hamburg, and Sveriges
Radio TV

1966 JOHN CAGE

F Klaus Wildenhahn 59½ min S B/W 16mm
Norddeutscher Rundfunk, Hamburg
John Cage on tour with Merce Cunningham Dance
Company

1967 MERCE CUNNINGHAM

29 min C
Cunningham demonstrates his technique with his
company

1967 498 THIRD AVENUE

F Klaus Wildenhahn 81 min S B/W 16mm
Norddeutscher Rundfunk, Hamburg
Includes rehearsal scenes of Scramble

1968 PLACE, SCRAMBLE, HOW TO PASS, KICK, FALL AND RUN

F Roger Englander 120 min S B/W 16mm
WNED/TV Buffalo
Live performance at Second Buffalo Festival of the
Arts Today, 8 March 1968
Includes interviews with Merce Cunningham and John
Cage

1968 RAINFOREST

F D A Pennebaker 26 min S C 16mm
Public Broadcast Laboratory
Film of first performance of RainForest, Second
Buffalo Festival of the Arts Today, 9 March 1968

1968 ASSEMBLAGE (a film for television)

F Richard Moore Choreography: Merce Cunningham
Music: John Cage, Gordon Mumma, David Tudor
KQED/TV, San Francisco, October-November 1968

1972 TV RERUN

Yugoslav Television, Belgrade, 19 September 1972

1973 WALKAROUND TIME

F Charles Atlas 48 min C S 16mm
Brooklyn Academy of Music, 1969/Théâtre de la Ville,
Paris, 1972

1974 A VIDEO EVENT

F Merrill Brockway 50 min S C VT
Part I: Class, Winterbranch, Second Hand solo,
Sounddance, TV Rerun
Part II: Sounddance rehearsal, Changing Steps,
Landrover, Signals
CBS Camera Three, New York, 10/11 May 1974

1974 *WESTBETH: a work for video

F Charles Atlas and,Merce Cunningham 32
min S B/W VT
Music: John Cage Costumes: Mark Lancaster
Cunningham Dance Foundation, New York, fall 1974

220 THE DANCER AND THE DANCE

1975 *BLUE STUDIO: FIVE SEGMENTS

F Charles Atlas 15½ min C VT
WNET/TV LAB, October 1975
(also included in "Merce by Merce by Paik", 1975)

1977 *SQUAREGAME VIDEO

F Charles Atlas 27 min S B/W VT
Music: Takehisa Kosugi Design: Mark Lancaster
Cunningham Dance Foundation, New York, May 1976

1976 EVENT FOR TELEVISION

F Merrill Brockway 55 min S C VT
Minutiae, Solo, Westbeth, Septet, Antic Meet, Scramble,
RainForest, Sounddance, Video Triangle
WNET "Dance in America," Nashville, Tennessee,
8/11 November 1976

1977 *TORSE

F Charles Atlas 55 min C S 16mm VT
Music: Maryanne Amacher Design: Mark Lancaster.
Produced by New York Public Library Dance
Collection Seattle, Washington, September 1977

1977 *FRACTIONS I & II

F Charles Atlas 33 min C & B/W S VT
Music: Jon Gibson Design: Mark Lancaster
Cunningham Dance Foundation, New York,
November-December 1977

1978 EXCHANGE

F Charles Atlas C S 16mm (unedited)
Music: David Tudor Design: Jasper Johns
Cunningham Dance Foundation, Berkeley, October
1978

1979 *LOCALE

> F Charles Atlas 30 min C S 16mm VT
> Music: Takehisa Kosugi Design: Charles Atlas
> Cunningham Dance Foundation, New York, January-
> February 1979

1979 *ROAMIN' I

> F Charles Atlas 15 min C & B/W S 16mm VT
> A film by Charles Atlas with outtakes from Locale
> Cunningham Dance Foundation, New York, January-
> February 1979

1979 MERCE CUNNINGHAM

> F Geoff Dunlop 60 min C S VT
> Includes excerpts from Travelogue, Squaregame,
> Exchange; and interviews with Merce Cunningham,
> Carolyn Brown, Karole Armitage, et al.
> "South Bank Show" (London Weekend Television), New
> York and Lewiston NY, August 1979

1981 *CHANNELS/INSERTS

> F Charles Atlas 32 min. C S 16mm VT
> Music: David Tudor Design: Charles Atlas
> Cunningham Dance Foundation, New York, January
> 1981

1982 *MERCE CUNNINGHAM AND COMPANY

> F Benoit Jacquot 45 min C S 16 mm VT
> L'Institut National de l'Audiovisuel (INA),
> in association with Cunningham Dance
> Foundation, 1982

***Cunningham Dance Foundation distributes this film/video**

1983 *SOMETIMES IT WORKS, SOMETIMES IT DOESN'T

F Chris Dercon and Stefaan Decostere
63 min S C VT
(Includes *Channels/Inserts*, q.v.)
Belgian Radio and Television, 1983

1984 *COAST ZONE

F Charles Atlas 28 min C S 16mm VT
Music: David Behrman Design: Mark Lancaster &
Charles Atlas
Cunningham Dance Foundation, New York, January
1983

1985 *DELI COMMEDIA

F Elliot Caplan 18 min C S 16 mm VT
Music: Pat Richter Design: Dove Bradshaw
Cunningham Dance Foundation, New York,
January 1985

1985 *CUNNINGHAM DANCE TECHNIQUE:
ELEMENTARY LEVEL

F Elliot Caplan 35 min C S VT
Commentary by Merce Cunningham
Cunningham Dance Foundation, New York, 1985

1986 *POINTS IN SPACE

F Elliot Caplan 55 min C S 16 mm VT
Music: John Cage Design: William Anastasi and
Dove Bradshaw
BBC-TV (produced by Bob Lockyer) and Cunningham
Dance Foundation, 1986

1987 *THE COLLABORATORS: CAGE, CUNNINGHAM, RAUSCHENBERG

55 Min C S VT (includes *Coast Zone*, q.v.)
KETC Public Television

1987 *CUNNINGHAM DANCE TECHNIQUE: INTERMEDIATE LEVEL

F Elliot Caplan 55 min C S VT
Commentary by Merce Cunningham
Cunningham Dance Foundation, New York, 1987

1989 *CHANGING STEPS

F Elliot Caplan 35 min C/B&W S VT
Cunningham Dance Foundation, New York, and La
SEPT, 1989

List of dancers from 1953

Armitage, Karole	1975–1981
Attix, Karen	1975–1976
Barrow, Helen	1982 —
Bartosik, Kimberly	1987 —
Blair, Shareen	1961–1964
Brodsky, Ethel	1953
Brown, Carolyn	1953–1972
Burdick, William	1958
Burns, Louise	1970–1971/1977–1984
Cole, Michael	1989 —
Cornfield, Ellen	1974–1982/1983
Charlip, Remy	1953–1961
Davis, William	1963–1964
Dencks, Anita	1953–1955
Diamond, Emma	1988 —
Dove, Ulysses	1970–1973
Dunn, Douglas	1969–1973
Dunn, Judith	1959–1963
Eginton, Meg	1978–1980
Ek, Niklas	1966
Emery, Susan	1977–1984
Ensminger, Morgan	1975–1978
Farber, Viola	1953–1965/1970
Finlayson, Victoria	1984 —
Fox, Lisa	1977–1980
Friedman, Lise	1977–1984

Good, Alan	1978 —
Greenberg, Neil	1980–1986
Harper, Meg	1968–1977
Hassall, Nanette	1971–1972
Hay, Deborah	1964
Hayman-Chaffey, Susana	1968–1976
Henkel, Ed	1971
Kanner, Karen Bell	1957
Kerr, Catherine	1974–1976/1978–1988
King, Bruce	1955–1958
Komar, Chris	1972 —
Kovich, Robert	1973–1980
Kulick, David	1986 —
Kurshals, Raymond	1975–1976
LaFarge, Timothy	1953–1954
Lazaroff, Judy	1981–1983
Lennon, Joseph	1978–1984
Lent, Patricia	1984 —
Lias, Barbara	1972–1973
Lloyd, Barbara Dilley	1963–1968
McGoldrick, Larissa	1987 —
Mehl, Brynar	1972–1973
Melsher, JoAnne	1953–1954
Moore, Jack	1960
Moscowitz, Deborah	1953
Moulton, Charles	1974–1976

Navar, Emily	1990 —
O'Connor, Dennis	1986–1989
Paxton, Steve	1961–1964
Preger-Simon, Marianne	1952–1958
Neels, Sandra	1963–1973
Radford, Karen (Fink)	1983–1987
Reid, Albert	1964–1968
Remley, Rob	1978–1987
Riopelle, Yseult	1966–1967
Robinson, Chase	1968–1972
Roess-Smith, Julie (Sukenick)	1973–1977
Sanderson, Randall	1990 —
Santimyer, Kristy	1985–1989
Saul, Peter	1965–1967
Schroder, Kevin	1985–1986
Self, Jim	1977–1979
Setterfield, Valda	1961/1965–1975
Slayton, Jeff	1968–1970
Solomons, Gus, Jr	1965–1968
Stone, Cynthia	1957–1958
Swinston, Robert	1980 —
Taylor, Paul	1953–1954
Teitelbaum, Carol	1986 —
Wagoner, Dan	1959
Walker, Megan	1980–1986
Weaver, Jenifer	1989 —

Wong, Mel	1968–1972
Wood, Marilyn	1958–1963
Wood, Robert	1987 —

A brief summary of Merce Cunningham's career

Merce Cunningham, born in Centralia, Washington, received his first formal dance and theater training at the Cornish Institute of Allied Arts in Seattle. From 1939–1945, he was a soloist in the company of Martha Graham. In 1944 he presented his first program of solos in New York City. His collaboration with the composer John Cage began at that time, and continues into the present. Throughout his career he has also worked closely with other composers, among them David Tudor, Earle Brown, Morton Feldman, Christian Wolff, David Behrman and Takehisa Kosugi. The dancers (p. 225ff) in the Merce Cunningham Dance Company from 1953 to the present have each made their own unique contribution to Merce Cunningham's art.

In the summer of 1953, Cunningham worked with his company at Black Mountain College in North Carolina, its first New York season taking place the following winter. Since that time, Cunningham has choreographed well over 100 works which have been presented on yearly tours in the United States and Europe, the Far East, and since 1979 in annual seasons in New York.

He has also choreographed two works for the New York City Ballet: *The Seasons* (John Cage/Isamu Noguchi, 1947) and a version of *Summerspace* (Morton Feldman/Robert Rauschenberg, original 1958, NYCB version 1966). *Un jour ou deux* (John Cage/Jasper Johns), an evening-length work commissioned by the Paris Autumn Festival, was first presented by the Paris Opera Ballet in 1973 and again in 1986 in a revised version. Cunningham's work *Duets* entered the repertory of American Ballet Theatre in May 1982. *Arcade* (John Cage/Dove Bradshaw, 1985) was originally created for

the Pennsylvania Ballet and then went into the Cunningham repertory. Cunningham's works have also been included in the repertories of numerous ballet and modern dance companies, among them Boston Ballet, Cullberg Ballet (Stockholm), Théâtre du Silence (France), Rambert Dance Company (London), GRCOP (the experimental wing of the Paris Opera Ballet) and Pacific Northwest Ballet.

Robert Rauschenberg, Jasper Johns and Mark Lancaster have served as designers and artistic advisors for the company. At present William Anastasi and Dove Bradshaw serve in the latter capacity. Other painters, designers, and sculptors who have collaborated with Cunningham include Richard Lippold, David Hare, Sonja Sekula, Remy Charlip, Frank Stella, Andy Warhol, Robert Morris, Bruce Nauman, Neil Jenney, Morris Graves, Charles Atlas, Kristin Jones and Andrew Ginzel, Afrika (Sergei Bugaev) and Carl Kielblock.

Cunningham has collaborated with the filmmaker Charles Atlas on three original works for video: *Westbeth* (1974), *Blue Studio: Five Segments* (WNET/TV Lab, 1975) and *Fractions I and II* (1978); and three filmdances: *Locale* (1979), *Channels/Inserts* (1981) and *Coast Zone* (1983). Atlas was succeeded as company filmmaker by Elliot Caplan, whose first collaboration with Cunningham was the videodance *Deli Commedia*. Their videodance *Points in Space* was co-produced with the BBC and shot in London in May 1986. Like most of these works, *Points in Space* was subsequently remade for the stage; the stage version was revived by the Paris Opera Ballet in 1990. The most recent videodance made by Caplan and Cunningham is *Changing Steps*, 1989. Caplan's documentary film on the collaboration of Merce Cunningham and John Cage, partly funded by PBS, is due for completion in 1991.

Cunningham's other activities include classes and workshops at the Merce Cunningham Studio, and workshops and lectures both in the United States and abroad.

Cunningham has collaborated on two books about his work: *Changes: Notes on Choreography*, with Frances Starr (Something Else Press, New York, 1968) and the present volume,

an updated version of the original French edition, *Le danseur et la danse*, interviews with Jacqueline Lesschaeve (Belfond, Paris, 1980; second edition 1988). The book has also been translated into German and Italian.

Cunningham has received two Guggenheim Fellowships for choreography, in 1954 and 1959; the Dance Magazine Award, 1960; the Medal of the Society for the Advancement of Dancing in Sweden, 1964; a Gold Medal for Choreographic Invention at the Fourth International Festival of Dance, Paris, 1966; an honorary Doctorate of Letters from the University of Illinois, 1972; the New York State Award, 1975; the Capezio Award, 1977; the Samuel H. Scripps/American Dance Festival Award for lifetime contribution to dance, 1982; the Mayor of New York's Award of Honor for Arts and Culture, 1983; a MacArthur Foundation Fellowship, 1985; the Kennedy Center Honors, 1985; the Laurence Olivier Award for the best new dance production in London (*Pictures*), 1985; the Algur H. Meadows Award for Excellence in the Arts, Southern Methodist University, Dallas, 1987; Dance/USA National Honor, 1988; the Porselli Prize (Cremona, Italy), 1990; National Medal of Arts, 1990; and the Digital Dance Premier Award, 1990. In 1984, he was inducted into the American Academy and Institute of Arts and Letters. At the end of his company's tour of France in the fall of 1982, he was made Commander of the Order of Arts and Letters by the French Minister of Culture, and at the close of its residency in Arles in July 1989, he was made Chevalier of the Legion d'Honneur by President Mitterrand of France.